The Subject of Aesthetics

Consciousness, Literature and the Arts

General Editor

Daniel Meyer-Dinkgräfe (*University of Lincoln*, UK)

Editorial Board

Anna Bonshek (*Prana World Group, Australia*)
Per Brask (*University of Winnipeg, Canada*)
John Danvers (*University of Plymouth*, UK)
Amy Ione (*Diatrope Institute, Berkeley*, USA)
Michael Mangan (*Loughborough University*, UK)
Jade Rosina McCutcheon (*Melbourne University, Australia*)
Gregory Tague (*St Francis College, New York*, USA)
Arthur Versluis (*Michigan State University*, USA)
Christopher Webster (*Aberystwyth University*, UK)
Ralph Yarrow (*University of East Anglia*, UK)

VOLUME 45

The titles published in this series are listed at *brill.com/cla*

The Subject of Aesthetics

A Psychology of Art and Experience

By

Tone Roald

With a Preface by

Hans Ulrich Gumbrecht

BRILL
RODOPI

LEIDEN | BOSTON

Cover illustration: Louise Bourgeois, UNTITLED, 2005. Fabric, 18 1/8 × 14 1/8"; 46 × 35.9 cm.
Photo: Christopher Burke. © The Easton Foundation. VAGA, NY/billedkunst.dk 2015.
Illustrations in the book: © Esbjerg Art Museum.

Library of Congress Control Number: 2015954712

This publication has been typeset in the multilingual "Brill" typeface. With over 5,100 characters covering
Latin, IPA, Greek, and Cyrillic, this typeface is especially suitable for use in the humanities.
For more information, please see www.brill.com/brill-typeface.

ISSN 1573-2193
ISBN 978-90-04-30871-8 (paperback)
ISBN 978-90-04-30901-2 (e-book)

Copyright 2015 by Koninklijke Brill NV, Leiden, The Netherlands.
Koninklijke Brill NV incorporates the imprints Brill, Brill Hes & De Graaf, Brill Nijhoff, Brill Rodopi and
Hotei Publishing.
All rights reserved. No part of this publication may be reproduced, translated, stored in a retrieval system,
or transmitted in any form or by any means, electronic, mechanical, photocopying, recording or otherwise,
without prior written permission from the publisher.
Authorization to photocopy items for internal or personal use is granted by Koninklijke Brill NV provided
that the appropriate fees are paid directly to The Copyright Clearance Center, 222 Rosewood Drive,
Suite 910, Danvers, MA 01923, USA.
Fees are subject to change.

This book is printed on acid-free paper.

Printed by Printforce, the Netherlands

Contents

Acknowledgments	7
Preface by Hans Ulrich Gumbrecht	9
Introduction: Toward a Psychological Enfranchisement of Art	17
1. The Framework of the Book	22

Chapter One:
Objects of Aesthetics. Philosophical and Psychological Explorations	27
1. Philosophical Aesthetics	28
2. Psychological Aesthetics	46

Chapter Two:
Subjectivity. Pre-reflection, Affect, Reason, and Understanding	59
1. Aspects of Pre-Reflection	59
2. Aspects of Affect, Feeling, and Emotion	72
3. Aspects of Reason, Reflection, and Self-Understanding	77

Chapter Three:
Methodological Considerations. From Singular Descriptions to General Explanations	83
1. General Concerns in Regard to Method	83
2. The Methods of the Empirical Study	96

Chapter Four:
Stories of Art. Aesthetic Experience as Intrapellation	99
1. The First Aesthetic Encounter	102
2. The Retrospective Aesthetic Interpretation	118
3. Horizons of Expectations	127
4. Art as Intrapellation	131

Chapter Five:
Aesthetic Experience as a Challenge to Subjectivity and Aesthetic Theory	137
1. Aesthetic Experience and Structures of Subjectivity	143
2. Aesthetic Experience and Aesthetic Theory	148
3. Beyond Classification Language	151

Conclusion: The Subject of Aesthetics 155
Bibliography 163
Index 169

Acknowledgements

Many people have been involved in the process of writing this book. Special thanks go to Bjarne Funch and Simo Køppe for their wisdom, generosity and support. It could not have been the same without you. Johannes Lang, Kasper Levin and Sofie Nielsen combined scholastic thoroughness with lots of cake, coffee and constructive criticism. It was wonderful. I also want to thank Hans Ulrich Gumbrecht for his inspiring kindness and intensity; the invaluable participants in the study; Daniel Meyer-Dinkgräfe, Esbjerg Art Museum as well as the National Art Gallery for their support; and the rest of my family, friends and colleagues. I greatly appreciate you all. Then there is Thomas, Jonas and Emil. For the role you play in my life words of gratitude cannot be enough; your beauty and warmth reveal the limits of art. This work is dedicated to you.

Redemption of an Adolescent Dream

What Tone Roald Has Achieved [not only for me]

It was an otherwise balmy spring evening back in 1972 that marked a traumatic – and perhaps decisive – academic experience for me. The then newly founded University of Konstanz, in the Southern-most town of Western Germany, was a young institution of great, sometimes even unlimited intellectual ambition that enjoyed its more than optimistic national aura as "Little Harvard at the Lake of Konstanz" ["Klein-Harvard am Bodensee"]. Central for this image was the emergence of a new position within Literary Criticism [a "school," as German academics have always and quickly liked to say] that was to become a historical legacy – and indeed still is, under the name of "Reception Aesthetics," a regular component of survey courses on Literary Theory taught today. A small group of middle-aged literary scholars found increasing international resonance with their efforts to explore, for the first time in the history of their discipline and systematically, the different dimensions of literary texts from perspectives whose vanishing point was "the reader" – "the reader" on various epistemological or ontological levels, as we may add today. Wolfang Iser, for example, tried to analyze literary texts as scores ["Partituren"] that guide the readers perception and meaning constitution, staying thus close to the linguistic forms on the textual surface. Hans Robert Jauss, by contrast, who had been my doctoral advisor and had become, by 1972, my mentor and main institutional reference person on the way towards the academic profession, was more interested in elaborating a theoretical and methodological framework within which he wanted to investigate the impact that literary texts might have had, through the mediation of their readers, on the "process of history." Clearly, this approach was more open than, for example, Iser's for extra-textual phenomena and even for an empirical style of investigation.

Jauss' work had been energized by two heterogeneous sources of motivation. On the one side, there was the ongoing development of Historical Hermeneutics in the teaching and the publications of Hans-Georg Gadamer, the most influential figure in mid-twentieth century German philosophy whose initial epistemological move had been a return to the intuition of Romanticism,

according to which changing historical environments would allow and provoke the unfolding of different readings for individual texts. But Jauss, much more decidedly than Iser, combined that interpretative approach which then produced the impression of an innovation in Literary Studies, with the claim that the new concentration on the readers belonged to the contemporary spirit of rebellion at European and American universities that wanted to be seen as a "Student's Revolution" and, also, to a recent opening towards social-democratic positions in West German politics. This "leftist" agenda, above all, had given me the idea that an "empirical" research project would have to be the necessary next step for the development of Reception Theory. Therefore, I submitted a quickly selected set of literary texts from past and present to readers belonging to a broad variety of social groups and asked them to write down their reactions to these texts, positive or negative, form- or content-oriented, sophisticated or spontaneous.

The results that I proudly presented to a Konstanz research colloquium of professors and doctoral students were, I admit, quite predictable, not to say tautological. I "demonstrated," for example, that the acceptance for modern poetry was higher among academic readers than among the workers of a factory for television sets, or that my university colleagues had a more pronounced tendency towards giving a political interpretation to police narratives than middle-aged doctors or lawyers. That I remember this presentation and the ensuing brief discussion at all has to do with my advisor's astonishingly strong reaction to it. Instead of simply pointing to the obvious shortcomings of my naïve experiment and to possible ways of relating it to his own research, he was visibly furious. That spring session of our colloquium was the only time ever I heard him raise his voice above the level of academic chamber music – and almost lose control over his temper. "You should never have started this silly type of empirical research," he said, "it is a waste of your time. For instead of opening up the text for interesting new readings, you are reducing it to the status of an empty matrix." From an emotional point of view, that moment of extreme embarrassment and trauma would set me up in an attitude of oedipal resistance against Reception Theory and Historical Hermeneutics for lifetime.

But I had also begun to understand a professional rather than intellectual limitation of these positions – for which their development during the following years would give me ample confirmation. The project of confronting us with a plurality of readings, under both democratic and empirical premises, was bound to challenge the absolute interpretative authority inherited by the academic literary critics from the history of their discipline. My advisor's aggressive reaction had a very plausible ground in his own practical interest. Jauss was scared by a logical and therefore inevitable consequence of the innovation ["there is always a plurality of readings"] that was just beginning to give him a

specific status within in his discipline – for this very innovation undermined his status and his institutional authority. Much of Jauss' work, during the following twenty-five years, were clearly attempts to limit and to contain the threatening freedom in the reading of texts that Reception Theory had potentially opened. I am of course not pretending that the spring 1972 seminar session and the very harmless results of my research project caused a crisis, let alone a turning point in the history of Reception Theory. Nobody except myself will ever have remembered that balmy seminar evening as a traumatic moment. Rather, the evening and its event were part and symptom of Reception Theory's alienation from an original and indeed democratic and potentially empirical openness, part also of its return to a traditional practice of subjective interpretation that would at least implicitly claim to be normative [and thereby turn authoritarian].

A good forty years later, when I first read the manuscript of Tone Roald's book on "The Subject of Aesthetics," I was all of a sudden reminded of that long faded and forgotten trauma – and above all I immediately understood that such a sophisticated empirical project was, to an astonishing degree, exactly what my own adolescent empirical project from 1973 had wanted but never managed to be. Tone's book became, so to speak, my failed project's redemption. The epistemological place that she assigns to Psychology as her own discipline in the description and analysis of aesthetic experience is a position between the "empirical" level of notes and transcripts from her conversations with nineteen persons who had been exposed to aesthetic experience and, as the other level, concepts and arguments from the tradition of aesthetics as an academic discourse and philosophical sub-field. Instead of just documenting and describing the empirical material from different reactions to different artworks and literary texts, as I had done in 1973, the new approach, Tone's approach conceptualizes and evaluates – in the first place – empirical data with philosophical concepts, trying at the same time to keep alive the uncontained immediacy of the "empirical" reactions that she refers to.

It is this constellation that enables Tone Roald, secondly, to transcend my "raw" demonstration of reading traces from a number of different social and cultural worlds. Based on her philosophical interpretation of the conversations that she conducted, Tone transforms, so to speak, empirically proven social plurality into the claim that every confrontation of an observer or reader with an artwork is a situation with a particular degree of individual freedom and flexibility. This freedom and flexibility in the confrontation with artworks – and through artworks the world – are the specific existential opportunity that aesthetic experience can offer to us. A third level on which Tone brings my adolescent project to its state of redemption and fulfillment is the analysis of the behavior facilitated by such freedom as "intrapellation." Intrapellation for her

implies that an observer or reader of artworks or texts will always start by reacting to a work of art or a text with a projection of meaning [that normally is an attempt to say what these works "mean" – although it could also be a reaction, a certain type of behavior triggered by the encounter with the text's otherness]. But as a specific discontinuity, a particularly evident "rupture" seems to lie between these projections and what the literary texts or the artworks have to offer – the texts, so to speak, "intrapellate back" on to the reader and observer. This of course is just the beginning of an ongoing intrapellation-process between text and reader, artwork and observer, a process that unfolds in an attitude of freedom and flexibility as we hardly ever experience it in everyday behavior. Beside the specific freedom that dominates intrapellation as a practice, Tone Roald also describes and highlights – quite optimistically, I believe [but supported by the empirical basis of her investigation] – the play of intrapellation as harmonious, quiet, and potentially epiphanic. As it continues to progress the reader / observer can increasingly see revealed – and thanks to the reader / observer: research can observe – formerly preconscious layers of consciousness.

Decisive, however, for the impression of seeing my adolescent project redeemed by Tone Roald's book was the possibility, in the fourth place, to say that she was indeed a treating the artwork or the literary text "as an empty matrix" – without any polemical intention. In other words: her work does not contain chapter or a passage that could be labeled as a "phenomenology" or even an "ontology" of the artwork and / or the literary text. She does not need such a component because the "fluctuation" [as she calls it herself early on] between the empirical basis of her work and the positions from the tradition of philosophical aesthetics that she uses for her interpretation are a sufficient basis for the development of her innovative theory of intrapellation. This is a quite daring step in the epistemological design of Tone Roald's work, step that I would not have been able to understand – and much less to use and to defend – back in my moment of empirical candidness and oedipal trauma in 1972.

There were some moments in my reading when I would have liked to have more access to the empirical basis of Tone's work. Being able to see how the effect of "rupture" and the condition of "intensity" belonging to artworks and to literary texts were noticed and then processed by readers and observers in acts of intrapellation could have been interesting – and perhaps even inspirational for further theoretical interpretations and conclusions. But this remaining intellectual desire – and even more so my personal feeling of "redemption" – are of course very marginal compared to the certainty, to the surprising certainty, if I may say, that Tone Roald has both used and replaced "Psychology" in her new epistemological configuration between empirical research and the philosophical tradition. She has thus furthered our knowledge as to what [rather than "who"]

the Aesthetic Subject can be – and she has furthered it both on an empirical basis and in an objective way.

HANS ULRICH GUMBRECHT
Stanford, September 2014

Archaïscher Torso Apollos

Wir kannten nicht sein unerhörtes Haupt,
darin die Augenäpfel reiften. Aber
sein Torso glüht noch wie ein Kandelaber,
in dem sein Schauen, nur zurückgeschraubt,

sich hält und glänzt. Sonst könnte nicht der Bug
der Brust dich blenden, und im leisen Drehen
der Lenden könnte nicht ein Lächeln gehen
zu jener Mitte, die die Zeugung trug.

Sonst stünde dieser Stein entstellt und kurz
unter der Schultern durchsichtigem Sturz
und flimmerte nicht so wie Raubtierfelle;

und bräche nicht aus allen seinen Rändern
aus wie ein Stern: denn da ist keine Stelle,
die dich nicht sieht. Du mußt dein Leben ändern.

Rainer Maria Rilke, 1908.
Der neuen Gedichte anderer Teil.

Archaic Torso of Apollo

We never saw his legendary head
nor saw the eyes set there like apples ripening.
But the bright torso, as a lamp turned low
still shines, still sees. For how else could the hard

contour of his breast so blind you? How could
a smile start in the turning thighs and settle
on the parts which made his progeny?
This marble otherwise would stand defaced

beneath the shoulders and their lucid fall;
and would not take the light
like panther-skin; and would not radiate

and would not break from all its surfaces
as does a star. There is no part of him
that does not see you. You must change your life.

Rainer Maria Rilke. *New Poems*.
Translated by Stephen Cohn (1997).

Introduction

Toward a Psychological Enfranchisement of Art

Rainer Maria Rilke wrote the poem *Archaic Torso of Apollo* in France in 1908. He was greatly inspired by August Rodin to whom he dedicated *The New Poems II*, the collection in which it first appeared. Apparently, Rilke was enthused by seeing a sculpture of a torso – as such, without head, arms or legs. Still, even without a head this torso possessed a particularly demanding stare. "You must change your life," its gaze insisted through Rilke's pen.

The poem was allegedly created at a time when Rilke himself was changing or had just done so. It was written in the period in which he gradually became a mature poet, his biographer Hajo Drees (2001) writes. Perhaps, with some guessing, this closing line of the poem is a materialization of Rilke's own desire to change his life or his declaration of actually having done so. Rilke's experience with this torso, whether real or imagined, is largely unknown, however. Except for his extraordinary experience, we know neither how nor why he came to this conclusion. We do not know much about the particular object of this experience or how he subjectively felt while before it; we do not know how his wonder and awe in facing this torso lead him to the particularly consequential statement that "you must change your life." Did this torso actually create in him such affects and desires – and if so, then how? In this particular case it is unlikely that we shall have a sufficient answer, yet answers to questions in relation to the powers of the aesthetic on a more general level are precisely what this book seeks. It is a seeking in the concrete, one which should be beyond guessing, by the thoroughgoing application of systematic and stringent methodological inquiry.

The task at hand is to investigate aesthetic experience, not limited to experiences where the subject undergoes personal change, or feels like changing, to the extent which Rilke claimed he should. This book is not only about experiences with the aesthetic where it is Grand Art, and where the transformation of the subject is explicitly radical. It is also about aesthetic experiences that are more subtle, less conspicuous, and not immediately obvious. It is about

how people experience art, not limited to how artists like Rilke experience it, and includes aesthetic experiences of those who do not necessarily draw upon a high-level, artistic educational background.

In contrast to philosophical inquiries that have long been interested in the aesthetic, it is a psychological investigation that draws upon concrete experiences without resorting to naïve empiricism. The investigation therefore fluctuates (not dialectically but hermeneutically) between the empirical material and relevant, extant aesthetic theory in order to arrive at a synthesis which gives form and meaning to aesthetic experience.

In *Truth and Method* (1960), Hans-Georg Gadamer starts by citing a poem by Rilke. Gadamer's main topic is the truth claims of the humanities and social sciences (Geisteswissenshaften), which are on the verge of adopting a position of claiming truth present in the natural sciences, thereby undermining their own position in the quest for knowledge and understanding. Toward this end, Gadamer begins by questioning how understanding occurs, arguing that understanding is not granted or secured by method, but takes place through taking part in tradition that is handed down via language throughout history. More specifically, Gadamer illuminates the nature of understanding, knowledge, method, and truth by penetrating aesthetics and arts; expressly the type of experience which arises in relation to art. The reason why Gadamer investigates the nature of experiences with art is because he sees art as exemplary of a mode of understanding which operates beyond the mode of understanding present in the natural sciences. He shows how the natural sciences need to delimit their truth claims based upon the mode in which understanding and experience occurs in relation to art.

Throughout this book it should become apparent that psychology in its more natural scientific garb needs to restrain its claims to truth when it comes to the aesthetic: it operates with considerable reductions through which its object is lost. That the aesthetic demarcates the limits of other fields of inquiry is old news, however. Art has been regarded as autonomous, as comprising the "totality of tensions," as sufficient onto itself. The aesthetic has, since its modern conception been regarded, at times, as that which limits what philosophy (and, accordingly, what psychology) can claim as true, or claim as having knowledge about. The limits of psychology are just as defined by the incapacities of language as are the limits of philosophy; the gap between experience and word sets the limits for both fields of inquiry (save that part of psychology which is practical, operating in the realm of behavior which lies before language). For instance, Martin Seel (2000, p.17) claims that "aesthetics makes an indispensable contribution [to philosophy] because it uncovers a dimension of reality that evades epistemic fixation but is nonetheless an aspect of knowable reality." Along this line, the philosopher and psychologist David Favrholdt says that

"aesthetic experience is included in that which philosophy often calls the 'ineffable.'" What this means, he says, is that "aesthetic experience cannot be described in the language of experience, but can be encircled through classification language" and that "it cannot be described, only designated" (2003, pp. 53-55; my translation). Similarly, within the field of the history of ideas, Dorthe Jørgensen (2003) tends toward a description of aesthetic experience as something ineffable since the description is very brief (albeit with an extensive and thorough argumentation): Jørgensen arrives at a description of aesthetic experience which she argues is general and ahistorical. It is a profound experience which leads to the understanding that there are objects that are valuable in themselves, where meaning arises in abundance. This understanding metamorphoses into a more ethical way of being in which the subject transcends itself in living; it is concerned with the welfare and meaning of objects that do not have direct, functional value, but which put us in contact with "something more."

The analytical philosopher Arthur Danto (1986) would most likely puzzle over such an argument, because he questions the impotency of art, including the proposition that art makes nothing happen – even after Picasso's Guernica we still go to war. It is not because art continuously makes nothing happen, however, that we have reached the "end of art," as he claims, but because of *"the philosophical disenfranchisement of art."* This disenfranchisement is founded in art's own internal history. With Minimalism art has become its own philosophy since it has answered the question of its own definition, its own self-understanding. "Philosophy makes its appearance just when it is too late for anything but understanding... [When] self-consciousness comes to history, it is by definition too late for something to be made in consequence to happen" (ibid., p. 17). Art is dead not because, as Hegel says, philosophy can better serve truth than can art, but because art has satisfied its own philosophical quest for a definition. This occurred, Danto exemplifies, most poignantly with Andy Warhol's *Brillo Box*, where it was shown that art is dependent on art history – on interpretation – to become a work of art; identical objects can be art in one context and not in another. It is the context which makes or breaks the work. Art does not need to be extraordinary – anything can be art.

To claim the end of art because (parts of it) has answered its own philosophical problem is to colonize art for the sake of hyperbole. Danto is, after all, aware of psychological consequences of art. He concludes that "the question of whether art makes anything happen is not any longer a philosophically very interesting question. It is, rather, a fairly empirical question, a matter for history or psychology or some social science to determine" (ibid., p. 18). Danto's claim of the "end of art" needs moderation since it is only some internal tensions present in the history of art which have ended.

Danto also says that "the post-historical atmosphere of art will return art to human ends" (ibid., p. xxix). Although there is no end to art and its human resolution have most likely been there all along, this book starts where Danto left off. Central questions are: what can art make happen? And what does the psychological enfranchisement of art entail?

Throughout this book, I will attempt to show that psychology can lead to descriptions of aesthetic experience which are richer than classification language and more precise than most philosophical abstractions, arriving at some human ends of art. I take actual, concrete experience as a primary object, not merely logically or primarily theoretically-delineated experience. The process of this book is therefore hermeneutical in the sense that the phenomenon is observed while oscillating between the theoretical and empirical, wherein the points of entry and departure cannot be fully separated and identified. Accordingly, this project is based in part on a psychological reality that is reminiscent of the French phenomenologist Maurice Merleau-Ponty's (1945a) insistence for the phenomenological project, namely on putting "essences back into existence" (p. vii); for the necessity of placing any thought within the domain of the real. This project, therefore, differs from the traditional philosophical project or philosophical aesthetics which tends to capture the aesthetic in the theoretical and abstract, and largely discount its living and dynamic meanings.

Philosophy frequently overlooks psychology in its attempt to understand aesthetic experience. Two telling examples can be found in the works of Martin Seel (2000) and Hans Robert Jauss (1982). Seel, speaking from the position of phenomenological philosophy, claims that "neither the reality accessible to aesthetic consciousness nor the presence attainable in this consciousness can be treated properly within the framework of other disciplines" (p. 17). Explicitly rejecting psychology, Jauss (1982) argues that "the analysis of the literary experience of the reader avoids *the threatening pitfalls of psychology* if it describes the reception and the influence of a work within the objectifiable system of expectations that arises for each work in the historical moments of its appearance" (p. 22; my emphasis). Jauss worries about the subjectification of experience he finds present in psychology. To him, individual descriptions of aesthetic experience reduce the meaning of art to the fleeting and subjective, reduce the meaning of the work of art that is to be found in the work itself. He ignores the phenomenological position that the work of art and the experience of it are mutually constitutive.

Yet, when philosophers discard psychology it is not always clear what it is they reject. Perhaps through their reading of Husserl, their understanding of psychology has not evolved beyond Husserl's critique of psychologism, and they regard his critique of psychologism as an overall critique of psychology when it

is, instead, about psychic phenomena being radically distinct from logic: logic is atemporal and not empirically based, and is therefore, in contrast to psychology, exact and precise. Psychology, on the other hand, does not give rigorous proofs, Husserl complained, but only proffers possibilities and vagueness as answers. Logic cannot be reduced to psychology – to a function of the psyche (Husserl 1900; Zahavi 2001a). The Husserlian critique of psychologism is therefore that *not all objects* can be reducible to the mind. It is not about the usefulness of psychology, which Husserl abundantly embraces through his descriptions and visions for phenomenological psychology. The misunderstood critique of psychologism as transferred to a rejection of psychology in general, is not the only possible explanation for why many philosophers reject psychology. Another reason could be that they reduce psychology to empiricism – to mechanistic psychology. (A third possibility could be that there is no proper psychological aesthetics with which to enter into dialogue.)

This book attempts to show that psychology, through its focus on immediate, lived experience, can arrive at descriptions that are more faithful to aesthetic experience of the human subject than can philosophy. It is an attempt to enclose aesthetic experience within a language that is not mainly philosophical but also psychological. Since there is little psychological theory on the topic, however, this book must also draw upon philosophy. The project is still empirically-based, without decaying into a metaphysics of presence.

To Gadamer, the aesthetic does not signify, but is significant. This book is about what the aesthetic signifies, viewed through the lens of phenomenological psychology. It is about the intertwined experiential structures and functions that the aesthetic elicits, including the psychological meanings involved. It is about aesthetic experience which cannot be fully captured in language, which nevertheless becomes partially ensnared in psychological questioning. Accordingly, the questions this book seeks to answer on a general level are: *what type(s) of experience(s) arise(s) in relation to the aesthetic and why are these experiences significant?* Or, differently, maybe more precisely: *how does the subject experience the aesthetic, and what are the objects of this or these experience(s)?* In order to answer these main questions, several more basic questions need first to be taken up. These partially structure this book and are as follows:

1. What is aesthetics, i.e., what is the object of aesthetics?
2. How does the subject which experiences the aesthetic appear, i.e., what is the subject which experiences the aesthetic like?
3. How does the subject experience the aesthetic?
4. Why does the subject experience the aesthetic?

These questions are internally related and mutually inform each other. Answering any one of these questions bears on the other questions too, and this reciprocal relationship has long been recognized in the phenomenological tradition where the understanding of subject and object are closely intertwined. Indeed, the aesthetic is not aesthetic if it does not open up toward the experiencing subject. The subject and the object are horizons for each other, whereby a thorough description and understanding of the one will invariably lead to increased understanding of the other (Roald 2008).[1]

The Framework of the Book

Since aesthetics has a long history, the above mentioned questions have been approached within many different traditions. Along the way, many reductions have taken place to the extent that the object under investigation lacks conceptual coherence. As such, the phenomenon is in need of phenomenological clarification. I therefore stress phenomenological descriptions of the personal in encounters with art, and not social, economic, or historical explanations. This emphasis does not mean that phenomenological descriptions are the only valid points of view. As Merleau-Ponty (1945a) argues: "we must seek an understanding from all these angles simultaneously, everything has meaning, and we shall find this same structure of being underlying all relationships" (p. xxi). Still, without a commitment to descriptions of the phenomena, the various explanations of relationships will lack a solid basis in the reality they seek to understand. To sustain my phenomenological inquiry I rely mainly on the work *Phenomenology of Perception* (1945a) by Merleau-Ponty to support a model[2] of subjectivity in aesthetic experience. No less important, I also rely on my qualitative empirical study in which I investigate experiences with art.

In Chapter One, *Objects of Aesthetics: Philosophical and Psychological Explorations,* an outline of the field of aesthetics is presented in order to search for the theoretical answers to the object of aesthetics. It is a search for a historical and contemporary fixation of aesthetics, both philosophically and psychologically, and begins with the philosophical tradition, as this is where aesthetic theorizing started and enjoyed its greatest prominence: aesthetics has

[1] Zahavi (2001b) underscores this point of reciprocal understanding in his discussion of intersubjectivity.

[2] The terms "structure" and "model" should be understood in their broadest sense. In this thesis "structure" does not refer to structure as it is used within Structuralism, with a distinction between form and content, but should be understood as a looser collective term for both. "Model" should not be regarded as referring to a comprehensive or nearly complete system.

Introduction

been a part of epistemology and metaphysics as well as ethics. But a comprehensive description of philosophical concerns in aesthetics is not the central topic of this chapter.[3] Instead, some important representative examples are chosen, with a focus on the phenomenological tradition(s), including those which essentially partake in the general aesthetic history that leads up to it. Since institutional psychology has a much shorter and more limited role than philosophy when it comes to aesthetics, particular attention is given to the role accorded psychology in philosophical history in order to probe into the potentials for psychology in aesthetics. After the philosophical presentation, the chapter moves into a discussion of the positions which aesthetics has held in psychology and the contributions psychology has made to aesthetics. Indeed, aesthetics is present from the beginning of academic psychology, yet the object of psychological aesthetics is not identical to that of philosophy.

The first questions sought answered are about the beginning of aesthetics: Why and how did the field of aesthetics arise? What tools were seen as appropriate for understanding the aesthetic? Answers to these questions move the inquiry toward more contemporary issues: What tools are currently seen as appropriate and what questions or concerns are at stake in modern phenomenological and psychological aesthetics? By proposing answers to these questions, a preliminary response can be given to the object of aesthetics.

In Chapter Two, *Subjectivity: Aspects of Pre-reflection, Affect, Reason, and Understanding*, I investigate the nature of aesthetic experience through its relevant structures of subjectivity as developed within the phenomenological tradition. In this regard, all of the phenomenologists emphasize in various ways the importance of "the world" or "the lifeworld" or "the social" in the constitution of the subject or subjectivity. For early Heidegger, experience is set out positively within the existentials developed through the primary principle of being toward time, while in later Heidegger, the degree of dissolution and relational constitution leads to a situation in which the subject or psychological psyche disappears as a point of originating experience. Along a similar line, Sartre's non-egological theory of consciousness posits the world and the will as two central determinants for experience. In this book an egological[4] point of view is taken, wherein both Heidegger and Sartre's theories of consciousness have been rejected. Instead, I partially embrace Merleau-Ponty's theory of subjectivity present in *Phenomen-*

[3] Thorough reviews can be found elsewhere. Eloquent examples are Jørgensen's (2003) work, *Skønhedens Metamorfose* (The Metamorphosis of Beauty), and Andrew Bowie's (2003) work, *Aesthetics and Subjectivity*.

[4] This fact does not mean that the psyche is neither centered nor transparent.

ology of Perception (1945a) with particular emphasis on those aspects which are proposed as being present in experiences with art.

Merleau-Ponty arrives at his descriptions through analyses of what he names empiricist and intellectualist traditions. He argues against purely theoretical as well as purely empirical models and finds the description of subjectivity to be found in positions which mediate between both. Subjectivity cannot be found in a Husserlian transcendental ego, but in the experiential and existential center of the body-subject that is continually constituted in relation to the world. Merleau-Ponty nonetheless takes empirical findings seriously and uses psychological studies to support his theory. Still, the book is not about Merleau-Ponty's aggregate works, but about that part of his works which I can use to illuminate aesthetic experience. I do not rely on his early work, *The Structure of Behavior* (1942), because in it he has not reached his central insight of the body-subject and corporality as a contrast to detached rationality. His later works are excluded on the basis that his theoretical development becomes more poetic than scientific, and because a review of the changes within Merleau-Ponty's authorship is, after all, not the object of this book.

It could be claimed *altmodisch* to use *Phenomenology of Perception* to build up a model of subjectivity. It was written during the Second World War, and theories of subjectivity have progressed during the sixty-four years that have passed since its publication. The reason why I hold onto the work as the focal point is that many aspects of his theory are ignored by contemporary psychology. Merleau-Ponty takes structures of subjectivity seriously, and I believe that his preliminary model has the potential to make an important contribution to psychology: he provides a layered model of the psyche which is neither dissolved into intricate structures of language and power nor reduced to biology. The model presents a complex framework for understanding the psyche with a unique and comprehensive portrayal of the body-subject which is fully committed to a description that is based on facticity. Nevertheless, where I find Merleau-Ponty's model obscure, I draw on other theories to add nuance to the necessary conceptual clarifications.

In Chapter Three, *Methodological Considerations,* the task is twofold. On the one hand, I discuss general methodological problems and, on the other hand, I detail the specific interview-, analysis-, and generalization methods I use. I take issue with a popular conception of phenomenological psychology, namely that it is committed to description and description only. Through a reading of Husserl, I challenge this claim and arrive at the conclusion that description is indeed primary because it is essential for an explanation. Explanation is dependent on description, and phenomenological psychology should employ both. This part of the book also provides a legitimization of some of my fundamental assumptions,

namely that I can arrive at valid and general research based on only a few cases of the investigated phenomenon.

In the empirical chapter, *Stories of Art: Art as Intrapellation*, I describe the results of the empirical, qualitative study of aesthetic experience. I rely on a model for the reception of literature by Hans Robert Jauss (1982), adjusted to that of the visual arts, and use the model to structure the findings from the open-ended interviews I conducted with museum visitors at Esbjerg Museum of Art as well as at The National Art Museum (in Copenhagen). The participants were asked to describe their most significant experiences with visual art at the current museum visit as well as their previous important experiences with it. Some of the participants were interviewed twice in order to further understand the meanings of these aesthetic experiences. Based on these interviews, I describe aesthetic experience as comprising several characteristics, and arrive at an explanation for why art works – it works by virtue of what I have named *intrapellation*. The psychological argument is that art works via projection and introjection,[5] and thereby takes part in developing subjectivity.

In Chapter Five, *Aesthetic Experience as a Challenge to Subjectivity and Aesthetic Theory*, I discuss the empirical findings with regard to the structures of subjectivity as developed in Chapter Two and in regard to the theories of aesthetics reviewed in Chapter One. Some of the outlined theories and concepts are indeed in need of a revision if the empirical material is to be taken seriously. The chapter also contains a discussion which confirms the claim I started out with, namely that aesthetic experience can be described beyond classification language.

The book' conclusion, *The Subject of Aesthetics*, restates the finding that experiences with art expand subjectivity in its various experiential dimensions. Since experiences with art expand subjectivity, the implicit object of aesthetics actually coincides with the subject. The subject, with its experiential structures, is a central topic for psychology, and the subject of aesthetics is therefore psychological. For this reason, psychology is in a position to discard the claim that art has come to its end because of its philosophical disenfranchisement.

[5] That art works via projection and introjection is not to be understood in any psychoanalytic way, as it might at first sound, but in a phenomenological sense. Merleau-Ponty (1945a), for instance, uses the term "projection" several times in his work.

1
Objects of Aesthetics.
Philosophical and Psychological Explorations

Aesthetics is a part of our lived experience, yet is often regarded as that which reveals the limits of academic knowledge. It has been thought to lack the possibility of "epistemic fixation" (Seel 2000). Nevertheless, when aesthetics was introduced as a distinct philosophical field it was because the philosopher Alexander Gottlieb Baumgarten (1714-1762) wanted to fixate the aesthetic, a property of the object, both practically and theoretically, to avoid losing the aesthetic to the irrational. Baumgarten did not doubt the existence of aesthetic objects (formal beauty); that is, he did not question the individual work's status as an object of aesthetics, and wanted to find scientific ways of investigating it.

Nearly three hundred years have passed since Baumgarten inaugurated the field of aesthetics, and although aesthetics has played a rather limited role in more contemporary philosophy, perhaps due to its complexity and linguistic opacity, the epistemic fixation of aesthetics has once again gained currency. The philosopher Mark Johnson (2007), inspired by both hermeneutic and pragmatist traditions, argues in his most recent book, *The Meaning of the Body. Aesthetics of Human Understanding,* that experiences with art are exemplary for all modes of meaning-making. Aesthetic experience, he claims, reveals meaning at an intensified level as it reaches beyond the linguistic, beyond the conceptual and propositional. To understand experiences with art is the beginning point for understanding experience. Drawing upon such different philosophers as Dewey and Gadamer, he argues that aesthetics should play a central role in philosophy for this very reason; it is actually the area of inquiry from which all philosophy should begin.

Philosophical Aesthetics

The Beginning of Philosophical Aesthetics
The field of aesthetics is a philosophical concern since Baumgarten's inauguration of it. He writes not long after Descartes and not long before Kant, and may have held the same opinion as Descartes that (sense)truth is granted through divinity, yet takes part in the Enlightenment's steadfast belief in Reason. Baumgarten attempts to extend the domain of reason to include perception and the arts too; they have their own *cognitionis sensitivae* (Baumgarten 1735, p. 77), or "sensate cognition."

Baumgarten's method is the same as that of his contemporary rationalists. He uses logical and rational arguments, and within the truth of his basic propositions the stringent arguments mainly stand or fall. Within Rationalism true knowledge is to be found through the use of reason. Baumgarten, through his love for poetics (and science/logic), realizes that if the arts are regarded as irrational then they lie outside the domain of what can be investigated scientifically. He wants to rescue the arts from the irrational and attempts to show how they have their own logic. "I wish to make it plain that philosophy and the knowledge of how to construct a poem, which are often held to be antithetical, are linked together in the most amiable union" (ibid. p. 36). Their logic, however, is different from that of the higher cognitive faculty. In *Reflections on Poetry* (1735), where the concept "aisthesis" or "aesthetics" is first used (Aschenbrenner and Holter 1954), he tries to show how poetics are the perfect representations for sense perception. It is perfect "sensate discourse" or "sensate cognition."

Baumgarten writes in Latin and the term "aisthesis" harkens back to the ancient Greeks: Aristotle used it in *De Anima* to describe sense experience. Baumgarten argues for an independent scientific study of perception or sense experience, which he calls aesthetics. It is the first time that aesthetics is construed as an independent field, and it is not only linked to perception, but also to the arts: Baumgarten regards poetics as sense representations perfected, a main point he argues for in *Reflections*.

To bring his point home, Baumgarten needs to concern himself with the powers of the mind. In keeping with the contemporary faculty psychology, a differentiation of the mind into discrete functions, he sees cognition as bipartite: it comprises the higher faculty of thought (including logic) and the lower faculty of perception (Aschenbrenner and Holter 1954). Perception is as such to Baumgarten not a pure sense impression but a cognitive act, and it does not only provide the higher cognitive faculty with food (or sensing) for thought – it contains its own mode of knowing the world, a knowledge that is perfected in the arts. Perception actually finds its outmost sensuous expression in the arts, and

Baumgarten's point is that logic (and therefore philosophy) should open up, not only to concern itself with the higher cognitive faculty but also the lower: with the sensuous and knowing perception, and particularly, the perception of art. The first object of the new field of aesthetics is therefore to subsume the arts, which perfects the lower cognitive sensing, within philosophical rationality in order to allow its scientific treatment.

Psychology in early philosophical aesthetics
As aesthetics is establishing itself as a philosophical discipline, psychology is regarded as particularly useful. Psychology is in fact that field which Baumgarten believes has the tools to compliment philosophy in moving the aesthetic into the realm of the rational (Baumgarten 1735, p. 77-78)[1]; it is the science which investigates the lower cognitive faculty in difference to philosophy which unfortunately limits itself to the higher cognitive faculty. Baumgarten's use of the term "psychology" may come from at least two sources. On the one hand it could be that he reaches directly back to the ancient Greeks as he did with the concept "aesthetics," and particularly to Aristotle's use of psyche as the soul, with psychology being the study of the naturalized soul. On the other hand it might be the case that he picks up the term from his teacher, Christian Wolff, who is known to have popularized the term "psychology" (as described by Krstič 1964). It is, however, ambiguous what Wolff claims psychology to be, as he first uses it to refer to "the empirical powers of the human soul (perception, etc.)," but later to refer to rationality as distinct from the empirical, psychology referring to the rational (Caygill 1995, p. 338). Whether or not Baumgarten uses psychology to mean the science of rational sensing, or the science of both rationality and the senses, it is clear that he thinks psychology and philosophy,

[1] "§115. Philosophical poetics is by §9 the science guiding sensate discourse to perfection; and since in speaking we have those representations which we communicate, philosophical poetics presupposes in the poet a lower cognitive faculty. It would now be the task of logic in its broader sense to guide this faculty in the sensate cognition of things, but he who knows the state of our logic will not be unaware how uncultivated this field is. What then? If logic by its very definition should be restricted to the rather narrow limits to which it is as a matter of fact confined, would it not count as the science of knowing things philosophically, that is, as the science for the direction of the higher cognitive faculty in apprehending the truth? Well then. Philosophers might still find occasion, not without ample reward, to inquire also into those devices by which they might improve the lower faculties of knowing, and sharpen them, and apply them more happily for the benefit of the whole world. Since psychology affords sound principles, we have no doubt that there could be available a science which might direct the lower cognitive faculty in knowing things sensately" (Baumgarten 1935, pp. 77-78).

perhaps the theoretical and empirical, should join forces in the study of aesthetics.

With this first object of the field of aesthetics that is to open up for a scientific and rational investigation into the realm of the aesthetic, Baumgarten not only saves the arts but also the affects from the darkness of irrationality. He sees the affects as intertwined with poetics: "Since affects are rather marked degrees of pleasure or pain, their sense representations are given in the representing of something to oneself confusedly as good or bad. Therefore, they determine poetic representations; and therefore, to arouse affects is poetic" (Baumgarten 1735, p. 47). (This is in line with his times as the arts were linked to affects for Baumgarten's contemporaries). Since affect is poetic and the poetic comprises a particular rationality, the affects are not divorced from reason and can be scientifically investigated in their representations in the arts. As the first object of aesthetics is to subsume the arts into scientific, philosophical investigation, the affects also becomes a part of this inquiry, as they too comprise their own kind of knowledge of the world present in the arts. It includes, as such, an attempt to move the domains of affect and rationality closer together, and to extend the field of philosophy to embrace all kinds of knowledge, not only the logical and linguistic.[2]

Summarized, the concept "aesthetics" is philosophical in its origin, denoting a certain philosophy of beauty and (beautiful) art. Art provides perception with perfect presentations, and the field of aesthetics should concern itself with delineating the rules for this perfected perception. Psychology is seen as an area of inquiry having something useful to add to the aesthetic, but it is not clear whether it is a psychology of the human soul or a psychology limited to that of perception. Although it is with Baumgarten that aesthetics is proposed as, and gradually becomes, a unified field of importance, theorizing about the aesthetic, however, have much older historical antecedents. Aesthetic objects and aesthetic experiences have inspired philosophical and psychological inquiries into Truth, Beauty and the Good since antiquity. Approximately 2500 years ago the Pythagoreans held the opinion that the objective cosmic order should be "harmoniously and symmetrically" represented in what we now regard as art. Plato held obverse opinions of aesthetics: tragedy could arouse emotions which lead to self-indulgence and less than useful citizens, alienated from their reason; poetry could create illusions and, therefore, be false. At the same time could desirable, absolute and true transcendent beauty be intuited through the "educative Eros" of

[2] Baumgarten expands upon the object of aesthetics in *Aesthetica*, which is, as Shusterman (2000) notes, embarrassingly enough, not yet translated from Latin into English.

Objects of Aesthetics 31

the transient senseworld (Jørgensen 2003, p. 56), through the experience of the beautiful forms of the sense world. After Plato, Aristotle saw the task of the aesthetic as one of mimesis and catharsis. *Mimesis* served the function of arousing pleasure, an inherent drive for depicting what could be idealized presentations as well as representations of forms in nature, creating a balanced and ethical mood of the soul. *Catharsis* was an experience of something new: in the reception of the tragedy, the viewers were taken through a series of feeling states and later a purification of these, whereby they got to understand or learn about actions and emotions and their interrelation (Jørgensen 2003, 2006).

Present in this early theorizing, the aesthetic is seen as psychologically relevant, wherein the work of art is a gateway to profound experiences. With the Pythagoreans it was a means of perceiving the cosmos; with Plato it could lead to an understanding of the world of ideas; and with Aristotle, a means for stabilizing the psyche and gaining new emotional knowledge. The psychological concept of catharsis appears, and from its ancient beginnings, aesthetics, then, had a psychological dimension in play.

If the modern beginning of aesthetics starts with Kant's Copernican revolution, then psychology has also been granted a prominent place in it, in one of Kant's major works. Kant claims in *Critique of Pure Reason* (1781, p. 60) that Baumgarten's task is futile, as Baumgarten's search for understanding of the aesthetic lies in finding "rules or criteria [that] are merely empirical." One of the reasons why he names Baumgarten's method *merely empirical* is perhaps because Baumgarten takes the concrete work of art (the poem) and tries to discover the rules on which it is built. To Kant the way to rescue the aesthetics from such *a posteriori* rules of the sense world, from the empirical, is to let aesthetics "share this term with speculative philosophy, and thus to use the term aesthetic partly in a transcendental, and partly in a *psychological* sense" (ibid., p. 60; my emphasis). What psychology means to Kant in this instance can be guessed to be the faculties of mind (empirical and transcendental), which should be investigated with the *a priori* principles in an effort to grasp the aesthetic. The investigations into the aesthetic should not begin with the concrete works of art (with the object), but with the mind's *a priori* ways of experiencing them, (with the subject), that is, exactly the way in which Kant proceeds with his investigations into the aesthetic.

One could claim that it is irrelevant that Baumgarten and Kant mention psychology since it is not certain what they mean, and whatever they actually did think psychology to be is nevertheless drastically different from what institutional psychology becomes or is today. What remains interesting, however, is that they do not think that philosophy can carry the tasks of the bur-

geoning field of aesthetics on its own, and that it needs contributions from a field closer linked to the investigations into the mind, whether empirical or rational.

Aesthetics as the philosophy of the beautiful nature and the beautiful art

To Kant investigations into the aesthetic are first connected to the experience of Beauty, a pleasurable experience to be found in Nature. It is the *experience* of Beauty that can be known, not beauty as it exists in itself. The experience of Beauty has a particular constitution: it is a pleasurable, disinterested contemplation with no other concerns present, created by the cognitive faculties of the imagination and the understanding in a state of distanced, free, and harmonic play. Since aesthetic experience is characterized by disinterestedness, it is an experience that is free. It is free from subjective interests, free from the intellectual as well as from the appetites. This freedom is essential to Kant's project, and aesthetic experience receives the place it requires in his system in order to achieve an apparent metaphysical completeness: since the experience of beauty is characterized by disinterest, the beautiful object appears as free, autonomous, and therefore unified. As Jørgensen (2006) writes, since beauty, for Kant, is located in a particular experiential constitution, this experience leads the subject to experience itself as an *a priori* unity, a necessity given that objective knowledge is founded in the subjective (Bowie 2003).

In *Critique of Pure Reason* (1781) aesthetics refers to the critique of taste, while in *Critique of Judgement* (1790) – the work through which aesthetics became central for epistemology – beauty is to be found in art, too. It is to be found in art because art is nature, mediated through genius (Bowie 2003). With Kant, aesthetics becomes a central topic for philosophy, and aesthetics is not stridently separated into the study of perception (or the perception of the beautiful), and the perception of beautiful art. They are intertwined in the field of aesthetics and gain their importance, via Kant, through their connection to subjectivity and consciousness in the attempt to grasp the relation between the self and the world (as Bowie argues), including the problem of self-consciousness. Aesthetic experience becomes a psychologically relevant concept and denotes an experience that consists of a particular mind constitution (which contemporary psychologists still at times regard as Kantian disinterest). It is a unique and theoretical mind constitution that has philosophical consequences, but it is also a conceptualization which is delineated in the rational and not through actual and lived psychological experience.

Aesthetics as the philosophy of art

As Adorno (1997) points out, within Kantian aesthetics, beauty in nature overrides the importance of beauty in art. By Schelling's time, however, the interest in the beauty of nature has disappeared, and aesthetics is only concerned with art.

Schelling's aesthetics is decidedly an aesthetics of art. Going beyond Schelling's premises, Hegel can be seen as a more important predecessor to phenomenology. All phenomenology includes reactions and opposition to Kant, and. Schelling has not played the most prominent role for phenomenology (save through his influence on Heidegger) and is left aside for the time being. Hegel (1886), in line with Schelling, however, begins his Introductory Lectures on Aesthetics[3] by limiting aesthetics from beauty in general to that of the beautiful arts, because, to Hegel, "artistic beauty stands higher than nature," because it is "born – born again, that is – of the mind" (p. 4), and, therefore, able to represent truth. Nothing else can but the mind. Truth, to Hegel, is to be found neither in correct representation (mimesis) nor in rigid rational systems like Kant's, but is instead dialectical. Truth is indeed the "resolution of … antithesis" (ibid., p. 60), where both book and antithesis exist in synthesis. The ultimate synthesis is the absolute which, in line with German-Idealism, includes subject-object identity. Hegel therefore not only distinguishes himself from Kant (at the same time as he is inspired by him) in his focus on aesthetics of the arts instead of nature, but revolts against Kant's metaphysics, including Kant's absolute separation between subject and object, and accordingly Kant's strict focus upon aesthetic experience.

Hegel begins his lecture series with a line of questioning, the first question being "whether fine art shows itself to deserve a scientific treatment?" (ibid., p. 5; original emphasis). Is not art just a relief from reality, without purpose; more like amusement, in other words just "a luxury." Or is it, at best, a medium for assimilating reason and sensing, thereby being only a means and not an end in itself? Is there no art for art's sake? Hegel's questioning continues: if it turns out that art is worthy of scientific treatment, is it then appropriate for it? Isn't it too fleeting, particular, and free to be captured in rigorous and general scientific systems? Also, since art is connected to feelings and feelings are merely subjective and in opposition to thought, will not thought, in its attempt to understand, and thereby dominate, destroy the feeling and annihilate the object which it is supposed to dwell upon? Would not a wholly intellectual investigation of art annihilate the object and reduce it to only its faint shadow?

Hegel's answer is that art, and investigations into art, can have all these characteristics but also has the possibility to contain even more. To Hegel, art, as do science and philosophy, have an end of outmost importance: "the attainment of truth." That is complete knowledge which includes synthesis with the phenomena (in Kantian terms – with the things in themselves), which can only

[3] Hegel has also written *Aesthetics*, the three volume work. The following is based upon his considerably shorter version published as *Introductory Lectures on Aesthetics*

be achieved when art operates without a purpose but truth. Then it reveals the absolute.[4] The absolute comprises subject-object identity which through history attains an increasing degree of freedom to the point of absolute, and manifests itself in art.

On a more concrete, psychological level, the revealing of truth leads to the possibility for understanding the Other and one's self. This process of understanding the Other and one's self is present in the creation of the work of art: when creating, the mind is alienated through its externalization of the sensuous. In this process of alienation and objectivation, the mind[5] can experience this process of alienation, not in thought but through feelings and the sensuous. It thereby gets to know itself in alienation. Praising the arts, Hegel claims that fine art "only achieve[s] its highest task when it has taken its place in the same sphere with religion and philosophy, and has become simply a mode of revealing to consciousness and bringing to utterance the Divine Nature, the deepest interest in humanity, and the most comprehensive truths of the mind. It is in works of art that nations have deposited the profoundest intuitions and ideas of their hearts; and fine art is frequently the key – with many nations there is no other – to the understanding of their wisdom and of their religion" (ibid., p. 9). This revealing occurs in the arts by their sensuous shaping of ideas, by making the intellectual present to the affects and to sensing.

Not all truths can be characterized in the arts however. It is only those which can be fully represented sensuously without a reduction in meaning. Such sensuous representations are possible in different historical eras, but not during Hegel's, he claims, as his times suffer from the alienation of reflection which it is impossible for the artist to free himself from. The differentiation between reason and the sensuous has become too wide for the arts to unify. Exactly for this reason – the alienation through reason – we need a science of the arts which can create the possibility for a new synthesis, he claims. It is a science that must be flexible, as art is a complex object with fluid borders. This Hegelian science of the arts – aesthetics – has three parts:

- The first is general, searching for the "universal Idea of artistic beauty." It is concerned with the *relation* between this Idea of beauty to nature and particular works of art.

[4] More contemporary – or phenomenological – versions of the subject-object relation reject a subject-object identity (Hegelian) as well as complete subject-object separation (Kantian).

[5] In *Introductory Lectures to Aesthetics* "Geist" is translated to "mind" instead of "spirit," but the translators claim it refers to both terms.

- The second is particular – concerned with the Idea *manifested* in particular forms; the particular works of art
- The third comprises the other two parts and concerns itself with "individualization of artistic beauty" (ibid., p. 80) as well as the move from the individual to the general in order to create a coherent system of the separate, sensuous shapes of art.

Although it is not clear as to why this tripartite (and apparently rational) aesthetics should overcome the alienation of reflection, the goal of the Hegelian aesthetics (based on the introductory lectures) is to assimilate reason and the sensuous through a search for both the general and the particular in regards to the sensuous shapes of art, and to create a rational aesthetics that can come to understand these forms. It is, however, clear that art and aesthetics to Hegel is closely linked to the development of mind and subjectivity.

Hegel distinguishes between three different eras of different mind constitution, all related to the way in which the Idea is grasped, and art represents the mind of different historical eras.

- The first mind constitution relates to the *Symbolic* form of art. The Idea is perceived (inadequately) as diffuse and abstract, but inspires artistic creation. Since the Idea is diffuse the symbolic form of art is based on a search for the depiction of the Idea. This search first takes place through the use of natural shapes, then through the distortion of them. It is an abstract, externalization of the Ideal (Hegel claims that the "primitive artistic pantheism of the East" [ibid., p. 83] is symbolic). It is not perfect in its presentation of the Idea for the two interrelated reasons that it is abstract and that the shaping of the Idea is incomplete.

- In the *Classical* form of art the Idea is perfectly presented, "it is the free and adequate embodiment of the Idea." It comprises no manipulation of form, rather the form must be found in accordance with its natural shape. It is the spiritual presented perfectly in its "sensuous form"; the internal perfectly presented in the external whereby it achieves identity. Art perfectly fits the Idea of the time, where the god has the physical shape of a human figure. The Idea can therefore be presented in its sensuous concreteness.

- In *Romantic* art consciousness has become self-conscious. This is linked to the development of Christianity, where the god is spirit and therefore different from the human shape. Christianity is linked to "intellectual inwardness" which is the main problem of representation for Romantic art. Romantic art is given different status in different versions of Hegel's work. In the *Introductory Lectures on Aesthetics* Hegel postulates Romantic art as the highest art form since it is able to overcome this gap between intellectual inwardness and sensuousness. It can represent both. At the same time he claims that Christianity's inwardness and focus upon rationality has the consequence that the sensuous presentation of art cannot represent this inward or rational Idea. Exactly for this reason, Hegel has famously been regarded as claiming the Romantic age as the end of art since art cannot represent the Idea when it is overtly rational, and that philosophy, instead of aesthetics, is better suited to the task of revealing rational truth.

Thus, in the *Introductory Lectures on Aesthetics* Hegel claims that aesthetics must concern itself with artistic beauty and its development throughout such different phases, as well as with the development of mind as it expresses itself in art. Ignoring Hegel's focus upon art's ability to represent the Idea, it is instead the focus upon the relation between mind and art that is psychologically important. This includes his thought that Art "reveals," and through feelings of beauty important aspects of life are laid bare; through revealing the work functions as art.

Although Hegel explicitly rejects that the functions of art are to be found in the subjective, another psychological object of Hegel's aesthetics lies in his treatment of the emotions. In connection with the focus upon the emotions in the Romantic era, Hegel suggests that arts provide for the education of emotions as when one sees emotions in works of art; then the emotions are externalized and objectified. They therefore become an object of reflection. When the emotions are observed they become external to those who view them, whereby one can free oneself from them. It is an immediate process which calms the emotions down. Through the objectification of the emotions, they lose their determinant power. Hegel is not completely consistent in his view of emotions (and the aesthetic), but in the end, perhaps by his own synthesis, having weighed them carefully, he grants them this positive status in relation to art. Emotional objectification is, however, not a process internal to the work of art. It is not a part of what art is, but instead something which can arise as an epi-phenomenon

or a side-effect. According to Hegel, when one asks about the use of the work of art, one has ignored art's autonomy which is to represent the "reconciled antithesis." What follows from the synthesis is external to the work of art.

Objects of early aesthetics
With the ancient Greeks, what we now call aesthetics and art were a part of a greater endeavor to understand the intertwined nature of Truth, Beauty and the Good. Aesthetics and art were not unified under one autonomous area of inquiry, and similarly, philosophical and psychological concerns were not bipartite either. Aesthetics had no one particular object, and was neither philosophical nor psychological, but both.

Although there is great variation in this early theorizing about aesthetics and the arts, certain functional similarities exist. The creation and reception of a work of art is not an end in itself; the work gains value through its functions. In early aesthetics it was a way of understanding and representing the cosmos, a transcendental world of ideas, a religious proximity to the divine as well as knowledge of the actual sense-world with its shapes and forms. It is not the work of art itself which is given the main attention, but rather the psychological aspects which follow, with the psychological functions of mimesis and catharsis as particularly prominent, from which knowledge into the Truth, the Good, and the Beautiful arise.

As aesthetics becomes a united field, it also becomes a part of rationality, along with its affective potential. With modernity the perceived divine harmony and consistency between the natural world and the experiencing subject has disappeared, and it is therefore precisely the relation between the world and the subject which becomes central for philosophy. Aesthetics, as Bowie (2003) elegantly writes, becomes central too, as it is art which is perceived as providing the necessary link for viewing this relation (as occurs with Kant). Its status is ambiguous, however. On the one hand, it could be that art creates artificial meaning, as there is no god and nothing exists but meaningless projections. On the other hand, it could be that in art the ultimate picture of absolute freedom is given, as we exist without divine intervention; art gives us the picture of our free relation to nature, that is, the ultimate way of existing (ibid.). At best, then, the object of aesthetics becomes an aesthetic of freedom, present in experiences of beauty and experiences of art where the subject finds itself and unites itself with nature. This is in line with Hegel's aesthetics where art lends the possibility for one to meet one's self in something which also points to something beyond individual subjectivity. It is a presentation of historical perspectives and ways of living, a prototype of externalization of subjective life-worlds (Bowie); a prototype for the externalization of the emotions.

To summarize, early aesthetics became an independent field of inquiry with Baumgarten, and central to philosophy through Kant and Hegel. To Kant, the object of aesthetics is to create the metaphysical link between subjectivity and nature. With Hegel aesthetics is concerned with art. Art has, or had, according to Hegel, the psychological function of increasing self-understanding through the externalization and internalization of dialectical truth, although he would disagree with any view that reduces aesthetics to subjectivity. Baumgarten, Kant and Hegel comprise the short story of the beginning of aesthetics, the common denominator for aesthetics, before it branches of into a plurality of variations. What follows is a presentation of aesthetics as it occurs within the phenomenological tradition. All phenomenology is to some extent a reaction to Kant, and although Hegel's Phenomenology of Spirit only ambiguously can be translated into Phenomenology of Mind, his general view of phenomenology is consistent with that of Husserl. According to Beiser (2005, p. 319) Hegel describes phenomenology as "the sciences of the experiences of consciousness," which involves investigating the appearance of phenomena. Subsequently, this sketch of the beginning field of aesthetics is also a sketch of the predecessors to phenomenology. Franz Brentano, who argued for a descriptive psychology, under whom both Freud and Husserl studied, should not be ignored in the development of phenomenology. He had, however, little to say about the arts. For many phenomenologists, art acquires a particularly important status and the following is concerned with the background for art gaining this potent position.

Phenomenological Aesthetics

Edmund Husserl
Husserl, presented as the founder of phenomenology proper, does not concern himself to any great extent with aesthetics (and art). He does not have a philosophy of it (Zahavi 2002). Husserl's musings on aesthetics, however, are scattered throughout his works, but mainly to be found in *phantasy, image consciousness, and memory* (1966b), the 13th volume in Husserliana. In these writings, Husserl thinks about aesthetics phenomenologically, searching for the underlying conditions for something being aesthetic. Instead of asking for the object of aesthetics he turns the question into what it means that something is aesthetic. He asks "is every interest in appearance aesthetic?" and answers: "certainly not. The psychological interest is not," the reason being that "in the psychological attitude, the appearance is an *object*" (Husserl 1966b, p. 168). Here Husserl seems to link psychology and any possible psychological aesthetics to that of a fully subjective (and impossible) aesthetics or to an objectivistic psychology that ignores the phenomenon as such, only grasping its material

appearance. Husserl relates aesthetics to the beautiful appearance (not only in art), and aesthetic appearance lacks precisely this object-ness of objectivistic psychology. Husserl is, as such, not concerned with the field of aesthetics, but instead with how objects that are perceived aesthetically appear. As the subject-object relation is of outmost importance to his transcendental or general phenomenology, the aesthetic of reception is of no less importance than the aesthetic object as it unfolds in the phenomenological realm of art.

Aesthetic objects have, to Husserl, a particular way of appearing that does not focus on its object-ness, but instead on its appearing. He does not give a comprehensive answer to the nature of this appearing, but sketches a response. The reason why he does not concern himself much with aesthetics is probably that aesthetics is only a part of a regional phenomenology and not a part of his main phenomenological project which has the transcendental task of investigating the necessary conditions for any appearance at all. At the same time, regional phenomenologies influence his main phenomenological project, but the field of the appearance of art does not. Husserl's epistemic fixation of aesthetics is as such a fixation of it as the appearance of the aesthetic, which must necessarily lead to investigations into aesthetic experience, but such investigations have no consequences for his overarching phenomenology.

All the same, aesthetic appearances are not deemed inconsequential to Husserl. He claims that there is something particular about the regional phenomenology of aesthetics. To perceive something aesthetically means to perceive it without concerns; disinterested without theoretical concerns and with attendant pleasure. When art is perceived as art, it is perceived aesthetically, and it "is the realm of phantasy that has been given form" (ibid., p.616). Art can, just like phenomenology, extend our attention and understanding to that which otherwise is ignored; the appearance or appearing of phenomena (Zahavi 2002). The reason for this function of art is that art is different from a physical thing because it can appear in various physical variations without losing its identity. It transcends the material and creates something imaginary – art is "perceptive fictions." As Zahavi states, the picture in relation to the viewer is in principle transcendent. It transcends the material presence as one grasps that which is created through artistic production. Therefore aesthetics is not a discipline that focuses upon the materiality of the phenomenon, but instead the phenomenon qua its appearance; the phenomenon in its phenomenality. There is thus, Husserl claims, a strong similarity between phenomenology and art in their focus upon the phenomenal appearance (ibid.).

Art has three modes of appearing according to Husserl. When it appears (that is to a subjectivity) it is either with a focus on its material appearance or on how that which is portrayed appears, or on how this appearance has taken place (e.g.

whether it is successful or not) (ibid.). Paradoxically none of these are necessarily a "pure aesthetic appearance of the work of art," as Husserl claims that to perceive a pure aesthetic work of art occurs through a suspension of the natural attitude, including a suspension of any intellectual judgment, feeling, or will which can lead to the natural attitude. In fact, the work of art forces a pure aesthetic appearance that has pure aesthetic pleasure as its consequence. The more the work of art affords judgments akin to the natural attitude – that the work of art exists independently – the less it is perceived as purely aesthetic.

Husserl's phenomenology of art with its focus upon the work of art as "perceptive fictions" runs into a particular problem when facing a naturalistic and objectivistic ontology which appears at first to have consequences for psychological aesthetics. As the work of art is "fiction," these ontologies contain the invalid claim that the object of aesthetics is unreal and that the experience of it is therefore *only* subjective (ibid.), meaning that the experience is not linked to a particular object but fully a function of the individual, e.g. the individual's mood or biography. This focus on the merely subjective in relation to art Zahavi names a *psychologising aesthetic*, as well as *psychologising reductionism* (ibid., p. 23), apparently giving psychology a rather bad name. When given this name it must again be a remnant of Husserl's critique of psychologism where he argues that not all objects can be reduced to functions of the mind.

One way of tackling such critique is to contest the nature of subjectivity present in such a claim. As Merleau-Ponty says, one of the chief gains of phenomenology is to have overcome the radical separation of the subjective and objective. The subjective is always intersubjectively constituted, and similar experiential structures are in play in meetings with art. There is therefore nothing inherently wrong in focusing on the subjective potential for experience, and investigating the subjective structures will inherently lead us to the nature of the object – or the phenomenon – too. The subject and object are reciprocally given. A psychologising aesthetic is not, as it might first appear, a psychological aesthetic, but actually something which, in principle, cannot exist as there is no *mere subjectivity*. There is therefore no actual *psychologising aesthetics*.

Zahavi's phenomenological reply to the objectivistic critique is, as seen, not to vindicate the name of psychologising aesthetics, but instead to return to Husserl's original project of "Zu den Sachen selbst," and thus to begin with aesthetic investigations into aesthetic experience, not aesthetic theories. Relying on theories, however, and not aesthetic experience, Zahavi writes that experience of the aesthetic in the phenomenological tradition is seen to occur not through sense experience or theoretical considerations, but through feelings.

Such a phenomenological claim is surprising, especially since Zahavi himself eloquently argues that what Husserl meant by the epoché is only to avoid ones

metaphysical preconceptions; the natural perception wherein one lives with the things with certainty about their existence independent of the subjectivity that experiences them. It is not possible to free oneself completely from one's theoretical background, not even in experiences with art, although one can suspend the attitude that the art object exists in it-self. Since a complete bracketing of all previous experience also is impossible, then theory on a more concrete, lived level is also a part of aesthetic experience. It is also surprising that Zahavi describes or accepts aesthetic experience as devoid of sensing, when e.g. Merleau-Ponty has so elegantly shown that sensing always involves feelings. The opposite is also the case. Feelings, in relation to the perception of art, must, in principle, always involve sensing.

Martin Heidegger
Heidegger does not try to fixate aesthetics, and is not concerned with the field of aesthetics as such. The term "aesthetics" would, to Heidegger, be a remnant of traditional metaphysics, and he breaks with such stable categories in order to arrive at a new kind of thinking that can properly pose "the question of the meaning Being" (1926, p. 2). Philosophy conducted within the traditional framework cannot not arrive at the necessary Being questioning, he claims. To find the proper way of asking the being question we need to break not only with traditional metaphysics but with the words and concepts of the tradition too.
Although inspired by much of Husserl's thinking, Heidegger has a radically different view of art. Experiences with art have nothing to do with disinterested, aesthetic pleasure but instead everything to do with revealing truth to a subjectivity that is also radically different from Husserl's. Truth cannot be accumulated and handed over in traditional axioms. Instead it can be understood and seen in the arts. Art becomes essential to his thinking about being, including his attempt to dissolve the traditional subject-object thinking.

Heidegger seriously starts to write about art after *Being and Time*. After his analysis of Dasein's being toward time, he understands that the being question cannot be answered in this systematic, rational way and instead poetically continues to search for the being question. His language turns poetic rather than scientific, and art becomes internal to Heidegger's later thinking. A work of art is poetic and art becomes a mode of revealing truth, and philosophy needs to take the form of art, too. Art reveals a world through the "opening" between the hidden and revealed; the work of art presents a new worldview. It is a "revolution" in its presentation of something new that nevertheless was paradoxically, or hermeneutically, already present, yet concealed. Through its presenting, the work of art can lead to a new way of being in the world that involves changes to self-understanding. "[F]or a work is in actual effect as a

work only when we remove ourselves from our commonplace routine and move into what is disclosed by the work, so as to bring our own essence itself to take a stand in the truth of beings" (Heidegger 1935, p. 199); "It gives ...to men their outlook on themselves" (ibid., p.168). Although paradigmatically separated, Heidegger and Hegel are similar in their conception of art as revealing truth, and not an objectivizing truth, but a dynamic truth that opens up in the realm between subjectivity and objectivity, and which facilitates for revelation, recognition, and reflection upon being. (Yet different in the sense that for Heidegger truth is unending men final for Hegel). A somewhat longer exposition of Heidegger's views on art can be found in Roald, 2008).

Maurice Merleau-Ponty
Merleau-Ponty is interested in the Arts throughout his authorship. He devotes three essays to the topic, while his other philosophical works also include occasional musings on the Arts as well. As it turns out, his work on the arts is somewhat difficult to utilize within the more concrete world of psychology, as it can be said to be more prosaic than scientific (but not lacking in psychological insights). Still, Merleau-Ponty (1945a) claims from the very beginning of the *Phenomenology of Perception* that art brings truth into being. It is not so surprising, then, that he finds strong similarities between art and phenomenology. He writes: "[Phenomenology] is as painstaking as the work of Balzac, Proust, Valery or Cezanne – by reason of the same kind of attentiveness and wonder, the same demand for awareness, the same will to seize the meaning of the world or of history as that meaning comes into being. In this way it merges into the general effort of modern thought" (p. xxiv). In his later writings Merleau-Ponty takes this claim of similarity even further and actually sees the artist as a phenomenologist who reveals our relation to the world, over and above that of the rational philosopher proper. Art *is* phenomenology.

Merleau-Ponty's own way of conducting phenomenology also moves closer and closer to that of the arts. He has in common with Heidegger that his writings become more and more poetic, to the extent that his style also becomes artistic. Art becomes internal to his phenomenological project first and foremost because through art the pre-reflective world becomes visible. Perhaps it is because of this embrace of the arts that Merleau-Ponty does not, in the scientific sense, have a theory of art, but instead gives particular examples of the creation and reception of art that the reader can then abstract to a more general level.

Merleau-Ponty finds the painter devoting full attention to the perception of phenomena. To the painter, nothing takes precedence beyond the portrayal of the phenomena whereby the painter experiences the phenomena intensified. Through the painter's depiction hidden aspects of the phenomena emerge into visibility

for the uninitiated, or non-painting, other. The pre-reflective world that lies before reflectivity emerges as visible through the painter, and the painter presents the purest version of sensing possible - sensing before thinking. The painter creates the link between the otherwise hidden world of pre-reflection and the world of reflection. In meetings with art Merleau-Ponty sees that the "primordial lining is woven into the fabric of our lives, leading the viewer to a pre-reflective experience of the life-world" (Roald 2008, p. 10). Since the pre-reflective world is ontological, it is philosophy's task to understand it. The painter is thus a philosopher who connects us with the hidden aspects of the pre-reflective world.

Art, and indirectly aesthetics, is essential to Merleau-Ponty's phenomenology. It is a realm of existence which reveals that which is otherwise hidden. Art is of utmost importance to his phenomenology of the quiet yet influential pre-reflective existence that forms the background for understanding all other kinds of existence and at the same time reveals meaning at an intensified level. In the work of art those fleeting aspect of the world that avoid our scientific or categorical gaze can be revealed for the body-subject whereby a broadened sense of understanding can take place (cf. Roald 2008).

Jean-Paul Sartre
Sartre (1972) has an altogether different phenomenological view about art. He shows his interest in art mainly through his engagement with literature, and he presents a social phenomenology of art, because, to him, literature's social function is its most prominent objective. Literature presents the desire to want to change social conditions and the views that humans have of themselves. The aesthetic, as a function of literature, has cultivation and portrayal of subjectivity as its objects, as subjectivity remains largely hidden in the awkwardness and functionality of everyday life. To reveal subjectivity is saved for the most intimate of relations, but in literature it is displayed openly. Sartre eloquently claims that literature reveals

> [...] a subjectivity which appears behind the mask of objectivity, a discourse which is so strangely complex that it corresponds to a silence, a way of thinking which rejuvenates itself, a reason which is only the mask of insanity, a historical moment which through the secrets it reveals immediately confronts us with the eternal of humanity, a continuous teaching which nevertheless occurs against the expressed intentions by those who teaches (ibid,. p. 40, my translation).

To read appears as an ontological act where the object (the subject) comes into being, whereby both subject and object (the double subjectivity) appear as

essential. In line with the phenomenological tradition Sartre presents a view of the subject-object relation which lies beyond extreme objectivity, as the object exists save only for a subjectivity.

> [...] the object is essential because it is strictly transcendent, because it forces its structure upon the rest of the world, and because one has to anticipate it and observe it; but the subject is also indispensable because it is necessary not only in order to reveal the object (that is, make it possible that it is an object), but also for the object to come into being (that is, to produce it)" (ibid., p. 46, my translation).

Aesthetics becomes important qua subjectivity and the imagination thus takes part in a constitutive play continually creating the object beyond the primary given artistic creation.

To Sartre, the work of art also produces aesthetic pleasure; a sign that the work is art. This pleasure arises in connection with the knowledge that the work is something which has its own, non-utilitarian value. When experiencing it, one becomes aware of one's own subjectivity as important as it stands in relation to, receives and develops, an important object. Sartre sees this aspect of the aesthetic meeting as characterized by security and therefore calmness - harmony between subjectivity and objectivity. And there are other aspects of aesthetic pleasure. Since the art work is a world of its own as seen through pictures it also leads to an awareness of the external world being valuable. When the world has value it means that it is a project which demands and confronts our freedom. The world becomes something which concerns the one who has experienced aesthetic pleasure. The work is, as such, both "a demand and a gift" (ibid., p. 57); it is consciousness-raising. There are, however, forces which do not want this effect and attempts to silence this critical voice. To write can therefore become a luxury, but that is only when the bourgeoisie has kidnapped it for fear of revolution. To write can be dangerous because when the writer is actually writing, then the writer reveals, explains, and changes. "To reveal is also to change" (ibid., p.34).

Martin Seel

The most recent account of aesthetics within the phenomenological tradition has probably been given by Martin Seel (2000), a German philosopher concerned with the appearing of aesthetics. In contrast to the other phenomenologists, he does not begin with a general phenomenology to which aesthetics becomes more or less important. Instead, he begins with a phenomenology of aesthetics.

Seel claims that the aesthetic appears as particularly sensuous, and this sensuousness drastically differs from that which can be conceptually determined.

Aesthetic appearing involves a "particular accentuation" (ibid., p.24) of perception; a particularly intensive way of sensing which he *a priori* distinguishes from "conceptually articulated perception" (ibid., p. 25). In other words, perceiving something aesthetically means to perceive something in its sensuousness, without concern for its conceptual resolution. Nevertheless, Seel continues his quest to conceptually fixate aesthetic experience and distinguishes three kinds of aesthetic appearing: *mere* appearing, *atmospheric* appearing, and *artistic* appearing (original emphasis). *Mere* aesthetic appearing occurs when attention is directed solely towards that which presents itself sensuously (no conceptual involvement). *Atmospheric* appearing takes place when the sensuous presents itself as existentially significant, i.e. as having affective relevance to "a life situation." It is meaningful, sensuous perception. *Artistic* appearing takes place when the sensuous presentation relates to understanding, where understanding is not only of a cogito but of a whole body-subject. This artistic appearing has a particular form. It is of a "constellation presentation" where none of its parts can be changed without its meaning changing at the same time. Since artistic appearing is of the understanding, Seel claims that it is "frequently accessible only to those who possess specific historical and art historical knowledge." It is also imaginative, can be reflective, and always contains interpretation.

Seel sees the three ways of appearing to relate to each other, with atmospheric appearing and artistic appearing being extensions of mere appearing. Artistic appearing is a continuation of, not a break with, aesthetic appearing. It is a subcategory of aesthetic appearing, which can nevertheless be in conflict with the other types of appearing as there can be competition as to how the object is supposed to appear.

Through these different ways of appearing, Seel proposes a hierarchy of experience ranging from "pure" sense perception, to affectively laden perception, to that of understanding." It is, as such, a relatively simple mode of viewing experience that does not take into account how experience actually occurs.[6] The "mere appearing" appears as acts of pure perception, and is phenomenologically rejected. Experience does not occur without interpretation, affection, or categorization. A related problem resides in the description of aesthetic appearing as non-conceptual, or as "that which evades epistemic fixation," i.e. that which cannot be understood, versus artistic appearing as relating to the understanding. Unless he wants to conflate the two categories of atmospheric and artistic appearing (affection and understanding), the ineffable in Seel's account lies in his claims that the aesthetic is that which cannot be put into

[6] This aspect of experience is detailed in the next chapter.

precise language and at the same that that artistic appearing relates to understanding of art history and so on (which is largely linguistic).

The object of phenomenological aesthetics
On the one hand, phenomenologically speaking, there is no formal object of aesthetics, as phenomenologists are not concerned with the traditional field of it. On the other hand, aesthetics as art becomes integral to the phenomenological project. It becomes an *inalian presence*: phenomenology is the science of the appearance of phenomena, including the conditions for their appearance, and art is concerned with portraying the appearance of the phenomena, and it is not phenomena reduced to their materiality but to their appearance as phenomena; art reveals phenomena in a way that we are not yet aware of that they exist and therefore elicits new experiences. Art presents pre-linguistic, pre-reflective sensuous experience, yet is not limited to it. It includes a level of meaning that if not taken seriously will be lost to the analytic reflection of philosophy in general, and phenomenology in particular. Experiences with art become epitomes of experience which philosophy needs to take seriously if it wants to retain its status as transcendental or ontological, i.e. concerning itself with the underlying bases for experience. As such, aesthetics is, paraphrasing Merleau-Ponty (1945a, p. ix), a problem to be solved and a hope to be realized.

Psychological Aesthetics

Aesthetics is the study of the beautiful and the study of art, and the results of inquiries into aesthetics have epistemological consequences for the nature of truth, the nature of subjectivity, and, psychologically speaking, for what we can know about the human mind. As such, aesthetics has not been a psychological discipline in the same way as for example developmental or social psychology and has not been present in the general education of psychologists. Although cognitive psychology and neuropsychology currently give significant attention to aesthetic phenomena, aesthetics have largely been treated as a marginal topic at the fringes of the various psychological schools of thought. Not that the topic of aesthetics demands such external justification, but if Johnson (2008, 2013) is correct in that through understanding aesthetic experience, or experiences with art, we get to understand experience in general, why, then, has psychology, to which experience is so central, hardly investigated this potential, but largely ignored it?

The Beginning of Psychological Aesthetics

Paradoxically enough, although interest in the aesthetic is marginal, aesthetic considerations are integral to psychological theories from their institutional beginning. William James is well traveled in the world of literature, and he ventures into the world of painting, training as an artist's apprentice before changing course and becoming a psychologist and philosopher instead. James does not have a theory of arts or aesthetics, yet David Leary (1992) argues that James not only thinks highly of the arts, but that his fascination with it penetrates deep into the core of his psychology. His basic principles are often based upon metaphors from the art world and are drawn from his experiences with art. For instance, his thoughts about objectivity as constituted through a plurality of perspectives arise from the multiplicities of perspectives stressed in art (ibid.). His thoughts on emotions (see James' [1884] article, *What is an emotion?*) are also deeply influenced by his regard for what he calls an aesthetic emotion, and the way he views the workings of the mind in general is inspired by his thoughts upon artistic creation. He writes:

> The mind, in short, works on the data it receives very much as a sculptor works on his block of stone. In a sense the statue stood there from eternity. But there were a thousand different ones beside it, and the sculptor alone is to thank for having extricated this one from the rest. Just so the world of each of us, howsoever different our several views of it may be, all lay embedded in the primordial chaos of sensations, which gave the mere matter to the thought of all of us indifferently (James 1890, p. 277).

Differing from James' pragmatic tradition, Gustav Theodor Fechner (1876) writes *Vorschule der Aesthetik* at the beginning of the psycho-physical tradition, investigating ways to quantify the relation between stimuli and their reception. He wants to measure sensations as they occur in relation to art as well as aesthetics, more broadly conceived. Along the same lines as Fechner, Alfred Lehmann (1884) discusses color perception in his first work which has an experimental psychological approach. His focus is not upon the arts but upon color relations, and he experimentally investigates laws of harmony between colors, seeing the experimental approach as the only scientific way to arrive at psychological knowledge (Funch 1986). John Dewey (1934), a philosopher and psychologist like James, writes the book *Art as Experience* where he rejects the focus on sense experience as being of objective stimuli, as seen in the tradition of Fechner and Lehmann, and argues that perception exists in an historical and social context from which it derives meaning. As such, the epitome of sense experience occurs in the reception of the work of art as it presents intensified

experience, which communicates emotions. To Lev Vygotsky (1922) art is also linked to the emotions. He sees art to work by transforming the emotions, which happens when the work of art reveals truth about the human situation. This happens when the personal emotions are given a more general meaning. Vygotsky searches for an objective psychology of the arts in reaction to what he sees as psychologism or subjectivism in art research. At the same time, he does neither reduce the work of art nor the psyche which perceives it to materiality, but tries to discover (actually somewhat phenomenologically in the description) rules of reception based upon the specific works of art.

Since the early days of psychology, then, aesthetics has been seen to aid in the study of the human mind in general and in the study of perception and emotion in particular. It is visibly present at the birth of psychology. With aesthetics being granted such importance, why has such a relative quietness prevailed in the history of psychology?

A phenomenological explanation
Husserl and Merleau-Ponty offer critiques of the sciences which can be adapted to explain why objectivistic psychology has given little attention to aesthetics. On a general level, an objectivistic psychology has a different focus than description and interpretation of experience, and it assumes that art can, or should, be understood "quantitatively, and with mathematical preciseness." The critiques of the sciences comprise the claim that the sciences do not concern themselves with the meaning of phenomena, but with objective, hard-edged facts. Following this argumentation, objectivistic psychology desires knowledge of a world which transcends subjectivity; knowledge of the world as it *actually* is, and ignores the constitution of subjectivity in the lifeworld which is so essential to the appearance of truth. The lifeworld, as Husserl describes, is sensed and concrete, and its truths are vague and rather relative (Zahavi 2001a). Therefore, in regards to such complex objects as art, idealized scientific exactness is impossible if art is to remain art, that is, transcending its materiality or the primary sense qualities. The arts can hardly be encapsulated in accurate definitions, making it problematic for objectivistic psychology to live up to its ideals of preciseness. As Husserl (1937) describes, the natural sciences have become specialized and successful to the extent that they ignore their own historical and intersubjective foundation in the lifeworld. In the quest for truth independent of consciousness they cannot comprise the lived truth of art.

An explanation from Critical Theory
Herbert Marcuse (1978) offers an explanation as to why the Left has largely ignored aesthetics and attempts to develop a Marxist aesthetic from within. In the

spirit of Marxism, he attempts to develop an aesthetic which he deems has been made vulgar or improper via the very same source. He starts off: "[I]n a situation where the miserable reality can be changed only through radical political praxis, the concern with aesthetics demands justification" (p. 1). His primary tasks are to show why and how the concern with aesthetics is not only justified, but absolutely essential in order for Marxist theory and praxis to push forth its aims. Accepting certain postulates of Marxism, he attempts to develop an aesthetics that contains similar goals of traditional Marxism, including the aim of emancipation from capitalistic, repressive forces. At the same time, he denies what he calls the Marxist "orthodoxy" or "imperative" in regards to art, namely that "the work of art represents the interests and world outlook of particular social classes in a more or less accurate manner" (p. ix). The goal of his task is show how "the aesthetic dimension," instead of being of a repressive dimension of the class in power, has an emancipating potential indispensable to the Marxist tradition. The Freudo-Marxism he espouses is one wherein subjectivity is not reduced to economy and where the political goal of freedom is the goal of individual persons, and must be founded in their subjectivities – in their "passion, imagination, conscience" (p. 5), or features of human subjectivity which transcend the realm of the social and economic. As such, a main premise of his critique consists in the Marxist rejection or diffusion of subjectivity into class-subjectivity, including reason and the subjectivity of emotions and imagination in particular. This subjectivity is ignored in Marxism yet is essential for radical political change, as it has to be grounded in the particular subjectivities of each single individual of "the ascending class," "in their intelligence and their passions, their drives and goals." In difference to orthodox Marxism, he sees subjectivity as containing an inwardness that is free from the capitalistic forces of the "performance principle and profit motive" (p. 5), including trade relationships – it is a retreat from these forces which disengage the capitalistic dimension by giving attention to, or becoming, "passion, imagination, conscience" (p. 5). Marcuse's critique of Marxist aesthetics comprises a critique of its reduction of subjectivity to economics. It is this reduction of subjectivity that is damaging for a leftist aesthetic, as it ignores dominant experiential dimensions at play in experiences with art, whereby the experience of art instead is seen as fully penetrated by economics and an image for the dominant class in power.

The reason why Marcuse sees the Marxist rejection as fatal is because he believes that art has the potential to alter the world, not directly, but indirectly through changing the hierarchy of needs, and thereby transforming subjectivity into "rebellious subjectivity." He agrees with Stendhal that beauty is the promise of happiness, and in this promise lies the radical potential in art. Beauty has

"radical potential" in that beauty is closely linked to sensuousness, Eros and to the pleasure principle. These principles object to the domination of the reality principle. This "radical potential" is not always present, however, as there can be beauty in forms antagonistic to freedom (in the "fascist feast" [p. 63], he explains), and in this sense, beauty can be neutral.

Art, then, to Marcuse, envisions a future where the current repression is lifted. When utopia is reached, art will disappear, as art no longer can represent a different reality principle. The one of art has become that of life. It is not, however, a leveling of all differences, as the basic ones, that of Eros and Thanatos, or the difference between "individual and individual, male female, humanity and nature" – "the permanent non-identity," will remain as basic forces which cannot be transformed. Through art, however, or in utopia, or on the way toward it, these repressive forces may become apparent, and one will therefore no longer be subjugated unknowingly or totally unwillingly.

As pertains to the primary question – why aesthetics has been ignored – Marcuse's answer would be that it is not because art is too personal that it is rejected. Instead, it is because the personal does not exist in that it is overridden by economics forces, and through this dissolution of subjectivity the tradition loses one of its most potent forces for change.

Continuing Psychological Aesthetics
That being said, psychology has dealt with aesthetics. The most comprehensive overview of psychological aesthetics is given by Bjarne Sode Funch in *The Psychology of Art Appreciation*.[7] It has been written about elsewhere (Roald 2007), and therefore only a summary of it will be presented here, updates with some relevant examples of new studies since Funch's publication. In the book, Funch shows how different psychological traditions have investigated experiences with art, which are given different functional conceptualizations dependent upon the overarching theoretical frameworks of these traditions. Asking the psychological question about the meaning of art, several competing and overlapping answers are given, dependent on the psychology in question. In brief:

- At the core of the psycho-physical tradition lies the assumption that the function of the work of art is to elicit aesthetic pleasure. This tradition proposes a stimulus-response model where biologically based pleasure arises when viewing art. To experience a work of art has hardly any consequences beyond this pleasure,

[7] See also Allesch (2006).

and the tradition is concerned with identifying the formal features of the work of art which give rise to it. Ramachandran and Hirstein (1999) are specific examples of this tradition and, stretching the borders of these traditions somewhat, the field of neuroaesthetics is a general example (cf. Zeki, 1999; Chatterjee 2010)

- The cognitive tradition, of which Helmut Leder et al.'s (2004, 2012) work is an example, proposes models of information-processing of experiences with art. In this tradition the reception of a work of art is seen to facilitate for specific perceptual and memory processes which are modelled in a stage-like fashion. They argue that the results of these various computations are emotion, understanding, insight and knowledge; these end-results can be pleasurable and amount to the reasons why we are taken by the arts.

- To the gestalt tradition represented by e.g. Kurt Koffka (1940), art understanding is an effect of the perception of the "good gestalt" present in art. Along this line, Rudolf Arnheim (1954, 1969) contends that experiences with art have the function of developing and extending perception, and through this progression in perception, thinking in general is also advanced. He investigates how the work of art is experienced through perceptual rules which create affects, tension, and harmony, that is, how different elements in certain works of art play together to create such effects. Arnheim's line of investigation has been continued by Ian Verstegen (2005, 2014).

- Within psychoanalysis, the work of art functions as a portrayal of unconscious forces wherein the artist sublimates energy. As Freud and later psychoanalysists' contend, the artist shifts libidinous affect that would otherwise appear as neuroses. In regards to the viewer, the work of art creates aesthetic fascination which arises from the pleasure which follows catharsis. Freud (e.g. 1910, 1914) wrote about the arts, showing how his theory could be applied to the artist as well as to the work of art. Judy Gammelgaard (2013a, 2013b), for instance, continues the psychoanalytic tradition and uses it to interpret classical and contemporary works of art.

- Within the existential phenomenological approach, Funch (1997, 2013a, 2013b) conceptualizes art as functioning through the emotions. The work of art portrays emotions clearly and distinctly. Since emotions often are confused or diffuse, by experiencing that work of art which relates to a person's existential dilemmas the emotions can become more fully integrated in the person's subjectivity.

Other psychological works important to mention in this context which cannot so easily be classified into one school of thought are those of Ciarán Benson (e.g. 1993, 2001, 2013a, 2013b), Gerald Cupchik (e.g. 2002, 2013, in press) and Pavel Machotka (e.g. 1979, 2003, 2012). They attempt comprehensive explanations of aesthetic experience, and include psychological aspect which are usually not discussed when it comes to psychological aesthetics, namely social and philosophical topics.

Although research into the psychology of the arts has been rather limited, the work of art remains an object of psychological aesthetics through the variety of ways in which it is seen to function psychologically. The different traditions take into consideration different levels of functioning, from biology to the psyche to the more multifaceted models wherein the two are intertwined in a complex way. As goes with all psychology, each tradition carries certain contentious assumptions. Perhaps crudely stated but nevertheless common point of critiques: Within the psycho-physical tradition subjectivity is largely ignored and oversimplified. Cognitive psychology cannot fully take felt aspects of experience into consideration, stridently separates between form and function, and disregards more complex models of subjectivity where experience cannot be categorized into clearly defined boxes of functionality. For Gestalt psychology, art is complex objects of perception, designated by reference to the canons, or works generally accepted as art. Perception is not just "nutritional channels for meaning," (Køppe 2008, p. 145) but the place where the meaning of art resides, and the tradition therefore only takes a few aspects of the art phenomenon into consideration. Psychoanalysis understands the creation and reception of art through a complex model of subjectivity, but it is also a model which contains controversial features such as the unconscious, wherein art is not important to normality, but serves as an escape or rescue from pathology. Existential-phenomenological psychology focuses on subjective experience in regards to art, but has a reputation for lacking a rigorous empirical and theoretical basis.

Philosophical and Psychological Aesthetics
It has often been said that the plurality of perspectives is a contemporary necessity because they all investigate different parts of the same phenomenon. Such plurality can be useful for many topics but when it comes to the world of art it cannot be understood on all these levels and remain Art – a totality not reducible to its parts. This is particularly pertinent for "natural-scientific" psychology, where truth is largely found in front of the subject instead of with the subject (Heideggerian concepts).

It is evident from the above, however, that psychology operates on a variety of levels which attend to different psychological functioning. Fechner's (1876) claim is, therefore, inaccurate for contemporary times when he names psychological aesthetics "aesthetics from below," and equates it with an empirical aesthetics concerned with perception; a psychological aesthetics which investigates formal aspects of the work of art, lending objective criteria for judging the experience as aesthetic. Psychology is more than an inductive field of inquiry concerned with sensing and perception, also when it comes to art. He is likewise inaccurate when he calls philosophical aesthetics "aesthetics from above," as though philosophy attempts to grasp art and beauty in relation to questions concerning the natures of truth and the relation between subjectivity and the world in mainly idealized systems concerned with epistemological and ontological questions.

The picture of philosophy as abstract and removed from the world and psychology as inductive and removed from theory is too simple. Although the most philosophically abstracted idealizations may at first appear lifeless, significant parts of philosophy, the most pertinently being phenomenology, constantly refer to the actual, lived word wherein idealizations are based upon real phenomena. Hegel, considered by many a speculative thinker, builds his theory of aesthetic upon the world of art as he sees it to exist. Yet he is certainly more speculative than anthropological. Husserl's essences do have a transcendental (idealized) flavor, yet in his later works, the essences also become functions of generativity and historicity. Although taking part in epistemological and ontological discussions, Merleau-Ponty is more concerned with functioning in facticity – the functioning of perception, alterity, sexuality and so – while retaining the ambiguity inherent in existence than in idealizations. Thus, with phenomenology, philosophy takes a major turn toward the lifeworld and it is, as such, an unwarranted idealization to name it an aesthetics from above. Similarly, in the psychological realm, aesthetics takes place at many different levels of functioning, and James, for instance, has a much more sophisticated approach to understanding the arts than do inductive traditions which largely abandon theory in their quest for grasping the aesthetic. Psychology certainly has one foot in the

door that opens onto naïve empiricism, but it is only the foot (albeit sometimes more) of a much larger animal. Instead of being limited to perception, psychology should be seen as an empirical science of the subject, with empirical being understood in its broadest sense. In other words, empirical does not mean being inductive. As argued elsewhere (Roald and Køppe 2008), theory is always a part of the use of method; normativity and theory lie at the core of how we experience the world around us.

In general terms, through the use of both qualitative and quantitative methods, truth becomes as complex in psychology as in philosophy. Yet, psychology does not give such prominence to questions of truth as do philosophy, where the conditions for truth are major concerns. The philosophers discussed conceptualize truth differently. In compressed form: To Baumgarten, truth lies in the object, and we need to find scientific ways to know it as it exists. For Kant, truth about the object – or the world – as it is in itself, is not attainable, but the conditions for experiencing the world are. For Hegel, truth is directly available, but is only perspectival to the extent that different philosophies contain different and incomplete (save for his own) perspectives of truth. Knowledge of one's perspective's limits is the best any investigation can hope to achieve. To Husserl, truth is found in essences that can be reached through reason, while for Heidegger, it is revealed in the constant movement between the hidden and the open. Merleau-Ponty relates truth to essences of facticity, as in the factuality of perception, including its epistemological consequences, while truth, to Sartre, is a matter of authentic living.

Instead of discussing truth, psychology is more about applying methods that, when used or abused, influence the claim to validity, that is, a truth which is always approximate. In regards to aesthetics, the psychological questions asked are not about the truth of art, but about how the work of art affects the subject in relation to different experiential functions and structures dependent upon the psychological tradition in question. It is about building a knowledge base which gradually encircles greater degrees of complexity in relation to the work of art, with some of these traditions being less feasible than others.

Psychological Objects of Aesthetics
Although philosophy alone is insufficient for a psychological aesthetics, it does imply a psychology; it is removed from a comprehensive psychology centered upon experience and the experiencing psyche, but nevertheless, maintain certain assumptions about the psyche, and postulates certain functions of a work of art that are psychologically relevant. Thus, both in philosophy and psychology, a variety of (sometimes overlapping) psychological functioning has been proposed (see also Roald and Køppe, in press). Summarized:

- The psychological meaning of art has been proposed to lie in its sensuousness (Baumgarten). Art presents, at best, the perfect object for sensing, or merely provides a complex object for sensing. Both these forms of sensing provide us with knowledge of the world which is no worse than, just different from, intellectual knowledge. It provides us with knowledge that cannot be fully fixed in language, but that is meaningful nevertheless.

- Art has also been seen as providing the basis for experience through its manifestation in and revelation of the pre-reflective; of sensing, feelings and rhythms that cannot be captured in language or precise delineation, but which nevertheless form the basis for experience and language. As Johnsons writes and empirically shows "Indeed, linguistic meaning is parasitic on the primordial structures and processes of embodied interaction, quality, and feeling" (p. 218). Or, as Arnheim proposed, the arts provide us with an extended range of sensing and experience that is pre-reflective, and through this experiencing, thinking is also developed.

- With Kant, aesthetics lacks psychological meaning.[8] It is a self-enclosed experience, i.e. it is inconsequential in the lived world. Nevertheless, with Kant, aesthetic experience becomes a topic of investigation, although it remains in his shadows for too long, with disinterestedness still today seen as a core feature of aesthetic experience.

- Psychological meanings of art have been argued to lie in its ability to influence the emotions. In the simplest explanation, art elicits, for various reasons, a basic pleasurable response which makes the viewer desire to re-experience the work of art. It is self-reinforcing. Art has also been proposed as objectifying the emotions so that they can be understood and seen; the personal emotions become understood at a more general or social level. Alternatively or additionally, they become more fully integrated

[8] Still, Kant's general system is more psychological than Hegel's as consciousness is limited and limiting, while it dissolves in Hegel's model where the subject-object relation collapses.

in the particular, viewing subjectivity. Catharsis has also been related to art, that is, an experience of release of tension wherein the emotions are purified, a process that is also attended by pleasure.

- The work of art has also been proposed to transmit existential, universal knowledge as concerns questions of the nature of living, dying, and loving, for instance. It portrays singular instances which carry universal meaning to which the perceiver may relate. The reflection from the work of art may transform into radical self-reflection.

- The work of art has also been seen to contain the totality of tension within itself, which, nevertheless, disputes our common ways of being through provocations or variations of everyday experience. Personal and cultural habits in terms of perception and emotions, for instance, are challenged – the work of art puts consciousness to the test, so to speak.

- It has been suggested that the work of art calls for a new social order. It reflects political situations and solutions, knowledge of which can liberate. It reveals aspects of the social order that can lead to emancipatory reflection and action unto one's own and society's practices. Through art, the self and the world are revealed as important, demanding engagement (Sartre).

- It has also been proposed that the work of art works on the mind in general, whereby the subject experiences the zeitgeist (Hegel) and dialectically understands certain truths of its own time, and thereby also the self. Art carries the potential to integrate both the subject with society as well as thoughts with feelings, in that it presents sensuous thoughts.

Apparently, there is no one unified object of aesthetics in philosophy and psychology save the more general attempt to understand the nature of beauty and the nature of art, including their internal complexities and their external relations. The next question concerns the nature of the subject which experiences these objects. In other words, how is the subject who experiences aesthetics, aesthetics here understood as art, limited to the visual arts. In this regard, both Hegel and Heidegger strongly object to "an aesthetics that reduces the work of art to a

subjective potential for experience" (Seel 2005, p.12). When Hegel and Heidegger make such claims, the questions arise as to what they think the "subjective potential for experience" is, and what they regard subjectivity to be. Significant parts of psychological aesthetics have largely ignored subjectivity altogether. The next chapter therefore deals with the question of what kind of subject or subjectivity it is that experiences art. It attempts to arrive at a model of subjectivity that is based mainly on the structures and functions of subjectivity to be found in Merleau-Ponty's (1945a) *Phenomenology of Perception*, because he presents a model of subjectivity which lies between intellectualism and empiricism. It is a model that can be used both to mediate between two such poles in the aesthetic dimension as well as to understand how the subject experiences the aesthetic.

2

Subjectivity.
Pre-reflection, Affect,
Reason, and Understanding

Merleau-Ponty (1945a) argues that reflective life builds on unreflective life and, in doing so, that pre-reflection is primary to understanding. In this chapter, subjectivity is first comprehended through an inquiry into pre-reflection then affection,[1] reflection, and understanding, that is, experiential features which pre-reflection gives rise to.

Aspects of Pre-reflection

It has been proposed that art works on the level or mode of experience which exists in between bodily materiality, consciousness, and language. This pre-reflective level is so diffuse that is not given anything but a negative definition, i.e. it is defined in relation to that which it is not. Since it occurs before language, attempts at describing it have been scarce, and, perhaps due to its fleeting and ambiguous appearance, it has been transfixed as particularly present in the somewhat indefinite realm of art. The pre-reflective layer of experience has been seen as the most immediate of experiences; as ontologically and ontogenetically first, yet epistemologically last. It is also of outmost importance to phenomenology as the realm where we might have the most direct contact with the world; where objects appear as genuine, without interpretation and construction. For phenomenology the problem of immediacy versus distance, that of descriptive phenomenology versus a depth phenomenology, or a "constructive phenomenology" (Merleau-Ponty 1945a, p. vii) is one of the issues of its identity: is

[1] The term "affection" is used as an umbrella term for emotions, feelings, and moods. The term "affection" is employed here, as it is within the phenomenological tradition, as a motivating power which is feeling, and not in the common everyday language of "a feeling of strong regard and dedication." Yet regard and dedication are also components of affection in the phenomenological tradition – affection as motivation contains a degree of care.

phenomenology committed to pure descriptions of pure phenomena or should it rather investigate how phenomena are experientially construed? Merleau-Ponty poses this issue as a still unresolved topic for phenomenology, present since its beginning.

Pre-reflection in Early Phenomenology
Phenomenology began, more or less, with Husserl's famous dictum "auf die Sachen selbst zuruckgehen" (1913, § 19).[2] One of his main points was that the question of a metaphysical world was irrelevant and that relevance was to be found in phenomena as they appear to consciousness – the world can only appear to it. At the same time, *direct access* to the phenomena's appearance occurs through several methodological steps, and is not immediately available, because, to Husserl, in the natural attitude, we see things as having an independent reality – as divorced from subjectivity. Through the methodological steps of the epoché and the reductions, he claims, we are able to reduce, or altogether avoid, personal interpretations of the phenomena. Consciousness – in the form of the transcendental ego – should arrive at "den Sachen selbst," that is, their appearance, without layers of interpretative noise.

Although it remains contentious whether Husserl himself at the various stages of his authorship remained committed to a transcendental ego, Merleauponty (1945a) describes the consequence of the postulation of a transcendental ego as a pre-personal consciousness, one that is disembodied, common to all. It is a structure (which he rejects) wherein the subject-object relation is dissolved to one of identity and where there is, accordingly, immediate contact with the world. It could be seen as a universal feature of subjectivity, linked to particular subjectivities, in unity with the world. However, another interpretation of the transcendental ego[3] presents it as the precondition for consciousness, where the mind contains mental representations. The point of direct contact through the transcendental ego is, therefore, much smaller, if not non-existent. The world and mind are ontologically independent, and the mind is noisy – because of the representations – to the extent that it is the precondition for a contact with the phenomena that is not direct. In this latter interpretation of Husserl, the transcendental ego is perhaps a point of direct contact, but one which is psycho-

[2] Husserl (1900) discusses the possibility of arriving at the "things themselves" in volume ii, part two, chapter three, four, and five of Logical Investigations (e.g. p. 264), and says in Ideen I "But to judge rationally or scientifically about things signifies to conform to the things themselves or to go from words and opinions back to the things themselves, to consult them in their self-givenness and to set aside all prejudice alien to them" (Husserl 1913, § 19, p. 35).

[3] E.g. Dreyfus' interpretation of Husserl, described by Zahavi 2004.

logically irrelevant since it is only seen as a prerequisite for consciousness. Additionally, a mind that is suffused with mental representations does not, Husserl contends, have direct contact by virtue of the representations. The direct contact in this interpretation of Husserl therefore disappears.

Other access to direct experience of phenomena can perhaps be found in some more concrete experiential features, however. In Husserl's (e.g. 1937, § 19) later writings he understands that consciousness is not constituted in front of the world but through it as well. Through the epoché and the reductions, consciousness also arrives at the world. Conceivably, then, there could be other experiential features where direct contact occurs, and that is for a subjectivity *in* the world where the point of direct contact could take place in the most primary of experiences, in the layer of pre-reflection that is also a condition for reflection. In Husserl's writings, this experience of pre-reflection can be found in his description of sensing. In *Logical Investigations* (1900), Husserl distinguishes between different ways the object can be given, characterized according to its degree of presence. Here he claims that it is only in perception that the thing is given to us directly (Zahavi 2001a), without representation but as presentation. There are no two distinct entities such as the object and its appearance in an internal, psychic representation. Husserl therefore claims that in perception we experience the world or the object immediately and directly. Perception is direct, not mediated through something that is different from the object (ibid.). The objects are presented to us, not represented, and Husserl's attitude is therefore that of "direct perceptual realism" (ibid., p. 30). But Husserl also says that sensing consists of sense impressions and interpretations. Sense impressions are not intentional and are the direct experience of the object. They are aspects through which we are in direct contact with the world. Husserl also argues, however, that all experience demands interpretation (ibid.), and sense impressions say nothing about the phenomena unless they are interpreted. "Through sensing and interpretation is the appearance of the phenomena constituted" (ibid., p. 44). Thus, to Husserl, in sensing, there is no direct contact, as sense impressions cannot exist alone, without interpretation. In principle it seems as though any experience containing interpretation is not direct, and interpretation as a fundamental part of experience is not only to be found in Husserl's description of sensing, but also in his analysis of intentionality.

Husserl views intentionality as the directedness with which the subject grasps the object. It is not that which links the subject with an actual object; intentionality is not dependent upon the existence of the object it intends. The object can be both fantasy as well as reality, and reveals a subject who, through its directedness, is itself transcendent. Alterity is a part of intentionality as the subject continuously grasps the things that are foreign at first. The grasping,

however, occurs through grasping meaning which is what the grasping refers to – the content of intentionality, not the form (ibid.). Through the content of intentionality, which interprets, the object appears. Intentionality is, as such, "the interpretation of something as something" (ibid., p. 45).

The direct contact according to Husserl, then, lies in the dictum that the object is what appears to consciousness, and, in this sense, there is no way around the direct contact. There is no meaningful world beyond its appearance to consciousness. At the same time, if direct contact means that the contact is pure, without interpretation or representation, then the picture becomes more diffuse. Neither intentionality nor sensing are direct experiences. If direct means that it occurs without interpretation, then Husserl's postulation about direct contact with phenomena is contentious. As Ricoeur (1970, p. 376) argues, Husserl's method of the reductions modifies "immediate consciousness" or the "natural attitude," away from having immediate access to meaning and truth. "[P]henomenology begins by a humiliation or wounding of the knowledge belonging to immediate consciousness" (ibid. p. 377).

Pre-reflection in Merleau-Ponty's Phenomenology of Perception
Merleau-Ponty, however, also contends that there is direct contact. In *Phenomenology of Perception* he claims that "we enjoy direct access to what it [the word] designates" (1945a, p. xiv), that there is "a field of primordial presence" (p. 106), and that the "object speaks directly to all the senses" (p. 264). It is a position which he continues to hold as he opens *The Visible and the Invisible*, his last work, with the sentence "We see the things themselves, the world is what we see" (Merleau-Ponty 1964, p. 3). How, or why, then, does Merleau-Ponty also claim that we are in direct contact with the world?
Merleau-Ponty's solution is to be found in his description of pre-reflective experience, that continuous movement towards the world in which the body-subject is first and foremost realizing the dynamic potential present in between bodily materiality and consciousness in a continuous, affective transcendence toward the world. Merleau-Ponty gives it many names, not limited to: "prepersonal consciousness," "antepredicative life of consciousness" (p. xvii), "primary consciousness," and "unreflective life" (p. xvi).

At the same time as Merleau-Ponty gives pre-reflection a most significant status, its features appear contradictory. On the one hand, he claims that sensing and perception (sensing is more primary that perception to Merleau-Ponty) are socialized. In other words, the way we sense is colored by personal history and biography. On the other hand, he proposes a pre-reflective layer of experience that is pre-personal. He says that "every sensation carries within it the germ of a dream or depersonalization" (p. 250). Along this line he also argues that there is

Subjectivity

"an anonymous life which subtends my personal one" (p. 191). Perhaps this pre-personal layer is the experiential access to the phenomena directly, and it must, at least, also be a part of pre-reflective experience.

It is not easy to penetrate either Merleau-Ponty's description of these experiences or this conundrum of direct contact, yet both positions can be illuminated through the contemporary philosopher Hans Ulrich Gumbrecht's (2004) descriptions of presence, because what he names presence experiences are pre-personal ones. Gumbrecht is inspired by phenomenological traditions, and he develops his eloquent account in reaction to interpretation being the dominant mode of inquiry in the humanities. To Gumbrecht, presence is experiences devoid of interpretation. He also links presence to materiality, and to a particular kind of perception of it. Drawing on Heidegger to describe presence, Gumbrecht posits presence as external to Dasein. To Gumbrecht, the way presence is present is in the form of being. Being, he argues, is "the things of the world before they become part of a culture" (p. 70). As such, it has no structure. It is acultural and astructural, and for this reason exists on the borderlands of what can be experienced. We can only catch a glimpse of it (which is perhaps the reason why he claims it inconsequential). The reason why we have a glimpse of it is because it moves, in Heideggerian terms, between the open and the concealed, and is revealed to a greater or lesser degree at certain historical points, with certain subjectivity positionings. Being is experienced in the in-between of structure and no structure; in the interstices between what we can know and what we can only have a slight feel for. At the same time Being – Gumbrecht interprets Heidegger here – is not beyond the world in any sense. Instead "being is tangible things, seen independently of their culturally specific situations – which is neither an easy feat to achieve nor a probable thing to happen" (p. 76). Yet, it is the cultural specificity which gives the objects their vivacity, he continues. (p. 77).

In terms of other essential differences between meaning-experiences and presence-experiences (and he largely sees meaning as linguistic), the experiences of presence remain significant outside interpretation; presence-experiences do not require interpretation in order to be significant. At the same time, presence experience holds a very limited significance as its import lies in presenting intensified experiences which are nevertheless inconsequential. Taking this presence experience of direct contact as exemplary of pre-reflective experience, however, characteristics of direct experience can be extracted. Direct experience

- is acultural
- has linguistic meaning
- is of materiality

- has experiential intensity
- contains no interpretation
- contains no representation
- has no structure

Using these characteristics of presence experiences to structure pre-reflective experiences in the framework given for subjectivity by Merleau-Ponty, then pre-reflective experience can contain both interpretation, representation, and meaning at the same time as it can be astructural and acultural. This is because Merleau-Ponty presents a complex model of subjectivity which allows for such ambiguity. This model will be delineated in the following pages.

In *Phenomenology of Perception* (1945a), Merleau-Ponty's primary task is to discuss the nature of perception. He argues that sensing, or perception, cannot be divorced from experience, which begins with the body and is continually constituted in relation to the world – experiences develop meaning in and through the body. Merleau-Ponty builds his case in opposition to the two polar positions which he names empiricism and intellectualism, and through his lucid discussions, arrives at a description of the experiential centre of the body-subject. This body-subject comprises the first-person's given-ness of experience, as well as the structures and processes of (and not limited to) sensing, perception, gestures, affectivity, reflexivity, language, intentionality, sexuality, pre-personal consciousness, motility, and self-reflection in a dynamic active/passive synthesis and action. Experience also partially constitutes a cogito, and, taken together, all these diverse formations present themselves in various configurations in a variety of situations in experiences of the "world," inevitably de-centered in the body subject. Accordingly, Merleau-Ponty presents a complex model of subjectivity from what he describes as a relatively anonymous and general existence of pre-reflective being to the reflective cogito; he presents a preliminary model for the expressive and expressed psyche that is fundamentally structured by the body which operates in two main modes: sedimentation (development of habit) as well as spontaneity.

Intentionality, time, and space
At the base of Merleau-Ponty's (1945a) model of subjectivity are the features of intentionality, time and space. In line with the phenomenological tradition, intentionality is viewed as a primary principle and is the directedness with which the phenomenal field is grasped. He argues that all experience takes place in an "intentional arc" (p. 157), which is a projection that comprises both the individual, personal past and the anticipated future, as well as the more general features of "our human setting, our physical, ideological and moral situation, or

rather which results in our being situated in all these respects" (p. 157). Experience is intimately linked to time and is the directedness through which we have and obtain a world in its experiential completeness. It is not only an aspect of all experience, however, but also that which unifies all experience. Merleau-Ponty proposes that "it is this intentional arc which brings about the unity of the senses, of intelligence, of sensibility and motility" (p. 157). Thus, intentionality, on a more general level, is a universal structural principle of subjectivity, as well as an experiential fact that through its universality is pre-personal but in its content also personal. It is certainly an experiential feature that lies before reflection and is a part of pre-reflective subjectivity. Intentionality and subjectivity are most intimately bound up with time-consciousness and space-consciousness (what he says about time holds just as well for space). To Merleau-Ponty there is an inseparable bond between intentionality, time, space, and subjectivity. Time and space are, to him, not physical or pure, but subjective. That means that the question of whether time and space exist without a consciousness to perceive it becomes not only irrelevant (as Husserl would claim in his mediation between idealism and realism), but absurd. The question of the nature of time and space cannot be asked without a consciousness asking it; it is impossible to know them "in themselves": we can only know them as they appear to consciousness (here consciousness = the whole body subject).The relevant question is instead about the nature of the relation between experience, time, and space, and Merleau-Ponty sees time and space *as* consciousness. That means that they are not prior to sensation or perception or a function of experience. Rather, "we must understand time as the subject and the subject as time" (p. 490). This means that time is subjectivity while subjectivity isn't only time alone, but that temporality is a dimension of all experience. This inseparable bond, then, is time as subjectivity where the former cannot exist without the latter and vice versa.

As subjectivity cannot exist without time it can neither exist without the world, so it is no surprise then when Merleau-Ponty also says "time arises from my relation to things" – time does not come from a centered psyche, but from the whole body subject in its relation to the world. Indeed Merleau-Ponty says time does "not run from a central "I" but from my perceptual field itself" (p. 484). Time is neither a fully idealistic nor empirical phenomenon. At the same time, Merleau-Ponty claims that consciousness is timeless as well as not intratemporal. The reason why he can claim this is because time arises as subjectivity, and as the relation between subjectivity and the world. It is internal to both yet also external. Time is everything and nothing, and that for the same reason neither intra nor extra. Time as subjectivity, however, with the point of origin in the "now" is not a succession of nows. One lives through the past, not as the original now, but as the past as well as the future is currently perceived. The now

– constituted through the intentional arch – contains both the past and the future at once, not in the mode of representations of events in the form of memories and projections but in a more intimate way to the extent that time is "reopened" in the experience of the past. Merleau-Ponty claims that the past is lived not as a representation but as a new now, which contains both the past and the future at once. Intentionality is therefore not a pure now but contains the past as well as anticipates the future.

The originality in Merleau-Ponty's time and intentionality analyses appears to be the way he encloses time, intentionality and subjectivity together, not to a mind or to a mind that constitutes these essential aspect, but to a body subject that lives, or is, time and intentionality, and which also serves as a structuring principle for all other aspects of subjectivity. They are therefore also parts of the pre-reflective experience that is sensing.

Sensing
Merleau-Ponty argues against the empiricist claim that sensation is "a unit of experience"; that sensation is a sense impression, or sense imprint, with a direct one-to-one relationship between the object and the sensation of it. The more overarching process of perception is not a unified experience created through units of meaningless sensations which become meaningful only as a whole. Sensing is processes of perception which reveal various aspects of the object according to the sense in question, and is "nutritional channels for meaning" (Køppe 2008, p. 145). There is also no such thing as "pure perception" as perception is always contextual (e.g., it takes place in a foreground/background configuration), without which perception would be undifferentiated. It takes place in a "phenomenal field." Sensing is not a function of external qualities of objects which are clearly and precisely delimited either. When sensing is diffuse or confused, it can be a function of the objects or the world; it is just as possible that it is a function of their "objective" being as it is because of our "subjective" experience of them.

Merleau-Ponty thus takes a stance against an empiricist approach where sensing is seen as a consequence of objective stimuli being processed by the brain; where sensing is forgotten as the precondition for knowledge. Instead it is intimately linked to a dynamic subjectivity that is not only a passive but also an active agent. (His time analysis shows how experience of time contains active and passive dimensions whereby both activity and passivity are at the core of subjectivity.) The experience of color, for instance, has an active existential significance in that it comprises a bodily attitude taking place before explicit consciousness. As such, perception always carries meaning since it is linked to objects and is the most primary way in which we come to know the world. Along

this line, there is no isolated, passive perception: "normal functioning must be understood as a process of integration in which the text of the external world is not so much copied as composed" (Merleau-Ponty 1945a, p. 10). Perception indicates a "direction rather than primitive function" (ibid., p. 13). It is an active, fundamental process of the subject's way of being in the world, already happening. It is not a fact but a lived, subjective experience which has to be discussed against the backdrop that subjectivity is decentered, and at "the core" of it lies a bodily way of being in the world: sensing is not "a state of consciousness" (ibid., p. 242), but a kind of behavior. Perception is motoric in nature (does not only have motoric consequences), comprising a bodily positioning, or "an attitude" (ibid., p. 244). As Merleau-Ponty explains, perception is not of a cogito, or an objective impression of the external world onto a cogito or mind; it is not dependent on the cogito, but upon the whole body-subject in action with the world. In other words, sensing is not something one lives through reflection or a lifeless or passive complex altered by the world. Sensing is the active experiencing of the world which reveals various aspects of it. Seeing and hearing, for instance, provides us with different aspects of the same perceptual field. They are bodily, existential, motoric actions.

Sensing can take over my bodily attitude to the extent that the attitude becomes what I experience. Then perception is closer to pure since the object fills the whole of being. A color, for instance, can comprise the entire field of perception to the extent that subjectivity is subsumed in it. The object "saturates" (ibid., p. 250). When the object saturates the subject it also demands something from it. For instance, if I experience the color blue I must take up the bodily position that flows from the experience of blue: "I must find the attitude which will provide it with the means of becoming determinate, of showing up as blue" (ibid., p. 249). The object, or the phenomenal field, demands specific or particular actions that are formed by our bodily ways of being subjects. At moments the contact can be said to be close to pure as the perceived object fills the structure and form of the subject. The self can be filled by the objects it perceive (it becomes or potentializes the objects, albeit momentarily), as when perceiving the color blue in the work *360° degree room for all colors* (2002), by Olafur Eliasson (exhibited at Tate Modern). It is not an active act of bracketing, but, instead, a passive acceptance of a uniform phenomenal field. At other times, our personal and cultural lens determines how we position our bodies, such as when we look at an ancient Greek sculpture wherein the more immediate sensation of pleasure or disgust, for instance, influences the sculpture appearing as vibrant or muted, as large or small, as pure marble white or as dull grey.

That the objects demand attitudes, or bodily positionings, does not mean that we all react to the same objects the same way or that culture does not have a say in our reactions. Merleau-Ponty argues that:

> I find that in the sensible a certain rhythm of existence is put forward – abduction or adduction – and that, following this hint, and stealing into the form of existence which is thus suggested to me, I am brought into relation with an external being, whether it be in order to open myself to it, or to shut myself off from it. If the qualities radiate around them a certain mode of existence (…) this is because the sentient subject does not posit them as objects, but enters into a sympathetic relation with them, makes them his own and finds in them his momentary law (p. 248)

Sensing is shaped by my history of sensing, where the object or fields of perception are formed both by my history of perceiving and by the objects themselves which demand a particular way of being perceived which cannot be avoided. "Taken exactly as I see it, it [sensing] is a moment of my individual history, and since sensation is a reconstitution, it pre-supposes in me sediments left behind by some previous constitution, so that I am, as a sentient subject, a repository stocked with natural powers at which I am the first to be filled with wonder" (p. 249).

Through these statements, Merleau-Ponty explains the acts that so far have appeared contradictory. Sensing is colored by processes of sedimentation, that is, of our previous, personal sense history. At the same time, I am a subject "stocked with natural powers," i.e., of a biology and a natural world, too. Thus, although perception is personal or socialized it is also general and anonymous. Perception begins as we are thrown into the world and it is also beyond our own knowing. It is the basis of our personhood, but also peripheral to it. Our perceptions happen to us although they are also of our choosing, yet always of the world that I do not fully possess. As such, sensation and perception are processes that are "primordial," before and beyond us, therefore general, anonymous, and pre-personal. As Merleau-Ponty describes, I cannot choose to perceive in the same way as I can choose my profession; I cannot reflect upon sensing at the same time as I experience it without losing the full extent of my perception. It is something one lives rather than reflects, decentered in regard to the conscious self, as it occurs through the phenomenal field – the world with the breadth of its potential horizons and perspectives. It does not consist of qualities, but of meaning, which is affective, instinctive and motoric in nature. Through sensing, the world is given to us. The body, however, is not a closed entity, but partially constituted through the phenomenal field and in this sense the contact is direct, pre-reflective, and pre-personal, yet personal, too. Merleau-Ponty's

phenomenology allows for, or even celebrates, the ambiguity of experience and he shows how pre-reflective experience is hazy in its characteristics, containing features of alterity at the same time as it is the most immediate of experiences. It takes place in the indefinite realm of existence that oscillates between the specific and the general, the personal and the pre-personal, the cultural and the biological, too.

Pre-reflection and representation
One feature not yet discussed which also aids the description of pre-reflective experience is representations. Merleau-Ponty does not explicate what he means by representations, but in various places he rejects that representations are mediating features between the world and the subject. Johnson (2008) explains what can be meant by representations, and through his interpretation it becomes clear why Merleau-Ponty would have a less than favorable relation to theories of representation. Johnson argues that in theories of representation the ontology is almost always one where an objective, external world is translated into mental symbols. Ideas, concepts, and images represent the external world in mental computations which are ontologically separated from the body. There is an external world, of which the mind creates mirror, internal images. To Merleau-Ponty such theories would be invalid as they focus upon the mind instead of the body as the core of meaning-making, ignoring the body as the locus of experience. They ignore bodily, pre-reflective experience that not only arises with, but also constitutes the world.

Shusterman (2005) suggests, in line with theories of representations of "the mind," that pre-reflective experience is void of representations while reflective experience contains representations. He distinguishes between at least four levels of perception according to the degree of consciousness and representation involved. The most basic level is perception as "corporeal intentionality" (p. 157) where perception is not explicit to the subject. The level above it is "conscious perception without explicit awareness" (p. 157), where what we perceive is not at the center of attention. At the third level we are "consciously and explicitly aware of what we perceive" (p.158), and the fourth comprises reflection of perception wherein the subject reflects upon its own perceptions. The first two levels, Shusterman claims, constitute primary consciousness (as described by Merleau-Ponty), and at the third level representations are introduced. Thus, representations are linked to the mind in reflection.

Johnson, however, argues against linking representations to reflection – or against a strong theory of representations. A reason for doing so is that he sees theories of representations to contain a mind/body dualism. In opposition to such duality he argues for a naturalistic account where there are no representations of

the world in the mind. Instead, the mind is formed by the world through the organism in action, and the world is directly present in the mind. There are no internal representations, as the external takes part in the constitution of the internal; the mind follows from the body's action in the world, whereby the mind is a continuation of the world and the body and not a separate ontological entity.

At the same time, Johnson proposes a few instances in which it is legitimate to talk about representations. On the most basic level, neurons fire according to external stimuli. This neuronal activity can be called neuronal representation (of the world). Conceptual structures, when seen not as of a body-less mind but of experiential original, can be regarded as representations, too. So can "external symbols of interactions": words, language, signs, and symbols can be said to be representations of aspects of the world. Verbs, for instance, can refer to concrete actions just as the word "picture" can stand for actual pictures; paintings can represent specific events and specific persons. Finally, theoretical models can also be said to be representations. A model of subjectivity can be said to represent features of lived subjectivity; a model of aesthetic experience, if convincing, can be said to represent actual aesthetic experience. In other words, the word "representations" can be legitimately used as long as it does not refer to a body/mind or mind/world dualism. (In this model, pre-reflective experience is void of representations.)

It is likely that Merleau-Ponty rejects representations in pre-reflection (or altogether) on the basis that is seems to refer to a mind/body and a mind/world dualism as well as because he is committed to the phenomenological tenet that experience of the world is direct. But as language, for instance, is a feature of the phenomenological world, then, as Johnson claims, it is indeed legitimate to talk about representations. Language has both pre-reflective and reflective features (with this Merleau-Ponty would agree), and the rejection of representation in pre-reflection seems therefore more like a postulation than a thorough argumentation.

Pre-reflection and materiality
How far into biology or materiality can socialization or individuation penetrate? This question also links directly to the psychophysical problem, and the nature of downward causality which has been greatly discussed by philosophers. One psychologist, however, who gives a psychologically plausible explanation, is Køppe (2000). As he writes, the psyche cannot penetrate biology. There cannot be direct downward causality, which, if it existed, would lead to an infinite regression where the psyche would be able to penetrate all biology to the smallest of constituent parts, i.e. it would directly affect changes on cellular and atomic levels. Scientifically, direct downward causality is a very unlikely

explanation. Instead, the psychic influences the physical, or the material body, by being its "constraining conditions" (2000, p. 96). It sets the stage for the direction the bodily materiality will take in all of its potentialities. The psychic, with its biography and historicity, influences which possibility or what material solution is to be realized in a specific situation. Materiality or biology, then, is one the definitive borders of pre-reflective experience, being a condition for it, but not a feature of it.

Positive characteristics of pre-reflection:
Although negatively defined, it is possible to delineate specific characteristics of pre-reflective experience. Reaching back to Gumbricht's description of presence, his characteristics can be used to delineate pre-reflection as discussed through a reading of Merleau-Ponty. This is not, of course, a complete portrayal, but a partial description of the phenomenon, and, as lists go, rather square.

- Pre-reflection refers to our bodily way of being in the world. At the same time it does not refer to the material body – materiality is one of the limits of pre-reflection, just as explicit reflection, per definition, is.
- Pre-reflective experience is – through processes of sensing – direct, more direct than reflection. In another way, though, all experience is direct as what we experience is the world; it is absurd to ask about the world independent of experience and, therefore, whether or not experience is direct. The world constitutes experience and vice versa.
- Pre-reflective experience might have some points of contact where we experience the world immediately, without representations. Interpreting Merleau-Ponty's stance, these would minimally include intentionality as well as time and space-consciousness. It would also include situations wherein the phenomenal field is so overwhelming that subjectivity is subsumed to it. These forms of consciousness are not likely to occur alone, however.
- Pre-reflective experience is characterized by pulsations, rhythms, and periodicity of progression and recession, plunges and withdrawal of subjectivity in sedimentation of habit versus spontaneity, in pleasure against displeasure.
- There are varying degrees of representation dependent on the experiential level in question. Experiences that are without representation are less influenced by interpretation than those with.

Maybe the most primary of pre-reflective experiences is an experiential mode or an experience that is there but that we cannot access any longer. It is probably the case that we develop, ontogenetically speaking, from more of presence experience to experiences where interpretation takes over more and more of the experiential field the more culturally engrained we are.

Aspects of Affect, Feeling, and Emotion

Hegel (1886, p. 15) claims that in art, "mind has to do but with its own." He sees a hierarchy of sensing from the "mere apprehension of the external things" to internalization, then, externalization of them. Having gone through this process of sensing, the things become objects of desire, as one can perceive oneself in them. Desire, which is affection, becomes a basic, orientating principle of the mind. To Merleau-Ponty, affect is not of the mind, but an orienting principle of the whole body-subject, and while the previous section dealt with pre-reflection in the body subject, this section deals with the body subject in feelings, affects and emotions.[4]

To separate affectivity, emotionality, and feeling from pre-reflection is a theoretical act, not completely faithful to lived experience where they exist intertwined. It is an artificial separation –inherent to concepts – as concepts are always too simple for the intricate reality they describe, yet it lends some theoretical benefits in terms of conceptual clarification. Also, feelings are, per definition, felt, and, therefore, aspects of conscious experience. At the same time, affects are pre-reflective, too, as described by Merleau-Ponty and Michel Henry (1985). This is an essential part of Merleau-Ponty's theory of perception (which is largely pre-reflective). Perception cannot be divorced from affectivity, and, as Merleau-Ponty (1945a) says, perception is of meaningful affection. It is surprising, then, that Merleau-Ponty does not tackle the topic of affect, feeling and emotion directly in Phenomenology of Perception; he does not directly discuss emotions as its own topic as he does with perception, spatiality, sexuality, and so on, though there are scattered musings found throughout. A reason why Merleau-Ponty ignores emotion as a topic which demands attention might be because emotion theories, since their modern psychological beginnings with Charles Darwin (1872) and William James (1884), have been thoroughly regarded as bodily. These modern, bodily oriented theories of emotion, however, take their points of origin not in the existential body-subject of Merleau-Ponty,

[4] In Merleau-Ponty's original French (1945b) version, *Phénoménologie de la perception*, the use of the terms "feeling," "affection," and "emotion" (sentiment, affection, émotion) is pretty consistent with their use in the English translation.

but in the physiological reactions of the body. And it is precisely such theories which Merleau-Ponty argues against, the kind of theories where affect is seen as discrete categories that can only be explained physiologically (empiricist theories). He also disputes intellectualist theories which claim that affects are intelligent in the sense that basic feelings of pleasure and pain have been conditioned to events no longer of the natural world; he argues against those theories where affective intentionality melds with the object and creates a representation, or an internal, affective mental image.

What, then, does Merleau-Ponty believe affectivity, emotions, and feelings to be? Affects, to him, are not more basic than perception, but they hold a special status in the sense that they color all perceptions, and are part of spatiality and sexuality, too (as well as all other modes of being in the world). He does not make an explicit distinction between affects, feelings, and emotions, but, through his use of the words, it can be assumed that all perception is intertwined with feeling or, rather, that all perception is felt, while emotions appear to refer to events having more specific content or specific subject constellations, such as "love," "shame," or "immodesty." Affect appears synonymous with feeling and is given in the most primary of experiences, in the first person givenness of experience, or for ipseity, an absolute beginning or endpoint of selfhood. Merleau-Ponty (1945a) describes it as at the core of subjectivity, as he claims that, "time is the 'affecting of self by self'" (p. 494), and "time which is aware of itself...is the archetype of the relationship of self to self, and it traces out an interiority or ipseity" (p. 495; original emphasis). The affecting of self by self refers to the selfhood of experience: it is I who experience my experiences; there is an experiential center of experience which makes distinction between the world and I possible as well as necessary. It is the experiential center of awareness that is stationary, an awareness that is always affective, that is to say, colored by affective tonality. The world and I are of difference, not identity, at the same time as the world is a part of identity, too, but at a different experiential level. As Merleau-Ponty writes, "subjectivity is not motionless identity with itself; as with time it is of its essence, in order to be genuine subjectivity, to open itself to an Other and to go forth from itself." (p. 487). Affectivity is a part of both the self's identity with itself as well as the self's openness which, through difference and identity, is desire. Henry's (1985) analyses of auto-affection, or self- affection, supplement Merleau-Ponty's explanation. Henry describes self-affection as the primary form of selfhood, the most fundamental and immediate aspect of subjectivity, where the subject completely coincides with itself. There is no alterity present. It is a non-intentional, passive aspect of subjectivity; it is the centered – not decentered – aspect of subjectivity where the subject feels (as it feels it is, by and large, aware of its feelings). In line with Merleau-Ponty, it

comprises the first-person givenness of experience, and the experience is that of affection. It is an inherent and general aspect of subjectivity, a structural aspect which is "pure interiority," not a Kantian or early Husserlian principle of a transcendental ego, but a lived experiential feature. It is absolute identity without "motion," an aspect of subjectivity which is self-enclosed. Otherwise subjectivity comprises openness through its directedness toward the world.

Venturing into the affects constituted through the world, Merleau-Ponty describes affect as a distinct kind of consciousness. In this claim there is probably some conceptual confusion, as it would be more consistent with his theory if he saw emotion as distinct, as he sees affects as feelings which are parts of all experience – there is no experience void of feeling intonations.

Turning to emotions, the most direct discussion of emotion by Merleau-Ponty can be found in the chapter of Phenomenology of Perception entitled The body in its sexual being. Here, the most prominent example of an emotion is the experience of love. To Merleau-Ponty, love appears in various ways: as true, false, and misrepresented. The differences in the ways these different forms of love appear, however, is at first not that easily distinguishable. They are not easily discernible because they refer to varying degrees of reality within us while their external presentation remains similar. In the case of "false love," one acts according to expectations, submitting to the context, so to speak, without making sure that it is I who "loves," but, instead, just passively going with the flow of expectations, but actually knowing, when pressed, that the love was based upon false pretences. In converse, to love is to "believe that my life is committed to that feeling ... a form which, like a melody, to be carried on" (p. 440). In misinterpreted love, I fully believe for a while that I actually love, yet it can be revealed in retrospect that the "love" was but an appreciation of a certain facade of "qualities" to which I was devoted, like a smile which reminded me of something to I once was attached. From this description of emotions, they are judged true or false when understood in relation to the situation in which they are experienced. One can only know one's true feelings in retrospect. "[I]llusion is possible," and ambiguity remains.[5]

This distinction between "true" and "false" emotions is similar to Sartre's description of "genuine" and "false" emotions, and it is evident throughout Phenomenology of Perception that Merleau-Ponty is inspired by Sartre's (1943) conceptions of emotions. And like Sartre, Merleau-Ponty also distinguishes

[5] Merleau-Ponty's (1945a) description of emotions becomes contradictory as he also says that "a feeling, considered in itself, is always true once it is felt" (p. 439), and it is impossible to have a feeling without feeling it.

between authentic and inauthentic feelings, and calls emotions magical. Merleau-Ponty argues that both authentic and inauthentic feelings are acutely felt, but the former more than the latter. In authentic feelings the whole being of the person is involved. In inauthentic feelings it is not, it is more of a feeling caused by some other influence than it being something taken up by the self. This reliance on Sartre's view of emotion is a bizarre feature of Merleau-Ponty's descriptions of them, as he otherwise argues explicitly and implicitly, throughout Phenomenology of Perception, against Sartre's phenomenology and theory of subjectivity. Naming emotions authentic or inauthentic has moral connotations (not that psychology should necessarily exist beyond morality), and when looking at the descriptions of the concepts, they are not in opposition to one another. The use of the terms involves a strange kind of opposition between the self and the environment. It cannot be inauthentic to be influenced by the environment or the world as the world partially constitutes the I. The descriptions are rather different degrees or versions of emotionality, the first all-encompassing and the latter less significant.

Another curious aspect of Merleau-Ponty's theory of affect lies in his description of emotion being somewhat arbitrary in nature. He claims "it is no more natural…to shout in anger or to kiss in love than to call table 'a table.' Feelings and passional conduct are invented like words" (p. 220). In the mildest interpretation of this statement, it could be that Merleau-Ponty means that the body allows for a multitude of emotional expressions. Such interpretation would be consistent with his theory. The more likely, but also more severe, interpretation, however, is that emotions are randomly assigned within a given culture, and this claim goes against Merleau-Ponty's description of the body taking part in structuring our being in the world. It seems unlikely that anger, in the heat of the moment, could actualize a soft and gentle kiss. Instead, it is more likely that, normatively, a kiss is not just a kiss, but the body moving closer to another body in desire for intimacy (which could take place after, or in between, anger but not as anger), and that shouting, for instance, as a sign of anger, momentarily creates the desired distance or put-down of the other.

Moving onto some other aspects of Merleau-Ponty's description of emotions, he also argues that affect and emotion not only orient us toward new situations, but also "sustains" a situation. In his description of the phantom limb, emotion is that which calls out for the lost limb; it sustains the experience which wipes away reality. Emotionality, connected to the limb, takes part in its unrelenting presence:

> [I]f we put back emotion into being in the world, we can understand how it can be the origin of the phantom limb. To feel emotion is to be involved

> in a situation which one is not managing to escape. Rather than admit failure or retrace one's step, the subject, caught in this existential dilemma, breaks in pieces the objective world which stands in his way and seeks symbolic satisfaction in magical acts. The ruin of the objective world, abandonment of true action, flight into a self-contained realm are conditions favouring the illusion of those who have lost a limb in that it too presupposes the erasure of reality. In so far as memory and emotion can call up the phantom limb, this is not comparable to the action of one cogitation which necessitates another cogitato, or that of one condition bringing about its consequences. It is not that an ideal causality here superimposes itself on a physiological one, it is that an existential attitude motivates another and that memory, emotion and phantom limb are equivalents in the context of being in the world (ibid., p. 99).

Emotion is a basic orienting principle, a part of the body-subject which holds onto situations and that creates new ones. Merleau-Ponty, however, touches not only on how emotions are a part of the body-subject in this process, but also upon how emotions themselves are formed, reaching back to Hegel (1807) and his famous master/slave dialectic (the famous section IV in *Phenomenology of Spirit*). The subject, with its emotions, is created in the relation to the Other, driven by desire.

> Shame and immodesty, then, take their place in a dialectic of the self and the other which is that of the master and slave: in so far as I have a body, I may be reduced to the status of an object beneath the gaze of another person, and no longer count as a person for him, or else I may become his master and, in my turn, look at him. But this mastery is self-defeating, since, precisely when my value is recognised through the others desire, he is no longer the person by whom I wished to be recognised, but a being fascinated, deprived of his freedom, and who therefore no longer count in my eyes" (ibid., p. 193).

Although the specific emotions of shame and immodesty are discussed here, emotions, in general, are formed in the same dyadic and dialectic fashion. This description, however, is contradictory to how Hegel in *Introduction to Aesthetics* sees subjectivity as constituted where the Other becomes desirable and not rejected (the dialectical process is not self-defeating, but self-constituting), because the other[6] is a part of the subject already (as explained earlier in this chapter, when things have gone through the process of sensing, internalizing then

[6] The other is therefore not the Other, that is, of radical alterity. Zahavi (2001b) makes this point.

externalizing, they become objects of desire as one can perceive oneself in them). The body is the ontological and experiential point of origin for the emotions which are created when the subject meets the world in a variety of subject constellations and where a variety of different projects are at stake. When the subject meets the other, it projects its own situation onto the other, which the other can respond to, most basically in the form of rejecting or ignoring the projection, or by meeting the projection and containing it. On this basis, the subject continually creates and sediments its emotions in its environment where cause and consequence become inseparable. It is not the mental thoughts that determine this process, but the whole body-subject in the specific situation. Merleau-Ponty has, as such, understood that there is no opposition between emotions and thoughts, but that they are continuations of each other. Hegel, however, claims that art mediates between thought and the sensuous (which is affective). But what kind of function does art have, now, when thought and sensuousness are reconciled –without dialectical opposition– where there is both sensuous thought and thoughts in the sensuous, still retaining their identity as separate phenomena? (see also Roald 2007, 2008b).

Aspects of Reason, Reflection, and Self-understanding

Experiences with art have been regarded, at times, as antithetical to reason and from an extreme rationalist point of view can seem to be absurd frivolities. Yet, since its inauguration as a philosophical discipline, aesthetic experience has also been regarded as a rational endeavour with the possibility of increasing understanding. Baumgarten views aesthetic experience as containing its own rationality, Kant claims that aesthetic experience is of the cognitive faculties, and Hegel claims that through the experience of art one gets to understand the other as well as one's self.

To Hegel, art was the epitome of experience in the classical and medieval eras, increasing self-understanding through its ability to represent the world of immediacy. Differently, in Hegel's own era of reflection, he sees the historical function of art to be more appropriately served by philosophy: Hegel refers to this era as a Reflexionskultur, where the primacy of reflection has the unfortunate consequence of alienation. In such a culture, truth is only acceptable as abstract and detached, demanding an attitude of constant questioning and differentiation, whereby the artist no longer represents the truth of the time, but only the artist's truth. The significance of art is lost to subjective self-expression (Beiser 2005).

Not only in Hegel's time is reflectivity seen as too much. Such a claim is also indirectly posited in Merleau-Ponty's writings and directly explicated in

contemporary times by Anthony Giddens (1991). In Modernity and Self-identity, Giddens seeks to clarify the nature of subjectivity in modernity which he links intimately with doubt and reflectivity. In modernity, he claims, truth and tradition are debatable and open for adjustment, having the consequence of an unstable self, since he views the self as created through reflection. Reflection is what maintains a continuous, yet continuously changing, biography in a plurality of contexts. Incessant reflection is a fundamental part of the subject's way of being in the world and becomes an existential. The self continuously reflects over possibilities and limitations in any given situation; reflection penetrates living. Maintaining the overarching salience of reflection, Giddens regards self-identity as self-consciousness, which to him is a reflective act. It is the reflective act that is turned upon the self. Feelings of self-identity exist in degrees, and a feeling of continuity of the self is linked to reflection (and feelings of security in childhood). The self has to make unremitting, exhaustive choices with a lack of certainty, consequently living in existential purgatory as to whom it is and who it wants to be, questions that demand continuous reflection. Giddens holds Descartes' cogito ergo sum valid for late modernity.

In order to argue his point of view on reflection, Merleau-Ponty takes issue with Descartes and Kant in regard to the nature of the cogito. Reflection (as doubt) was radically introduced through Descartes' cogito as the solution to finding true or absolute knowledge; knowledge beyond doubt, knowledge about the principles for reflection, and knowledge of the principles for the existence of a self. Through his famous use of doubt as method, Descartes (1651) concludes that reflection is of the mind, distinct from the body. Reflection defines the mind (comprising passive perception and will) connected to, yet fully distinct from, the body. It is raised, during the Enlightenment, to the absolute goal or ideal for living, rather influential in the Kantian system.

Kant asks, as does Descartes, whether there can be knowledge independent of sense experience, creating a basis for his metaphysics via his answer that knowledge can be divided into transcendental and empirical. There are transcendental faculties that can make "pure intellectual judgments," that is, judgments independent of sensory input. In relation to the self, there is for Kant an unchanging, n which underlies all experience, a permanent identity; it is not an experiential I, but something arrived at through analysis as a basic principle within his metaphysics. Kant also postulates an empirical I, synonymous with the psychological I, the one affected by experience. It lies beneath "all perceptions and their connection, whose apprehension is the way the subject is affected" (Kant 1791, p. 73), and can be described through observation. For the empirical I, Kant (1790) clearly distinguishes between the intellect on the one hand and the emotions, passions, and affections on the other. The intellect is fully rational and

logical while affections are closely linked to passions and are completely divorced from reason. The absence of affection is a "noble" mental state, and has "pure reason" as its ally (ibid., p. 113).

The Kantian system has been viewed as overly rational and formal; as "pathological rationality," critiqued by numerous philosophers, such as Hegel and Scheler to psychologists such as James and indirectly through Freud. Kant's system is far too rational, precise, and categorical, not accounting for ambiguity, Merleau-Ponty argues, which is one of the main characteristics of how experience occurs. Merleau-Ponty also reacts to Husserl's continuation of a transcendental ego and breaks with this view of reason. Instead, Merleau-Ponty (1945a) shows that "rationality is precisely proportioned to the experiences it discloses. To say that there exists rationality is to say that perspectives blend, perceptions confirm each other, and meaning emerges" (p. xxii). This view of rationality is based on Merleau-Ponty's argument that reflection, reason, and self-understanding are embodied phenomena. As he reflects on the body-subject in the world, he discovers lived experience to be the precondition as well as the limit of reflection (and as such, for the phenomenological project). This is because "radical reflection amounts to a consciousness of its own dependence on an unreflective life which is its initial situation, given once and for all" (ibid, p. xvi), and the fact that "when I begin to reflect my reflection bears upon an unreflective experience" (ibid, p. xi). Reflection is of consciousness and since consciousness is always consciousness of something, and since Merleau-Ponty has shown how perception is constituted through our incarnate being in the world, all reflection must be founded, or conditioned, on this bodily being that is largely pre-reflective. Bodily existence is, paradoxically, the precondition for reflection. The paradox derives from the absoluteness of the claim: through his ontology of the body-subject, Merleau-Ponty discloses how reflection must be temporal, existing in "temporal thickness," revealing temporal truths.

Therefore, against Descartes and Kant, Merleau-Ponty reveals how reflection has perception as its point of origin, which is the body's orientation toward the world. Reflection is, as such, intimately linked with affect as affect is a part of all experience. Thought is "pure feeling of the self" (ibid, p. 470), and reveals the subject to itself: I think, therefore I am, but it is not an independent or sovereign cogito, but one that is constituted through the world: "my reflection cannot be unaware of itself as an event, and so it appears to itself in the light of a truly creative act, of a changed structure of consciousness, and yet it has to recognize, as having priority over its own operations, the world which is given to the subject because the subject is given to himself" (ibid, p. xi). As such, reflection has pre-reflective life as its object and is lived experience, never "pure," but less indistinct and opaque than pre-reflective life. Since it is based upon pre-

reflective life, reflection does not reveal crystallized or clear truths, but imbues life with lucidity. "Reflection is not absolutely transparent for itself, it is always given to itself as an experience...it always springs up without itself knowing whence it springs and offers itself to me as a gift of nature" (ibid, p. 49).

In contrast to historical figures such as Descartes and Kant and contemporary ones such as Giddens, Merleau-Ponty shows how subjectivity is not limited to, or taking place after, a cogito which reflects. Subjectivity comprises first and foremost the affective body-subject in action in the world, an existence which is the foundation of reflection as well as the object of reflection. For Descartes reflection reveals the absolute beginning point for subjectivity, but Merleau-Ponty shows that reflection reveals the limits or end points for understanding subjectivity. There is a pre-reflective layer of experience that principally and continuously is lost to the reflective gaze. Hence, reflection reveals subjectivity beyond reflection. On the one hand, Merleau-Ponty therefore partially agrees with Husserl.[7] For Husserl, reflection works by objectifying, but through this act it loses the temporality and dynamic of subjectivity. As such, reflection reveals the limits of phenomenology, which is lived experience limited to the reflective understanding of it (Zahavi 2001a). On the other hand, Husserl's argument only holds for one kind of reflection and Merleau-Ponty argues for different modes of reflection and understanding: there is a pre-reflective reflection which is a primary functioning of the body-subject. The body-subject is immediately and intimately familiar with itself and its world through its natural and smooth action – a kind of "tacit understanding." Merleau-Ponty writes that "behind the spoken cogito, the one which is converted into discourse and into essential truth, there lays a tacit cogito, *myself experienced by myself*" (ibid, p. 469; original emphasis). Bodily understanding is a primary or immediate grasp that the body-subject has on itself and the world. Merleau-Ponty thereby differentiates between "formal" and "informal" reflection (ibid., p. 448). These are different ways of attaining truth, and as a philosopher, Merleau-Ponty holds formal reflection as a "gift," yet informal reflection, i.e., "tacit understanding," is our primary way of knowing truth. And formal reflection is fuelled by informal reflection:

> [...] the fact that formalization is always retrospective proves that it is never otherwise than apparently complete, and that formal thought feeds on intuitive thoughts. It reveals those unformulated axioms on which reason is said to rest, and seems to bring to reason a certain added rigour and to uncover the very foundations of our certainty; but in reality the place in which certainty arises and in which a truth makes its appearance

[7] Albeit implicitly, as he does not mention Husserl in this context.

is always intuitive thought, even thought, or rather precisely because, the principles are tacitly assumed there (ibid., p. 448).

"Intitutive thought" or "tacit understanding" arises through our bodily experience in the world and assures and secures "formal reflection" and reason of their accuracy as they are based on the pre-reflective facticity. The informal is the prerequisite for the formal. To Merleau-Ponty, formal reflection and reason are modes of subjectivity which understands (also itself). They are not of an atemporal cogito, but of a body-subject in the world. Descartes' priority of the formal cogito is nevertheless not entirely incorrect, as we understand through reflection. But it is an unspoken reflection of the body-subject in the world. As Merleau-Ponty elegantly concludes, "the primary truth is indeed 'I think,' but only provided that we understand thereby "I belong to myself while belonging to the world" (ibid, p. 474).

Through this direct contact with the self and the world rises the most primary, "primordial," or fundamental forms of self-understanding. It is formally understood through philosophical considerations but, most significantly, informally understood through the experience of the self in the world: "At the root of all our experiences and all our reflections, we find, then, a being which immediately recognizes itself…through direct contact with that existence. Self-consciousness is the very being of mind in action. The act whereby I am conscious of something must itself be apprehended at the very moment at which it is carried out, otherwise it would collapse" (ibid, p. 432).

Besides formal and informal reflection, as well as self-consciousness, Merleau-Ponty hones the description of another kind of reflection, namely "hyper-reflection." In his final work, *The Visible and the Invisible* (1964), he argues that hyper-reflection is a process that takes itself as an object, including its effects in the acute mundane. In hyper-reflection the mode in which the world is given is pondered, not in the somewhat strict arrangements and formulae of language, but in the primordial, pre-linguistic (auto-affective) connection with being. Reflection exists as a break from the otherwise lived immediacy through the objectifying act of taking this immediacy, among other, as its object. Hyper-reflection is the act which investigates this reflective act; this break and its preconditions and the interplay between reflection and being; the relationship between existence of the world and the existence of being. It is reflection stretched to its outermost dimensions, to the most fundamental of questions, yet it remains unknown whether there are any answers that can be fixed in these matters of experience. These features, however, are the essential topics of philosophy, he contends (and the essential topics for a philosophy focused upon art). This is one reason why Merleau-Ponty turns to the arts and why his

language becomes less scientific and more poetic in his later works: through the intuitive understanding revealed in the arts, subjectivity beyond reflection can be understood in a pre-reflective way.

3

Methodological Considerations. From Singular Descriptions to General Explanations

Answers to the questions of how and why the subject experiences the aesthetic are traditionally found in a more theoretical realm. Since this book searches for an empirical reply, methodological concerns in such an unusual inquiry need explication. This will take place both through general methodological discussions as well as through a delineation of the methods of the empirical study that follows.

General Concerns in Regard to Method

Internalism versus Externalism
The debate about externalism versus internalism is to a large extent outdated. It was an issue frequently discussed in relation to the history of science in regard to different conceptualizations of the development of science (Køppe 2004), and whether one adheres to internal principles within the paradigm or whether it is specific political and ideological structures which are the driving forces of development. The internalism vs. externalism debate, however, can expose differences between approaches using the first-person vs. third-person perspective, and the reason why this issue is taken up again here is because this book, at first glance, might appear to be supporting strong internalism (or solely the first-person perspective), with its focus on singular descriptions of aesthetic experience and not the social, or more political, dimensions of art experiences. When looking more thoroughly, however, this is not the case. As seen in relation to subjectivity, the individual partially constitutes the social and vice versa; they are dimensions which mutually inform and shape one another without being conflated into one. This book focuses on the individual meeting with art (which is also social and thus not strongly internalistic), yet this does not mean that more externalistic approaches have nothing to add. No single approach is sufficient in itself and never, in principle, tells the whole story. That being said, the phenomenological critiques of the sciences reveal that externalistic approaches

need to take the more internalistic perspective seriously. There are many externalistic or third-person approaches such as neuroaesthetics, which prematurely ignore the internalistic. Their results therefore risk becoming meaningless in relation to such experientially complex situations as aesthetic experiences.

In keeping with Køppe (2004), this book can be seen as espousing "moderate internalism," here meaning that the first-person perspective is ontological. The "infrastructure" (Althusser, 1971) is also an intra-structure. It is primarily egological and not economical, yet acknowledges the fact that such analysis reveals only part of the phenomenon because, as Merleau-Ponty (1945a) elegantly argues: "every cultural phenomenon has, among other, economic significance, and history by its nature never transcends, any more than it is reducible to, economics" (p.200).

If one takes the phenomenological insights seriously, truth takes place in a subject-object relation. If the object reveals truth, it cannot but have an effect on the subject. Depending on how one views causation, the phenomenon's effect is either internal or external, but a consequence nonetheless. The autonomy of art is not complete in the phenomenological world.

The Interview
The interview is introduced in the beginning of the 1900's as an integral part of qualitative research, as sociology and anthropology are becoming established branches in the university setting. Over half a century later, the qualitative interview becomes an independent research method, described in seminal guide books on how to conduct interview research, such as James Spradley's (1979) *The Ethnographic Interview* and Steinar Kvales (1996) *InterViews*. Kvale shows how the interview has derived its theoretical basis from various different traditions, mainly postmodern construction, hermeneutic interpretation, phenomenological description and "dialectics" (with focus on internal contradictions); the qualitative interview arises from a mixture of traditions which do not provide a unified theoretical basis without tension (see Helles and Køppe (2003) for a further discussion). The interview method which Kvale advocates lacks internal consistency, and is instead given as a pragmatic tool for qualitative research which extracts the useful parts from these traditions, focusing on practical instructions and advice. Such interview methods have a relatively long tradition within the American version of phenomenological psychology which was practiced at Duquesne University (the *Journal of Phenomenological Psychology* begins publishing from there in 1970), as being the most common way of gathering empirical material. Kvale's interview techniques become descriptions

Analysis

Based on the quartet of theoretical schools, Kvale describes several different possibilities for analysis of interview material. The methods are again pragmatic, and this pragmatic emphasis conceals the underlying theoretical tension that is revealed when stringently adhering to tradition. For instance, Kvale (1996) links the analytic tool of "meaning condensation" to phenomenology. As he describes it, meaning condensation is a method of analysis that specifically pays attention to the content of what the participant says (pp. 190, 192-193). It is not a method which looks at meaning beyond the factual statements and their actual content – it is about what the participant *means*[1] and actually states, and about how this relates to the overarching research question. It is a condensation of the content of what the participants say and ends, more or less, as a summary of the participants' descriptive statements. In this way, it is probably *the* method for taking the first-person perspective seriously (and is not solely employed within phenomenological psychology), yet is a surface phenomenology rather than a depth phenomenology, if it is a phenomenology at all.

Based on interpretations of phenomenological psychology as singularly descriptive, it has been given short shrift in psychology, criticized for being only common sense or without explanatory potential, for not being analytically savvy and without an analysis proper. It has appeared as comprising a naïve metaphysics of presence.[2] Phenomenological psychology has, accordingly, a reputation for being insignificant. The critique from the left would say it is too neutral and not sufficiently critical or political, while the critique from the right would say that it is not objective enough (see e.g. Habermas 1968). Both positions fail to see the way in which phenomenology and phenomenological psychology on the one hand (potentially) investigates the constitution of subjectivity which – in a comprehensive description – cannot avoid the political dimension, and, on the other hand, how it investigates the constitution of objectivity (see e.g. Merleau-Ponty 1945a, pp. 403-425).

[1] Meaning in phenomenology is a multifarious term, its content dependent on the phenomenology in question, but it hardly relates to the content of the participant's statements alone.

[2] It can, however, be a useful way to obtain an overview of the interviews and for voicing the importance of the lived experience, the first-person perspective and the life-world. It can also provide a solid basis for further analysis, holding the continuing analyses in abeyance through reference to the participants' descriptions.

Kvale (1997) bases his brief description of meaning condensation on Amadeo Giorgi's (1975) text *An Application of Phenomenological Method in Psychology*, but he both misinterprets and fails to include the full scope of Giorgi's method. It is clear that the meaning condensation (as named and described by Kvale) is only partially linked to the phenomenological project. Giorgi describes phenomenology as "the study of the structure, and the variations of structure of the consciousness to which any thing, event or person appears. It is interested in elucidating both that which appears and the manner in which it appears, as well as the overall structure that relates the "that which" with its mode or manner" (ibid., p.83). Giorgi's description is related to Husserl's intentions for phenomenology and his "*noema*" and "*noesis*" (the what and how of appearing, respectively). For phenomenological psychology, the task is not to arrive at summaries of the participant's statements in relation to the research questions, but to investigate experience in its complexity, that is, underlying structures as carriers of meaning related to the participant's description of experience, without a complete divorce between form and content, but where the one informs the other.[3] Giorgi does not call his method of analysis "meaning condensation," and his analysis is a continuous mediation between the participants' descriptions and their implicit experiential structures. He arrives at descriptions both at a specific as well as a more decontextualised, general level, claiming that the significance of these descriptions arise with the researcher's continuous elaboration and interpretation (also maintaining that descriptions cannot exist without interpretation, as he holds that the epoché, or complete exclusion of pre-predicative understanding, is impossible). Meaning condensation is not in itself a method commonly recognized within phenomenological psychology as Kvale claims, but is similar to what is named descriptive phenomenological analysis (Langdridge [2007], for instance, describes descriptive phenomenological analysis). Meaning condensation and descriptive phenomenological psychology differ, however, as Langdridge claims that one should "assess for psychological relevance" (pp. 92-106), which Kvale does not include in the process of analysis when using meaning condensation. As unspecific as "assessing for psychological significance" is, it nevertheless opens up for a deeper psychological investigation, and this is exactly what Giorgi (1975) emphasizes in his description of the method. When Giorgi describes the phenomenological method in psychology, the method should take into consideration the psychology of both the ideographic level of the specific cases and the more general level of essences. It is, accordingly,

[3] Conversely, meaning condensation operates with an artificial dichotomy between form and content, and gives priority to the actual content of the participant's statements, not the experiential form.

important that the method focuses not only on content but also on form; in the individual analyses, the situational details and the experiential structures are included, not only the content of the participants' statement. And it is also noteworthy that these processes cannot take place without psychological interpretation. As Giorgi claims, "precisely because lived meanings are not always known explicitly but must be discovered and thematized, interpretive procedures have to be used" (ibid., p. 100). Thus, Giorgi claims that the immediate context is important, and should be accounted for in the descriptions of the singular cases. He also adds investigation of underlying or hidden psychological meaning in the analysis. In this way, he avoids the naïve metaphysics of presence which plagues meaning condensation which Kvale sees as *the* method of analysis for phenomenological psychology.

However, it is still not so clear how to "assess for psychological relevance" and how to access the experiential form and content. A detailed description of the process is provided by Funch (2003). In keeping with the phenomenological tradition, he claims that in order to investigate the way in which the phenomenon appears, one has to investigate consciousness as it grasps the object. To investigate consciousness involves analyzing its various aspects as fully as possible; aspects of sensing, imagination, emotion, thought, and intentionality, all including bodily aspects of these experiences. It involves identifying these features in the material, giving a description of their structural appearance as well as of the relative relation between these features in specific subject-constellations as relates to particular phenomena. Therefore, to "access psychological significance" can mean to access such experiential structures, including relations between form and content, and to relate these to psychological topics such as subjectivity, intersubjectivity, selfhood, and self-reflection. Each of the participant's relevant experiences are described as relates to these structures of subjectivity, from which more general characteristics of the experiences can be extracted.

In order to arrive at psychological significance which extends beyond the already existing knowledge or presuppositions openness in the meeting with the other is essential. Openness is a necessary ingredient to allow new knowledge to penetrate. This openness in the meeting with the other – it being a text or an interview – is foundational to phenomenological psychology. It is essential to maintain in the literature analysis, as well as when gathering the empirical material and in the more formal process of analysis, wherein the final descriptions of experience are contextualized and discussed together with the theory that informs them. At the same time, the theory should not narrowly solidify the already extant concepts, but allow new concepts to arise in the continuous development of the empirical and the theoretical.

Description, explanation, and interpretation
When phenomenological psychological analysis has been erroneously called descriptive phenomenological analysis, it is because the analyses have ended up with descriptions of phenomena rather than explanations as to how these phenomena are construed. In such instances, the descriptions of the lifeworld are seen as sufficient in themselves. There is no deeper explanation found. Viewed this way, phenomenological psychology appears as naïve and unsophisticated, and as ignoring the constitution of the phenomena and the world. Such a description of phenomenology stands in sharp contrast to the phenomenological projects, which include investigations into basic constituents of experience, such as intentionality, time, and space. It is not the case that phenomenology does not explain, but rather that explanations are found through descriptions.

The assumption, however, that phenomenology and phenomenological psychology are descriptive is hardly surprising as Husserl repeatedly names it the core feature of phenomenology. It starts in his early works (Logical Investigations 1900, § 7, p. 89),[4] continues both in his middle work (Phenomenology. Edmund Husserl's Article for the Encyclopaedia Britannica, 1927) and through to his latest (The Crisis of European Sciences and Transcendental Phenomenology, 1937 §69, pp.235-241). For instance, in his famous article in the Encyclopaedia Britannica (1927) he states that, "the term 'phenomenology' designates two things: a new kind of descriptive method which made a breakthrough in philosophy at the turn of the century, and an a priori science derived from it; a science which is intended to supply the basic instrument (Organon) for a rigorous scientific philosophy and, its consequent application, to make possible a methodical reform of all the sciences" (p. 78; original emphasis). Description is the main tool: the tool that should do nothing less than revolutionize both philosophy and the sciences, and with it psychology. Husserl goes on to argue that with description, with phenomenological psychology, there "came into being a new psychological discipline parallel to it [phenomenological philosophy] in method and content: the a priori or pure "phenomenological" psychology, which raises the reformational claim to being the basic methodological foundation on which alone a scientifically rigorous empirical psychology can be established" (ibid. p. 78).

[4] "Psychology's task – descriptively – is to study the ego-experiences (or conscious content) in their essential species and forms of combination, in order to explore – genetically – their origin and perishing, and the causal patterns and laws of their formation and transformation. For psychology, conscious contents are contents of an ego, and so its task is to explore the real essence of the ego (no mystical thing-in-itself but one only to be demonstrated empirically), to explore the interweaving of psychic elements in the ego, and their subsequent development and degeneration."

Description is primary to Husserl, and the description should be of "eidos," (ibid. p. 80) or the essential forms. It includes the essential forms of consciousness and intentionality in all its variations, with the goal of reaching the "universal description of intentional experience" (ibid., p. 78). For psychology, the overarching, all-encompassing task is to describe intentionalities, their structure and form and dynamic transformation from one to another, including the general rules for transformation, thereby arriving at knowledge of all mental life. To Husserl, the description contains two essential features, the "noetic" and the "noematic" (ibid., p. 80), that is, a description of the appearing object and as well as the way in which it appears.

To Husserl, description is of outmost importance to psychology. It is "absolutely necessary as the foundation for the building up of an "exact" empirical psychology." It can provide a new basis for academic psychology which historically has been physical in its scientific disguise (Husserl 1927). In his continuation of the discussion of the function of a psychological description, he realizes, however, that these descriptions will lead to the problem of origin or the "problems of genesis" for which a "dynamic or genetic phenomenology" will be the solution; a phenomenology that also explains (Husserl 1927, p. 81). It is in line with his earlier works (Ideas pertaining to a pure phenomenology and to a phenomenological philosophy, 1913) which take part in the "transcendental turn," where he introduces a transcendental phenomenology in a turn away from descriptive phenomenology (Zahavi 2001).

Although the genesis which Husserl attempts to describe and explain is epistemological and ontological, rather than ontogenetical and psychological, the point here is that the tasks Husserl sets are not singularly descriptive. In his analyses of the I, the life-world, and his time analyses, the layer of description serve as the prerequisite for accurate explanations. Along this line he claims that, "for instance, the phenomenology of perception of bodies will not be (simply) a report on the factually occurring perceptions or those to be expected; rather it will be the presentation of invariant structural systems without which perception of a body and a synthetically concordant multiplicity of perceptions of one and the same body as such would be unthinkable" (Husserl 1927, p. 81). Also in his last work, The Crisis of European Sciences and Transcendental Phenomenology (1937), he maintains the insufficiencies of description, but hold them as primary, before "inferences," or theoretical building, can take place: "Here we construe the concept of a descriptive psychology just as broadly as that of the other descriptive sciences, which after all are not bound to the mere data of direct intuition but make their inferences to those things which cannot be made present as actually existing through any actually experiencing intuitions but which must be representable through analogous variations of intuition" (p. 239). Descriptive

psychology should take precedence for psychology as a science, but description is taken to be more broadly conceived, as the psychologist makes inferences based on description.

Beyond description
As should be clear, Husserl sees psychological theory in the first instance to be descriptive, but also that description is the first phase of phenomenological psychological theory, and through description, the constitution of phenomena will appear. Phenomenological psychology needs to engage in descriptions – to rise to the level of explanation – of the things themselves. That phenomenology is not only descriptive but also explanatory, however, does not mean that it offers causal explanations in the manner of a natural scientific psychology with stringent, numerical patterns of cause and consequence, but, instead, rigorously describes and explains lived experience in its partial, yet inherent, ambiguity and unavailability. Merleau-Ponty, for instance, describes and explains various features of the body-subject in the world. He describes meaning of lived, bodily experiences through a meticulous analysis of underlying experiential structures. He has never, to my knowledge, offered an explicit and concrete method for phenomenological psychology nor given priority to the actual content of people's statements, but continuously gives descriptions that engage factual experiences with interpretations, never relying on the first-person perspective alone.

Thus, description should lead to explanations, and descriptions and explanations do not occur without interpretation. As discussed in Chapter Two, interpretation is a part of the most basic of experiences (sensing), whereby also higher-order functions such as descriptions and explanations are interpretations. There are varying degrees of interpretation, however, in pre-reflective experience as well as in reflective experience. Experience and interpretation take place in a "phenomenal field" where the context influences the interpretation. Personal history also influences interpretation, as when the socialization of habits or language determines the way phenomena appear (for example, when reading a text in a language one knows, the text is immediately available [and unavoidable] as having content). More explicit, reflective interpretation, as can take place when reading a text, is also historically given, in a context we cannot fully separate or transcend (as described by Gadamer 1960).

Interpretation is greatly discussed within phenomenology, starting with the rejection of the epoché and the controversial "hermeneutic turn," caused by the works of Heidegger, Gadamer and Ricoeur, among others, as well as by an awareness of seminal works from other traditions, significantly those by Freud, Marx and Nietzsche. Standing on the shoulders of these works, Ricoeur devises

two sets of moves, the "hermeneutics of empathy" and the "hermeneutics of suspicion," as part of the hermeneutic circle in the act of interpretation. Langdridge (2007) has appropriated these features of Ricoeur's philosophy into phenomenological psychology wherein any description should ideally be subjected to an empathic, trusting understanding to minimize the interpersonal, cultural and historical alterity, as well as one wherein more hidden structures of power and ideology are sought out. The hermeneutics of empathy and suspicion has, most likely, been present in the phenomenological tradition since its beginning, but less directly explicated. These acts are decisively present in Merleau-Ponty's (1945a) Phenomenology of Perception as he emphatically attempts to understand the body-subject in the world, but it is by no means an uncritical investigation.

Description and Interpretation in Template analysis
One way of structuring the understanding of the empirical material can occur through template analysis. It was officially named by Nigel King who has developed a web-site to maintain an ongoing discussion about the method.[5] It is a top-down method, a kind of analytic induction, where a template for analysis is made prior to even the transcription taking place wherein the central themes for analysis are described and interpreted. King calls these themes a priori themes. Adjusting King's claim, these themes are only a priori in so far as they are derived from the theoretical work, before the particular empirical work is involved, and not a priori in any philosophical sense. And that the themes are selected before entering into the empirical does not mean that it is a definite list of themes that involves a pure hypothetical-deductive method. Instead, it is a template of topics of interest that is continually developed in the meeting with the data material. Parts of the analysis in this project take the form of a template analysis, as the central themes were developed prior to the interviews, but these were also continually developed as the transcription, theoretical work, meaning condensation, and phenomenological psychology analyses were taking place. Template analysis contains room for the empirical to influence the categories of the theoretical (which only in theory are completely divorced phenomena), and here the empirical was used not only to illuminate but also to develop, widen, nuance, challenge, and confirm the theoretical.

Issues of Generality
Generalization is closely connected to the scientific legitimacy of qualitative methods. The methods are based on relatively few cases of the investigated

[5] http://www.hud.ac.uk/hhs/research/template_analysis/ (consulted 26.01.2008).

phenomenon, and have (erroneously) been afforded no, or only a low, potential for claiming validity at a more general level. The methods have often been criticized for producing results which are too subjective and specific, lacking the commonly recognized potential for generalizing present in the natural sciences. However, against this claim of reaching completely objective, universal knowledge stand the humanities and social sciences which, via their questions and concerns, radically manifest issues which the natural sciences are unable to deal with, namely those of the human being in a social world with its plurality of signs and meanings; a world, or worlds, not describable in such an objective fashion (see Faye 2000; Habermas 1968). Nevertheless, as Helles & Køppe (2003) and Kennedy (1979) note, if research findings do not extend beyond their own immediacy or particularity toward some general concerns then the theoretical as well as practical applicability will be rather limited and restricted. Thus, if the humanities and social sciences are involved in "pure" idiographic research, then they are in dire straits, both in terms of scientific legitimacy and utility. Along this line, the issue of generality in qualitative methods is at the core of its status as scientifically legitimate.

An important description of the legitimacy of the humanities that sets such scientific questions aside has been given by Gadamer (1960) who, in his magnum opus, *Truth and Method*, faults the humanities for having accepted methods derived from an image of the natural sciences. Through his analysis he shows that the humanities attain their legitimacy or worth neither through their use of method nor through arriving at descriptions of general concern. Their legitimacy is granted through their immediate involvement with historical questions; through their involvement with cultural inheritance and existence replete with human expression; through communicating with and partaking in truths historically posed in the form of questions.

Gadamer's concern is not with the humanities' scientific legitimacy, but only with its legitimacy as a topic of investigation, and not necessarily of scientific investigation. Science, defined here as expansive methodological stringency,[6] is no truth finder. Method, he claims "is precisely not truth. It in no way exhausts it" (2001, p. 55). Gadamer does not mean that methodological sturdiness cannot lead to truth, but only that it is an incomplete truth. Truth is here not a static

6 According to Collin and Køppe (2003), "Science is viewed as a process characterized by a higher degree of methodological awareness and discipline than everyday knowledge or know-how. It contains a search for inter-subjective results, i.e. when tested by others the same results are reached" (p. 34; my translation). The results here are conceptual, based on theoretical and empirical studies, which mean that although the interviews to a great extent are colored by the particular interviewer and interviewees, the concepts developed should be intersubjectively available for evaluation.

entity or form that can be objectively discovered. Instead, the intertwined, reciprocally given, subject-object relations are recognized as partially constituting truth, allowing for a creative search for meaning which is something not fully motionless or stationary, but wherein new meaning can arise.

How can new meaning arise which is both general and scientific? Although Gadamer's argument for the legitimacy of the humanities is excellent, the humanities also derive their worth through the use of method. Heidegger, Merleau-Ponty, and Gadamer, however, have shown that it is impossible to investigate a phenomenon without any preconceptions or prejudices, thereby discarding a fundamental assumption of the inductive method, namely that a phenomenon can be investigated without bias or theory. Conversely, if inductive research appears impossible in its pure, theoretical form, then hypothetic-deductive research appears rather uninteresting in its inflexible structure. Such research is practically possible, but leads to knowledge that, in principle, is fully singular and atomized, and therefore needs an interpretative framework in order to have any theoretical or practical validity (Helles and Køppe 2003). In practice, then, it seems more likely that new meaning does not arise within a static, polarized and overarching methodological system. Rather, it arises within the dynamic potential that exists between these theoretical dichotomies of method (inductive and hypothetic-deductive), where hypotheses are created and continually developed in the intertwined process of theory-building and data-collection, wherefrom results can be obtained which are of potential general applicability.

With new meaning, generalizing is possible by various means and in various fashions, sometimes more explicit than others. At the core of the issue of generalization lies the fact that there is always universality in the particular. A stringent separation between the singular and the general, between the ideographic and the nomothetic is not valid; no analysis can take place without generalized knowledge, present in language, materiality, historicity, subjectivity etc. (Collin and Køppe 2003). All theory comprises generalizations, as theories are general statements about a specific area or topic; all researchers are a part of an historical situation where they on the one hand use hypotheses they are not aware of, and, on the other hand, use a system of suppositions and hypotheses which are undifferentiated in the empirical collection and analysis. Also, in every empirical connection there is a world comprising particular entities whose regularity and relative degree of generalization is related to its degree of simplicity. In other words, the generality of theories, both in the natural sciences as well as in the social sciences and the humanities, is based on observing cases that are of differing degrees of complexity, and the more complex the object is the more intricate the generalizations are, too.

A main critique of qualitative methods has been that criteria for further use of research findings beyond a particular, complex phenomenon are obscured by a lack of methods for making available findings which have applicability for a wider population or for other cases of similar concern. Holding such critique in abeyance, methodological ways have been developed to unfold the process of arriving at general knowledge based on few cases. Wertz (1983), for instance, describes a series of steps for research into the lifeworld in the tradition of phenomenological psychology and provides a method for arriving at nomothetic knowledge through a methodological step-by-step explication, illuminated by concrete examples. Going from the individual to the general has the benefit of making certain general features visible, but also involves a reduction of data by largely ignoring the complexities of singular accounts, which involves a continuous amount of description, *ad infinitum* (ibid.).

Wertz explicates four useful methodological steps in going from the individual account to the more general account. The whole procedure "involves understanding diverse individual cases as instances of something more general and articulating that generality of which they are particular instances" (pp. 188-189). He names the first step *Seeing general features of individual structures*, which has as an underlying principle that the individual account is hardly individual, but partly shared and, thus, in principle, sharable among other individuals, too; not necessarily all, but at least some. The first step appears as a common sense step of critical, yet open, reflection on the way that the researcher evaluates the various features or structures of the phenomenal descriptions of the various accounts and their potential for generality; both for local generality, or a local context, and more universal generality, or a global context. This is done through a likely versus not likely judgment based on the individual accounts. Some will be "naturally" apparent as general, others not.

The second step is called *Comparisons of Individuals* and involves sedimenting the previous judgments in the data material. Thus the preliminary evaluations from the first step are sought to be confirmed or rejected in the data material across the various, obtained accounts. Similarities and differences are identified and critically evaluated and contextualized. The idiosyncratic features, those features or structures not explicitly present across cases, are evaluated for their potential for being present in them. Accordingly, this second step is both a close continuation of the first step as well as an expanded inquiry, analytically scrutinizing the contingencies of the various features.

The third step is called *Imaginative variation*. It appears to be descendant from Husserl's eidetic variation and can lead to the understanding of the "eidos," or essential shape of a thing, which is an "advanced conceptual analysis" (ibid., p.61) where one attempts to imagine the object differently from its current

appearance. Through imagining the various possibilities for an object's mode of being, its modes of impossibility or non-being are explored. Through such a continuous search one will arrive at "borders" for what makes the phenomenon still a being of the same kind and not a migration into being something else. The variation allows us to identify the features that necessarily have to be the same for the thing to retain its identity, as opposed to those that are contingent and can vary, thereby identifying its essential and inessential features (Zahavi 2001, p. 61-62). Any variation in the investigated phenomenon and its possible structures are imagined "to see what is invariably necessary for a phenomenon to qualify as an instance of it" (Wertz 1983, p. 190). Imaginative variation is also used to clarify the parameters for generality of the various features. Do they appear as having a more local, contextual, space-time based, historically dependent generality, or do they appear as certain necessary features of a phenomenon in all its instances? In other words, is it a local generality in the sense that the phenomenon or structure applies to first year university students at the University of Copenhagen or is it necessarily inherent in the human constitution as the body, for example, is the ontological nexus for intersubjectivity as described by Merleau-Ponty.

The *Imaginative variation* is followed by *Explicit formulations of generality* – the fourth and final step – in which the various findings must be as clearly and coherently articulated as possible, including the apparent forms or structures of the phenomenon with its internal and external relations, the conditions and contexts for its existence, and its minimal and maximal inclusion for self-identity. A complete account is impossible partly due to the phenomenon's hermeneutic situated-ness, so the goal is to make these features as visible as possible.

Another way of making analytic generalizations in qualitative research is to explicitly introduce the issue of generality at an earlier stage of the research process, namely in the data collection process. The processes of data collection and analysis, then, are closely intertwined in the sense that the data-collection stops when the phenomenon of interest has been saturated with meaning. Similarities and differences between the cases are continually identified and the topic under investigation is explored by way of semi-structured interviews, for example, wherein one continues interviewing until the possibilities for variation is exhausted. In other words, when another interview only adds minimal or no new knowledge, it is time to stop interviewing and finalize these apparent features in descriptions.

Conclusively, generality is possible but also necessary, always present yet in need of explication in qualitative (and quantitative) research. A degree of generality is always present, even in the most singular of cases, such as a work of

art, and to focus on individual cases can deliver extensive and elaborate information of a particular phenomenon, investigating it from many different angles. It makes it possible to reveal many layers of detail and connection which produce a nuanced understanding of the phenomenon that can be used to illustrate similar cases. Many features of the phenomenon can be investigated by studying only a few examples. Theory is always present in the analysis of empirical material, and already existing generalizations are constantly used when dealing with it. It is not only the results that become generalizations; new generalizations cannot be stringently differentiated from already existing ones (Roald and Køppe 2008).

The Methods of the Empirical Study

The Interview
For this book, twenty-five semi-structured interviews based on Kvale's description of techniques were used[7] in order to obtain concrete descriptions of peoples' actual experiences with art. The participants were asked to give as nuanced descriptions of their experiences as possible, both in regards to their current as well as previous experiences, detailing those experiences with art which had been the most important or meaningful for them. I asked them about their affects, bodily feelings, and thoughts in regards to the works of art. The interviews were conducted as an informal conversation, often rather unstrucktured, based on the nature of the topic. Most of the participants had never discussed their experiences with art in depth with anyone before, so the loosely structured conversation functioned as a means of having them relate as much as possible about their experiences with art, giving room for detours and small-talk which gave them time to process ways of conveying their experiences. All in all, the participants had hardly talked about their experiences with art before. They had talked about the art works, but not about their experiences with them. Their stories appeared raw and fresh, and therefore less ideological than experiential. They would not be rich in description if they were not mainly experientially based, but, rather, ideology detached from experience.

Analysis
Nineteen of the interviews were selected for analysis, based on linguistic fluency and richness of description. The formal analysis of the interview material took several different forms. Most of the interviews were transcribed, and the method

[7] See also Roald (2007) where the same techniques used in this thesis are described in greater detail.

Methodological Considerations

I have criticized – meaning condensation – was used to make the material more comprehensible. It is a decent entrée into analysis, but it is not phenomenological. I continued with structuring the analysis after Jauss' phenomenological model for the reception of literature, separating aesthetic experience into three distinct, yet overlapping, acts. These are 1) the first aesthetic perceptual reading, 2) the retrospective interpretative reading, and 3) a historical reading, which begins with the reconstruction of the horizons of expectations (this model is detailed more in the next chapter). From there the analysis took the form of a template analysis where I searched for and found examples of these different structures of Jauss' model in the interviews and "assessed for psychological significance" by analyzing how the subject and object appeared in these acts. This took place through first identifying and describing, with examples, different features of subjectivity (as detailed in Chapter Two) found in the interviews, comparing these different features between the participants, and gradually synthesizing these different descriptive characteristics. After the first round of analyses was conducted, the remainder of the interviews was analyzed in audio form, transcribing the elements which would enrich the already extant characteristics of aesthetic experience. Based on these different characteristics of aesthetic experience, as well as through the theoretical considerations, an answer appeared as to why the subject experiences the aesthetic. The analysis was based, then, on description and interpretations of aesthetic experience, whereby I arrived at an explanation, all taking place via continuous questioning of my own interpretations, in a continuous attempt to grasp what the participants wanted to convey without accepting facile solutions.

Assessment of the generality of the characteristics of aesthetic experience, as well as its explanation, was conducted according to Wertz's description of arriving at general knowledge, and those features that appeared as belonging to the individual and not to aesthetic experience (through a comparison with the other interviews) were excluded as features of aesthetic experience.

4

Stories of Art.
Aesthetic Experience as Intrapellation

The task set out for this book is to give form and meaning to aesthetic experience. It is to "show that psychology can arrive at descriptions of aesthetic experience that are richer than classification language and more exact than most philosophical abstractions" (see p. 12 of this book) by developing a psychological account of aesthetic experience that is founded on concrete experiences. The role this chapter plays in the greater scheme of the book is essentially to encircle how structures of subjectivity, as discussed in chapter two, configure in aesthetic experiences. It seeks to answer the questions: *How and why does the subject experience the aesthetic?* and the seeking takes place primarily through phenomenological descriptions and interpretations of aesthetic experiences in the life-world. The chapter therefore does not significantly deal with aesthetic experiences as they are revealed in theory but with how aesthetic experiences take place in the concrete, in the actual, or in the "live." Such live experiences are nevertheless influenced by theoretical[1] expectations toward what aesthetic experiences should be; expectations as to how these experiences should take place. Instead of ignoring the exquisitely intertwined nature of the empirical and the theoretical – and of aesthetic experience colored by expectations – it seeks to account for these aspects or characteristics of aesthetic experience based on a model of aesthetic reception that acknowledges its temporal aspects. Although it is an empirically based chapter, the empirical is dependent upon the theoretical to make sense, and just as Merleau-Ponty provided a preliminary model of subjectivity, there is a need for a preliminary model of aesthetic reception. In this chapter, the structure of aesthetic reception is based on Jauss' (1982) composition of the reception of literature which he developed in dialogue with hermeneutics. The model comprises:

[1] Here I do not mean theoretical in the scientific sense as in the sentence above, but in a folk-psychological sense.

1. a first aesthetic perceptual reading
2. a retrospective interpretive reading
3. a historical reading, which begins with the reconstruction of the horizon of expectations

(Jauss 1982, p. 139)

This is quite an unusual model of aesthetic reception as it goes against the Kantian aesthetic legacy, for example by portraying a process of how experiences with art unfold in time. This model is therefore more faithful to lived experience which is the reason why it is used in this book. Aesthetic experience does not end with the first encounter with art, which is the way it was theorized in modern aesthetics from Kant to contemporary aesthetics with Seel. It is found neither singularly in the first encounter with the work of art nor in any one of the movements in Jauss' model, but, instead, in their mutual interaction and dependency.

Jauss focuses on the concrete work of art and investigates its possibilities for interpretation, using his model to interpret Charles Baudelaire's poem "Spleen II" as an example. He argues against a "super-reader," one who superbly and correctly interprets the work of art, but uses a concrete and historical reader, presented in the forgotten disguise of his own subjectivity. Jauss ignores, or actually rejects, interpretation by concrete psychological and subjective persons.

In this chapter the focus is on subjective experiences with art. Focus is on the psychology of significant experiences with art, which in their tangible and corporeal presence pose a challenge to aesthetic theories. And in contrast to Jauss, it is not a specific work of art that informs the analysis, but, rather, subjectivities in their most important experiences with art. It is not the work of art that is held constant; it is the most significant experience that is investigated as constant across works of art and subjectivities. This does not mean that the experiences which arise are identical; rather that they potentially hold some identical or similar features. The experiences, however, in their subjective appearance, reveal, through comparison, their intersubjective nature. On this aspect, Jauss' fine model is purposefully adjusted up against Jauss' erroneous principle, as he claims that we "must limit the arbitrariness of readings that are merely subjective" (1982, p. 141). To him subjectivity is boundless and capricious. Against such a claim it is here precisely the subjective that is the precondition for finding generalities in the reception of art. And while Jauss wants to "make the aesthetic character of the poetic text expressly and demonstrably into the premise of its interpretation" (ibid., p. 141), the aesthetic character is demonstrably found in aesthetic experiences expressed in the

particular combinations of structures for subjectivity present in the encounter with art.

Jauss' wants to investigate "whether and how the hermeneutic unity of all three movements [of his model] realizes itself in the interpretation of a poetic text" (p. 140). The goal of this chapter is to explore whether and how these movements are realized in experiences of visual art. Jauss' model is therefore adjusted from the reception of literature to the reception of painting, through which the process becomes a first aesthetic experience as well as a retrospective interpretive experience, both of which include a historical experience based upon "horizons of expectations." Jauss' model of reception is also interpreted in light of Merleau-Ponty's model for subjectivity, wherein experience is dynamic and continually evolving, hardly occurring in the framework of pure perception. Jauss' differentiation of reception into different "steps" or stages is, therefore, used to theoretically sharpen the descriptions of actual experience. However, experience is normatively neither singular nor autonomous, but constantly in a dynamic flow of the past, present and the future encompassed in one single act, whereby the horizon of expectations colors both the first encounter as well as the retrospective interpretative meeting. Similarly, the first aesthetic encounter is impossible, in principle, to fully describe, but can gradually be enclosed via a retrospective introspection, whereby the two phases gradually meld into one another. These evolving phases will, as such, be described as they occurred in this study, with detail given to their occurrences in the first encounter and in the act of retrospective reflection, with both comprising horizons of expectations. It also includes descriptions of structures of subjectivity as they take place in these movements of art.

Each individual work of art creates specific circumstances for experience and there are specific and unique experiential potentials inherent the particular work of art. These potentials determine how the work is to be experienced, limited by the horizons of reception, that is, of the experiential horizons present in subjectivity. Aesthetic experience is, as such, an incredibly complex process with different possibilities, and can be a prospective for, though not necessarily actualized in, a particular subjectivity. In other words, not everyone has aesthetic experiences but it is a possibility given the necessary circumstances. The following analysis focuses on specific structures of subjectivity at play in the generality present in the individual's most significant encounters with art. This is a generality which is not universal, but rather of a significant typicality which happens for some people, not necessarily with the same picture, but as the most important experience with particular works of art.

The First Aesthetic Encounter

Jauss describes the first aesthetic encounter in regard to literature as a perceptual reading, as a perceptual understanding. In contrast to "everyday perception [which] generates into a norm," aesthetic perception is "at once more complex and more meaningful, which as aesthetic pleasure is able to rejuvenate cognitive vision or visual recognition (aisbook)" (Jauss 1982, p. 142). In the case of this analysis the first aesthetic encounter is conceived more broadly and taken to refer to the immediate experience that takes place when faced with the work of art. Based on the participants' descriptions of the first aesthetic encounter, it is indeed one of intense meaning and dense significance. The perception is not normative, in the sense that the first aesthetic encounter takes place with a new object and is therefore of new perception that thereby invigorates perception. Still influenced by rationalism where sensing becomes cognition, however, Jauss ignores the affects and forgets that perception is colored by affection. And affection is personal, or subjective, whereby subjective interests are active in the first aesthetic encounter.

The first aesthetic encounter is one of intense personal interest.
In all the participants' stories about their most significant experience with art, their experiences are colored by intense interest. The interest is personal in that the work of art calls to certain aspects of their subjectivity; it activates their personal history and biography, and contains an interpretation of the work of art as existentially relevant. What is existentially relevant is that which is personal.

The two strongest examples are found in Frederik and David's experiences. Frederik, for instance, talks about a highly personal encounter with three works of art which he sees almost every time he visits the National Museum of Art. These three paintings look mysterious and iconic-like, where good is divorced from evil (see two of the pictures on pages 99 and 100). They are "amazing," to him, and he thinks that these pictures are forces of attraction in part because of the pain they portray. Fredrik frequently imagines that the world originated when these paintings were made, when the Black Plague raged. The arbitrary way in which large parts of the population died and the pain of the survivors of the Black Plague can be seen in the faces of the depicted figures. He can see that they have really experienced something which we do not normally know, and that is complete annihilation. The paintings portray pain caused by unknown forces which strike arbitrarily.

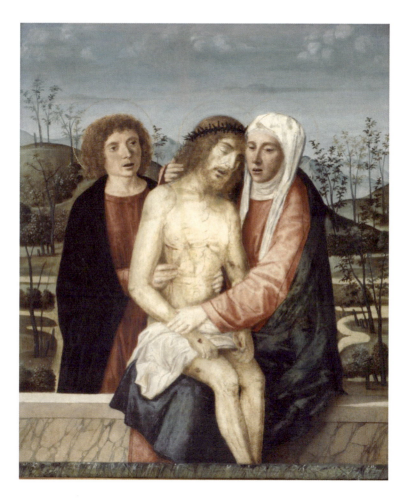

Picture 1
"The Dead Christ with Virgin Mary and John the Baptist"
Giovanni Mansueti. Pieta, ca. 1470.

Picture 2
"St. Michael with the Dragon"
Artist unknown, Spanish, 1500s

To Frederik these paintings show him something which he normally does not have to deal with to such an extent, but which is still significantly present in his world. "I think loss is, and has been, rather present in my world. I have suffered some great losses which makes it [the picture] very present," he explains. What he finds fascinating is the way the artists have made concrete the experience of being powerless, of relating to that which is not concrete, the arbitrary and the inexplicable: that vast pain is so precisely depicted. It is a pain we live with but which is hard to place. He claims that it is difficult to relate to the fundamental existential crisis which we meet in relation to death, and it is possible that we today are not very experienced in handling such issues compared to what was the case in the 1300s, because they had no way of escaping it. These pictures mirror his own pain, and he finds them "wonderfully liberating."

David's experience at a Edvard Munch exhibit at Hamburg Kunsthalle is also an example of an aesthetic experience marked by intense personal interest. As he walks through the exhibit he is captivated by the pictures which portray the mood of melancholy he was already experiencing. It is a "fantastic" and "strong" experience to immerse himself in the exhibit where melancholia was clearly depicted, reaching him both affectively as well as more intellectually. He experiences that "one is not alone in one's depression. It [depression] is a common human experience," and "I have some symptoms, some characteristics, that also have a positive side, and it was something that was accentuated by this Munch exhibit." This coincides with the story that he had just been to England to produce a record which included a song entitled Melancholia. At the exhibit he "got a sense of what kind of piece it was that we actually had made."

The intense interest is characterized by affection.
It is perhaps a bit tautological to say that interest is characterized by affection as all interest has some components of desire. Experientially, however, there are different kinds of interest that comprise different degrees of affection, and the first aesthetic encounter is characterized by an overwhelming affection (in the phenomenological sense). Both Frederik and David, for instance, are intensely affected in a rather similar way when they describe their most significant experiences with art. As Frederik talks about his experiences with the above mentioned paintings his voice lowers, his eyes become teary, and his whole body posture is marked by affect. When David talks about the experience he appears to relive the experience again, with his face looking intense and markedly altered.

An example of intense affect as characterizing the aesthetic encounter also takes place in Siv's description of a visit in a sculpture garden which contained the sculptures by Barbara Hepworth in Cornwall. It is a sunny, wonderful day,

and she feels content as she strolls around in the garden. Pretty soon she comes upon a sculpture and immediately starts to cry. She says, "I found it overwhelming... It touched me, and I became a bit agitated." She knows that she easily cries, both from joy and from being moved, but still she is not used to crying publicly, and she felt vulnerable and restrained herself from going further into the experience. She pulls herself together and is thinking, "this is incredible, what is it? What is it with the form?... it was like a bolt from the blue." She decides to walk around for a little and returns to it. As she walks around she questions herself: will the same happen to her with other sculptures, too? But it was only with this one particular sculpture that it took place. She returns to the sculpture and starts to cry all over again, but this time she is more comfortable with crying. She does not know what kind of crying it is; it is not necessarily out of happiness or sadness; but it fills her with gratitude. She feels touched, very, very deeply. She has never experienced anything like this before or after that garden visit.

Stefan also describes experiences that are of intense emotionality. In general, paintings can be very shocking to Stefan. Some affect him intensely in a positive way, while those that he considers not good can have an opposite effect, in the sense that he may become nauseous upon viewing them. For instance, when he enters a Modigliani exhibit in Berlin, he gets a kind of contact, a strange, inexplicable feeling. It is "grand" or "large," just as with certain music. Stefan is first interviewed at the National Museum of Art. He has just seen the exhibit of Andre Derain's paintings which has moved him greatly. He is close to tears several times, shaking as he tells about the experiences he had with some of the paintings. The tape recorder did not function according to plan, however, and the recording is indecipherable. I contact Stefan again and this time the interview takes place in his home. I ask Stefan to describe an experience with art that had made an impression on him, and he began by talking about an experience with art in Paris when he was rather young. There he saw Derain's painting, *The Two Barges*. It made an immense impression on him, as many pictures do (e.g. paintings by Matisse and the Fauvists). He claims that his early experience with these paintings affected him in such a way that he never became an artist himself. He was, for instance, incapable of painting the above-mentioned picture by Derain which was a shock for him: "It was very strong, almost somewhat violent." Seeing Derain's and these other painters' works in Paris made such a strong impression on him that he decided not to paint for the simple reason that he could not. He could not see, he could not get it right; he attempted to, but could not avoid copying, he claims. If he was going to paint, he had to be able to paint something as good as *The Two Barges*. Now he can paint it, because he has figured out how it is done, but that is no fun. One of the most boring things is to

copy others. Since he could not make art, he became an art lover, as analogous to eating good food instead of becoming a chef, he says.

The first aesthetic encounter is one of subject-object ambiguity and, as such, of time and space ambiguity.
Since the first aesthetic encounter is one of intense interest whereby subjectivity is highly involved, it contains no pure epoché, as postulated by early Husserl (1900), wherein subjectivity does not influence the experience. However, if the epoché is presented as interpreted by Zahavi (2001a), the first aesthetic encounter is a situation where the epoché is most completely present because questions with regard to the metaphysical reality of the picture are dissolved in the subject-object relation whereby the object is experienced as the subject. What this means is that in the first aesthetic experience, time and space as experiential characteristics take place ambiguously in the picture. The subject loses the subject-object distinction and feels present not only in the object but as the object. This indicates that Merleau-Ponty (1945a) might be right when he says that "every sensation carries within it the germ of a dream or depersonalization" (p. 250).

Siv describes an experience of subject-object ambiguity which necessarily includes time and space ambiguity. It takes place in front of a picture by Niels Larsen Stevns which depicts a tranquil nature scene.

First she looks at the picture by herself, and, later, as the two of us stand in front of it, she explains her experience. She says that, the picture is one she can "rest" in. "I can easily sit and look at it for a long time... look into its horizon... and then you sort of disappear in it." She keeps on looking and claims the eyes rest although they wander around in the picture. She experiments with different positions for seeing it and moves closer and further away with her body, feeling that she disappears into the picture both when it is close up as well as when it is further away. At the same time she contends that she feels present in the body, and states that when seeing it by herself she had not thoughts and no consciousness of time.

Lise also describes a first aesthetic encounter of immense importance to her. She sees some frescos and mosaic works which she finds very beautiful at a national museum in Rome. It is an overwhelmingly beautiful experience; it portrays the most intense beauty she has ever seen. The museum walls are covered with frescos which depict nature scenes, orange groves and trees, painted with a turquoise background, other places with a rust color and other nuances of red. The experience moves her in time and space to the Palatine Hill which is depicted in one of the frescos. She feels fully present in the experience: "I think I am highly present in the pictures... I was present in the pictures and at

the same time it feels magnificent inside the body too." This experience lasted for a relatively long while at the museum, until she became "completely swallowed up or absorbed" in the works of art. She says, "it was almost like walking besides oneself... after a while I think I was no longer myself... it was magnificent... it gives one a sense of how it would have been to live there... It cannot be described... I feel as though I am moved in time and space." Thus, at certain moments she feels present in her body, in the art work, and in both at the same time. At the most intense moment, she loses regard for her own subjectivity and is present *as* the picture. It is not that she depicts herself *in* the picture, but instead that her whole intentionality *is* the picture.

Picture 3
"Udsigt ved Florens" (View from Florence)
By Niels Larsen Stevns, ca. 1923

In both the above experiences a subject-object ambiguity is present in that the subject dissolves into the object and does not experience its subjective time and space, but instead the time and space of the work of art. The subject becomes the object, albeit briefly. The ambiguity not only takes the form of the subject becoming the object, but also in the form where aspects of the object manifest in the subject. It feels, at times, present in the subject without the subject losing itself in the object, wherein the subject-object relation oscillates.

For instance, Adam describes a deep rhythm that he can feel in the stomach: "It [the work] presses in the stomach, like a loud bass." It is a bit like taking LSD, he says, as when the senses are not experienced in their normal way (and allegedly as when the subject-object distinction is dissolved); "you should try it." This experience takes place with one of his favorite works at Esbjerg Art Museum by Trine Boesen, where the rhythm he experiences in the picture physically manifests itself in himself.

Therese also feels the work of art physically present in her. She recalls what she considers to have been a great experience with art when she viewed the decoration of Ishøj Church, a recently built structure decorated by Peter Brandes. They are three friends together, talking and looking at different features of the decoration. Then they sit down and contemplate it more solitarily. She relates this experience to the forms and shapes of the decoration; it feels almost god-like. Her thoughts are minimal and it appears as though the art becomes a part of her, she claims.

Kristina[2] describes a previous exhibit that has made strong impression on her. It is an exhibit she views in Lisbon by Anthony Gormley. The exhibit spreads out over three floors which thematically creates a coherent whole of bodies in situations of violence to situations of redemption. The part she starts describing is one that elicits fright in her, associated with images of systematized terror. She finds this part of the exhibit to exude a sinister and dismal atmosphere. Had it not been for the presence of other people she would have left immediately. It was no particular object that created this impression, but the entire atmosphere. The ghastly impression makes her guarded, and as she enters into other areas of the exhibit, she anticipates frightening works. She continues to describe works of art that elicit discomfort in her, but then the nature of the exhibit changes radically, and she experiences "lightness." It is an enormous relief and she feels reprieved. It is a release from her discomfort that alters her own sensations and affects. Her experience of nausea dissipates; the art work improves her condition radically. The art work appears balanced and restores her sense of balance, and she views

[2] This section has been printed before in my article *Toward a Phenomenology of Art Appreciation* (2008).

herself as having gone through a range of affects and bodily movements. She changes from feeling "heavy," then questioning, then light and almost dissolved – the same characteristics that she perceives the art objects to contain.

Picture 4
"Everybody Everywhere". By Trine Boesen, 2004.

The first aesthetic encounter is characterized by the body (and body ambiguity) as an affective presentation.

As seen in the section on subject-object ambiguity, the body is both intensely present and intensely ignored in the experiences with art. At times, the participants are significantly aware of their bodies, in other parts of the experience the body becomes a background that experientially fades out, too. It is explicitly present in Lise and Kristina's above mentioned accounts, for instance. For Lise, the body is intensely present but then gradually fades out; for Kristina, the art work calls to her bodily being in particular, and her body experiences the rhythm and situation of the exhibit. When experiencing both happiness and discomfort, it correlates with a physical sensation in her stomach. During the frightening parts of the Gormley exhibit, she could feel a sensation in her stomach which returned during the interview. For her, the body takes on the same situation as the exhibit and she experiences what Merleau-Ponty names "the things' motorphysiognomy." The body is present in the experiences of high intensity and, accordingly, in experiences they prefer the most as well as in the experiences they prefer the least.

For Thomas, the body is also present in the significant encounters with art. He claims that "it bubbles in me," when he views his favorite picture by Asger Jørn. For Adam, "It [the work] presses in the stomach, like a loud bass." For Therese, "my heart can start to pound in front of a very pretty painting," and one's "heart can start to beat [when viewing] a fantastic artistic execution." Maria and Elisabeth enter the installation "*My World Does Not Exist*" (see detail of it on the next page) which it is a completely white room with an forceful white light and where white yarn crosses the room at different places, linked to the figures on the wall, all interconnected through the yarn. Maria claims, "entering into the room one become completely dizzy," and Elisabeth adjoins, "it was a strange feeling in the body, one did not know what was about to happen because it was all white, as if there was nothing."

Picture 5
Detail of the installation "My world does not exist."
By Kirstine Roepstorff, 2004

Stefan experiences an intense bodily presence, too, at a Modigliani exhibit in Berlin. Stefan and his wife stand in line for three hours in bad weather, yet it is a "fantastic experience." As soon as he enters the first room, he is faced with six paintings, and seeing them is so intense that they were worth the three hours' wait. They are already rather content before they enter the second room and he has never experienced anything similar. Asked to describe it more closely, he asserts that it was a physical, very intense experience. It was fantastic with a "very intense" onset. When felt physically, it is in his breath, and he can become dizzy or short of breath or restless, he says.

Kristina also provides another description where it appears as though the work functions through "osmosis." It takes place in relation to the installation *"Meaning is What Hides the Instability of One's Position"* by Sander and Geyer, where text and image keep moving constantly. It penetrates into Kristina's body and she feels overwhelmed and exhausted. "I don't feel very comfortable... it was the exhibit, I don't think it is a place where one feels comfortable. I do not think you are supposed to. It has a physical effect to see those pictures and to receive those messages into the head... the grey color of the room. It is not the intention that you are supposed to feel comfortable here." The topic of the art work becomes the topic of her body, and her body feels muted, limp, and exhausted: "those hallways remind me a lot of airports... and one thinks, next time I want to sit in a wheelchair and they shall pick me up and drive me down through these elevators." At an exhibit of works by Bill Viola her body is again intensely present: "I think that the strangeness gives a kick...it feels like the solar plexus, like a butterfly in your stomach."

114 *The Subject of Aesthetics*

Picture 6
Detail of the installation "Meaning is what hides the instability
of one's position." By Katya Sander and Andrea Geyer, 2004.

The first aesthetic encounter is largely pre-reflective
Without a doubt, the first aesthetic encounter is largely pre-reflective. Something happened that the participants want to communicate, yet they can only tell part of the story; some of its significance and characteristics escape them. Almost all the participants claim that it is exceedingly difficult to describe their experiences with art. For instance, Lise says "it is almost indescribable," and "not easy to put into words," as she attempts to relate her experience at the National Museum in Rome. Stefan also finds it difficult to convey his experience. He finds it easier to talk about the artists and the works of art than the phenomenology of his own experience, and talks briefly about his experiences before he steers the conversation to other topics, whereby the interview takes the form of a continuous return or mediation between talking about his experience and about surrounding topics with regard to the works of art. He observes, "I get contact with something that is more than the picture. It is difficult for me to explain." And in relation to his fascination about a picture by Købke, he says "I cannot explain it [his fascination]." Similarly, Maria contends that she cannot describe properly her feelings in relation to the experience of the installation My World Does Not Exist. A further example is found in Adam's account, when he states that to experience Munch's picture The Scream "says much more than one can read about it." Heidi claims that "it is hard to say something about it [her experiences with art]. It is just something one does." Henrik claims that experiencing art gets one in contact with some other ways of thinking and gives one a sense of "being lifted...but I find it very hard to put into words." To experience art comprises more than can be described linguistically.

Also, the way the body is present, the time and space ambiguity, and parts of the affection are all aspects of pre-reflective experience. The first aesthetic encounter is, as such, largely pre-reflective, where the characteristics claimed for the aesthetic experience are not co-extensive with the totality of the aesthetic experience. They are moments of it. The first aesthetic encounter cannot be described in its phenomenal completeness.

The first aesthetic encounter is a meeting with something new and unexpected
In the above descriptions of the participants' most significant stories with art, it becomes clear that the first aesthetic encounter is a meeting with something new. Since the encounter is something novel, it is also largely unexpected. For instance, in David's account he experiences new aspects of melancholia that make him understand his own melancholia in an unforeseen, new way. Lise experiences startling novel beauty, and Siv describes an experience with a sculpture she has never seen before which elicits a completely new reaction in regard to works of art.

Once in a while Frederik sees a work of art which leads to his "world changing," wherein something is transcended. He has had this kind of experience with a small picture by Paul Klee which concretely depicts a different world. Frederik says that the transcendence which he experienced can happen when a very good artist has "walked some roads," and by "taking in" their works one gets to experience a little of what the artist has seen and, therefore, gets to experience an unknown landscape. Exemplified by Klee's painting, it becomes a landscape where things are turned on their head, and into which Frederik can enter. He says that "the landscapes we normally experience become dissolved and the painting becomes a mind-landscape" instead, where the diffuse and unknown is depicted.

For some of the participants, the newness of the first aesthetic encounter persists in relation to the specific work of art. Although the participant is familiar with the work, the alterity of it lingers and leads to a continued fascination which is different from the appreciation that follows when the newness has sedimented in the one experiencing the work. Stefan, for instance, says that he can be affected, struck, or touched again and again by the same picture as well as by new pictures. For instance, Derain's *Two Barges* took him by surprise and continues to take him by surprise, although he has known the picture for almost a lifetime now: "it surprised me, it is a fantastic painting, it cannot be made... it does something that is completely surprising." There is something in the picture that remains inexplicable to him and which has caused a lifelong fascination. The same, he says, can be said for some works by van Gogh, Modigliani, and Matisse. When he saw these works as a young man for the first time, they were completely surprising and fantastic to him, and they preserve these characteristics: "if you take a picture like that (van Gogh– Café Terrace at Night), I am deeply fascinated by it. Can one make something like that? I continue to be lost in reverie over it. What is it? Why is it so good? I cannot explain it to you." Thus, some paintings retain a kind of impenetrability and present something incomprehensible; Stefan describes it like an experience "analogous to a UFO arriving... it breaks the sound barrier, so to speak." To Stefan that is what art is about, and it is incomprehensible: "How can they do it, how can they see it, how do they know and how do they create, how do they create that synthesis?" "It must be a lie – can that actually be done?" He claims it is the incomprehensible synthesis which moves him deeply.

There are, however, times when the newness does not persist but instead is transformed into familiarity that also leads to a continued fascination. For Stefan this takes place with some pictures: "When I meet paintings, they become a kind of friend whom I seek out." Sometimes the newness sediments and the work is appreciated for what it once did. It leads to a fondness for the work, a desire to

see it "like an old friend." Seeing the works again, however, is not a first aesthetic encounter, but a meeting with something that points back to the first aesthetic encounter. It is also present in Thomas's descriptions of a fondness for certain works by Asger Jorn. Thomas returns to the same picture every time he visits the museum, "just to say hello." To see them, and to anticipate seeing them, "makes me happy," and he has moved the picture into a closer sphere of intimacy, as he has a copy of one of the pictures hanging at home.

The first aesthetic encounter is a meeting which resonates as convincing
The work of art excites and stimulates through the newness which, all the same, comprises aspects of familiarity. Although Stefan says that, "it is like a UFO arriving," the work contains aspects of familiarity in that he immediately recognizes the work as "just right," and says "it could not have been otherwise." In the works he appreciates, there are new aspects and new syntheses which are familiar, or harmonize, with his subjectivity. Otherwise he could not be mirrored in it, and would possibly reject it. The works reveal alterity in familiarity. Through its familiarity the newness is allowed to sediment, whereby the subject extends its subjectivity to incorporate the work of art.

For Therese, her most intense experiences take place with works which she finds ideal. Seeing van Gogh and Rembrandt's pictures in Amsterdam is "fantastic, also to see some pictures that have belonged to one's existence for many years…you don't really speculate over what it is, over why I am here in existence, you are just present in a way, right? It is perfect in some moments and everything else is indifferent, only what you experience is present." Its meaning is immediately available and "you don't need to explain much."

Convincing perspectives of European culture arise for Heidi when she experiences art. For instance, through experiences with art she becomes convinced that "Denmark has changed a lot since I was little," she says. In general art gives her new, persuasive angles for understanding. For example, she visits art museums when in a new city, giving her "an understanding of European culture," she claims.

For Andre, what he calls "wow-experiences" are the kind he can get at a museum. He can stroll around without expectations and still "experience something where it is just fantastic that someone can express themselves that way." The fantastic expression convinces him of the content of art.

In regards to paintings by Per Kirkeby, Henrik claims that when viewing them he feels lifted above the everyday into some other spheres of existence. He says "in one way it is something archetypical [in the paintings] which gives something…it has something to do with feelings…I can notice I have been lifted somehow." Henrik would not be able to have this experience if the paintings

weren't convincing to him, and, in general, the participants would not have these experiences unless the works of art were persuasive and credible.

The first aesthetic encounter is one of openness.
Since the first aesthetic encounter is a meeting with something new, it demands openness – art demands willingness to face and seek out that which is new. Therese claims it explicitly: aesthetic experience "demands openness, resources, and energy," and, as she says, "that is a political question."

For Nadja, openness is an explicit demand when facing art that she unambiguously attempts to stay open. She says, "I am open to all kinds of things that appear, and I force myself, whether or not I like it." She tries to give time and energy to all the works which cross her path, although, of course, it is an ideal more than a real possibility.

Heidi seeks out works of art because she desires to understand more; she is seeking to grasp aspects foreign to her. She wants to understand through art, and thus displays a degree of openness to alterity.

Henrik looks for something which is foreign to the everyday, and openness is present in that he expects and desires that which challenges him. His everyday is very structured, he states, where things are almost the same. With art in general "the everyday is supplemented with something amazing and beautiful...but also with something ugly and disgusting which provokes something. It extends the horizon in one way or another... it is a bit like chaos theory... [Art] is unpredictable and extends one's view on life...it becomes bigger...one gets a bigger perspective."

Most of the time, however, the first aesthetic encounter is an unexpected meeting so the openness is mostly an implicit mode of being in front of works of art, or in front of specific works of art.

The Retrospective Aesthetic Interpretation

In contrast to the first aesthetic meeting which Jauss (1982) claims is a perceptual encounter where "understanding can be at work allowing the reader to experience language in its power" (p. 142), he regards the reflective interpretation to be a re-reading of the text which reveals its conceptual importance beyond the rhythm of its language. The "progressive horizon of aesthetic perception" which is only hinted at in the first reading can be "thematically articulated." The first aesthetic encounter is, as such, an unfulfilled one, and the aesthetic experience is not complete without the retrospective interpretation. The retrospective interpretation contains the hermeneutic act of having perceived the work in its entirety, to having grasped the whole, for then to return to its parts

and whole in order to understand its significance. In this book' application and adjustment of Jauss' model, the reflective interpretation is not a re-read or a revisit of the work of art (which, if the situation allowed, would otherwise be ideal), but encompasses a reflective return to the first aesthetic encounter. It is an act of memory in which the participants muse over the first aesthetic encounter and its continued significance. As such, the retrospective interpretation contains some of the same aspects as the first aesthetic meeting as the participant's relive the encounter and re-experience it, but it also contains a new reflective layer, not present in the first aesthetic meeting, where its meanings are encircled.

The work of art becomes most reflectively meaningful in the more immediate time after seeing it.
After the first aesthetic encounter, reflection over the experience takes place and provides an experiential background. In relation to the Gormley exhibit mentioned in the first aesthetic encounter, Kristina states that she keeps thinking about the work of art: "one can find one's own solution, perhaps it arrives after a while, perhaps I discover it in three weeks," and "it was actually not until I came home that I discovered how completely fantastic that exhibit was and how sinister I had thought it was." With art in general she says that, "it can happen that I after a while I think: what was this that I saw, it was really strange, it was really peculiar," and "it is perhaps [with] the most exciting pictures from the exhibit that one afterward thinks: wow, that was rare, not like an open book, and which perhaps keeps spinning at the back of my mind." In other words, the pictures can be present as a background tone for a while, coloring the everyday and the way she perceives the world. If it is an exhibit that speaks to her, it is something she continues to speculate and think about for a while: "one is not finished with it." Then it slowly fades into the background.

To Lise, her experience at the National Museum in Rome is "still not something that is easy to put into words...but I talk a lot about the fresco paintings, and I tell many people about my experience... so it is something that fills... so it is... it is an experience I am terribly delighted I got to have." She talks to people around her about it and it is a backdrop that gives content to her conversations. The continued talking gives room for continued reflection over the work of art and gradual sedimenting of the experience.

Immediately after her experience with Hepworth's sculpture, Siv starts reading about the artist and finds out more information about her. She questions why the sculpture was made and tries to make sense of her own experience. Later, when we talk, about a year after the encounter, it is something she hardly thinks about, yet, at the same time, it is something, she says, that is present as a significant event in her life.

For Thomas, the works of art are most intensely meaningful in the time closest to the experience. Thomas talks intensely about his fascination for Asger Jorn's paintings during the first interview. Since that time he has seen the works again and has had a chance to say "hello" to them. He has a postcard of one of Jorn's paintings hanging at home. He finds it "awesome and I sometimes look at it for a while, yet it does not carry the same meaning as those of Carl Henning Pedersen." Time has taken its toll yet the works still hover in the background of his everyday. However, it is his most recent encounter with Pedersen's paintings that take precedence. He claims in relation to them that, "when I look at the postcard then that film appears, that feeling of what it was like to walk around there, and many, many more pictures arrive, it is not just that postcard which I am looking at, a whole lot of different pictures [from the exhibit] appear...When I look at the picture by Jorn, it is to a much greater extent just that picture which appears." The fascination with Jorn has lost its potency, and now it is the more recent encounter with the paintings of Carl Henning Pedersen that takes the foreground.

The retrospective interpretation is characterized by affection, including the body as an affective presentation.
Affection is present as the participants tell about their experience. Therese says with a smile that works of art, in general, have some specific characteristics which one can talk about and discuss, but over and beyond that they give "some kind of happiness or pleasure to existence. One appreciates being in it somehow, don't you think?... and it is not only because it is beautiful... we could easily take a picture that is not pretty, like a Sven Wiig Hansen...and it [leads to] contentment that there is someone who concern themselves with something important for me, important aspects of existence."

Siv talks with powerful emotions about her experience with the sculpture by Barbara Hepworth and she feels like crying again, similarly to when she sees it the first time. Her face becomes red and her eyes watery and she says, "I was standing looking at it and I started crying. I can notice it now when I am about to talk about it. I really had to cry."

Talking about her experience of the Gormley exhibit in the first interview, Kristina relives the experience quite intensely. She re-experiences her bodily feelings as when actually seeing the work of art: "I can really notice it in my stomach when I think about it, that chaos displayed all-devouring evil... I can notice it in solar plexus." Affect comes over her face and she touches her abdomen as she says it.

Lise is also affected when talking about her most significant experiences with works of art. For instance, she feels what she names a "bubble of happiness" in

her chest during the experience at the van Gogh Museum in Amsterdam, and as she talks about the experience with me she frequently touches her chest.

When Thomas thinks about his encounter with the pictures of Jorn it "is sometimes just aaahh." It is a pleasant experience that fills him with joy. He says, "it means a lot to me, so it does." Thomas describes the works: "I think it is his figures, they are not mythological… it reminds one of children's drawings with the very simple points and lines. I think it is also the way he uses color. One becomes happy when looking at [the pictures]. It does not portray anything specific, but we each have our own image about what it is, and "it is not the mundane everyday, it is something else, lifted out of the trivialities and humdrums of the everyday." Reflecting on the experience takes him back to a different, joyous sphere of life which, nevertheless, illuminates the more mundane, albeit briefly.

The retrospective interpretation is characterized by open inquiry.
In general, all of the participants ponder the meaning of the first aesthetic encounter when asked. It is not a closed story, but one that is open to speculation. For instance, in the second interview, two years after the first, Kristina still remembers well her experience with *Meaning is What Hides the Instability of One's Position*. She says that after we had talked together the first time she came to think that perhaps she had misunderstood the exhibit, that there were parts she had misinterpreted, because perhaps the one part was just the back of a part of the exhibit that she did not see. Thus, she gives not a closed interpretation of its meaning and its meaning for her, but is open to reconsidering it. She displays a degree of openness.

After the first aesthetic encounter with Hepworth's sculpture, Siv investigates it. Siv finds out that the artist had lost a son in the Korean War and she wonders whether the sculpture was made around that time, embodying her sorrow, although it was an abstract form. She keeps musing over the experience in the interview but she gets no further in her reflection. As described, the sculpture is not particularly large and consists of two forms close together, one bigger than the other. Two forms, however, can mirror so many relations: intimacy, rejection, mother and child, etc. It could be that she was relating to something like that, that the sculpture awakens something in her that is incomprehensible to her, which could mean that the sculpture echoes a relation of importance a while ago. There is something in that particular sculpture that she is reacting to, which activates her subjectivity.

Stefan still ponders how the pictures that have fascinated him for years came into being, and comes up with some tentative answers in the interview. As described earlier, the first painting that takes him by surprise is the one by Derain

portraying Matisse. Stefan states "the picture cannot be different. It is absurd. It does something one cannot do; one cannot paint a picture in that way. It is fabulous." In order for a painting to surprise it has to be technically good and has to say something to him. When these conditions are met, he then poses the questions: "How do they know what they are doing? Where have they learned it? What is it that makes a picture so pure and exactly as it should be?" Whatever it is, it is something they know and at the same time do not; it is something they do and are doing right.

When Stefan was younger, Ny Carlsberg Glyptotek was a "great revelation" for him. He was fascinated by those less known artist, especially Sisley and the way he could paint light – the way the light would glitter and shine. Similarly he was fascinated by Monet and the way he could paint light. Many years later he still wonders about how these paintings were made: "How could both of them conceive of it? Monet, for instance, painted light, yet something more than light, and it is deeply fascinating". Stefan tentatively answers his own questions: "First of all it is technically fantastic. Secondly we know something or we don't know something – it is somewhere between knowing and not. But it does something which is both surprising and places one off balance."

The explicit significance of the work of art appears through intuitive reflection.
Kristina cannot explain the direct significance for her of *Meaning is What Hides the Instability of One's Position* (see detail of the installation on p. 130). In the second interview, the process of direct reflection over the particular work has ended and its particular significance has escaped her, yet she intuits its importance and it takes part in her reflection of art's overwhelming importance: "I would find it sad if there were no experiences with art. It would actually be a catastrophe." In the second interview, talking about the Gormley exhibit, Kristina says she has thought about the experience many, many times. She cannot remember all of it, but thinks about it with "great delight and horror." It is very meaningful to her life. She contends, "it is of outmost importance" without giving more concrete examples than it being something she thinks about, and it being in the background of her living.

Similarly, Lise says that art in general "has taken part in opening my eyes to something which was greater than I earlier perceived." How it is greater is difficult to capture in words, but interpreting her experiences it seems as though she becomes aware of meaning in the object divorced from her own existence which, nevertheless, gives her an awareness of conditions of hers. The object is beautiful and meaningful in itself, and therefore shows her the limits of her own existence, whereby she recognizes her own historically-placed conditions for existence. In relation to an exhibit at an Etruscan museum in Toscana, she says,

"I feel a deep, deep gratitude for it, and being allowed to experience it. But also for what we would have done if they had not begun? Would we then ever have found out? It cannot be known where we would be today if they had not started, or how should I explain it, I don't know, but somehow I think that much of what we do today has its roots in [what] they [did]."

For Therese, seeing Francis Bacon's pictures is "completely fantastic." She cannot reflect about the experience in other than fairly abstract terms: the pictures "touch many things in one's attitude to life," and "they rise above the mundane and become something. It somehow gives birth to something... which changes... one, right?" Still, the experience and its consequences cannot be fully captured linguistically: "I don't know whether I can formulate it." The furthest she gets in this difficult task of making her experience explicit is to say that the paintings are "fascinating because they contain a whole lot of human nature," and "they contain a whole lot of messages that I cannot explain. Do they move me? I cannot say whether they make me more tolerant, but I believe that the more people you get to meet and experience, the more you know about diversity."

For Siv, the significance of the work of art appears through intuitive reflection. In relation to her experience with the sculpture she says, "I found it a very life confirming experience. I thought a lot about that afterwards. I think it was a gift... I thought: wow, such a form. And now she [the artist] is dead and she has made a form which makes me stand here and cry on such a sunny day in this wonderful garden." She intermittently reflects over the meaning of the experience in the interview. Without being able to further explain the encounter she thinks about it now and again, placing it in a special sphere: "I think that all people can tell about a little handful of special moments, something special... which touches one."

Thomas finds the explicit significance of art to be what certain works do to him. It is an act he cannot explain more than it being an experience that lifts him and fills him with joy. He explicitly knows that it is an extraordinary experience, yet the knowing is more intuitive, more a reflection on the feeling and an explicit acknowledgement of its significance than formal reflection. It is, accordingly, not the formal aspects of the work of art, that is, the objective facts about the work and the experience, which reveals its explicit significance. Instead it is a rhythm or pulsation of intuitive reflection which reveals a condensed meaning as significant in sensitivity, intuition, and understanding. Objective, rational reason appears largely as trivial in comparison to the intuitive reflection and understanding of its perceived meaning.

Understanding the work of art is a dialectical process through which the work becomes internal to the subjectivity.
The participant's experience the art object, and through engaging with it the art work, gradually or abruptly, becomes a part of their subjectivity. Directly or indirectly they experience the art as a part of themselves. For instance, Kristina explains in relation to the Gormely exhibit that "one lives through a gamut of feelings at the same time as you are walking, right? There is something very funny that happens in relation to time and space. I go through a process, right? And I simply do it through moving, through the architecture, because I have to. But I also experience a gamut of feeling, so there are many movements that are forced upon me through physically seeing the exhibit, room by room, but also psychically, by running the gamut from one feeling to the other."

Lise states that after seeing a Picasso exhibit she "was *filled up* with experience." It becomes the content of her subjectivity and she claims she "cannot *contain* more." Also, in relation to her experience at the National Museum in Rome, she says, "I do have some pictures [from the exhibit] here at home which I can pull out and look at when I want to, but I prefer to *have them in my soul*, so to speak," and "without art one becomes poor in the soul, I believe that."

Reflecting on her experience in the church at Ishøj, decorated by Peter Brandes, Therese says, "I have absolutely no idea what it is that speaks to one, it is something with form and color, yes, but it is like God's nature, right? You don't use the head much... actually, what I want to say is that it is a kind of experience with art where it actually just *comes into you*."

Siv says, again in relation to the sculpture, that the experience, "is something I can *pull out*... where I think about the situation with gratefulness," and Thomas claims, in relation to his experience with *Meaning is What Hides the Instability of One's Position,* that "it touches something which is very central *in* us... it goes into something central *in* us... *I was very filled up*."

One of the pictures Henrik saw for the first time over forty years ago made a strong impression on him. It is the picture "Those Who Wait" (De Ventende) by Sven Wiig Hansen and Henrik claims it is "stuck in [his] head" To him it was and still is "violent and alluring," and he repeats several times how it is "in [his] head permanently."

The retrospective interpretation reveals art as expanding the self-understanding.
Within the framework of Merleau-Ponty's structure of subjectivity, when the self expands, so does the self-understanding as self-understanding is an immediate, lived, and tacit feature. Since experiences with art are experiences of something new that becomes internal to the subjectivity, expansion of self-understanding is

present in all meetings with art. Most vividly, however, reflective expansion of self-understanding is present in the stories of Frederik, Stefan, and David.

In regards to the paintings from the 1500s, Frederik finds that the painters have made concrete their sense of arbitrary loss and mysticism that were present during their time. He thinks that their "immense pain in so precisely depicted," because they had to deal with loss to such a great extent. For Frederik, seeing this concretization of pain gives him a picture of his own pain and loss, which he feels he is more adapt at dealing with through seeing the pictures. The pain becomes more concrete and tangible. Also, these painters' depiction of death and destruction represents to him that progress is not linear, and that they were better at doing some things in the 1500s than we are today. This is a confirming experience for Frederik, again in regard to loss, because there were some things he was better able to do or more adept at ten years ago. Seeing these pictures comforts him as they him help understand that his own situation is a common one, making him accept or resigned to this fact of life, he says.

When Stefan reflects on his experiences with art, he claims that art has had such an effect on him that it has altered his general course of life. When he was young, Stefan was very good at drawing and desired to become and artist. He went to Paris where he saw Derain's painting, *The Two Barges*. It made an immense impression on him, as many pictures have, e.g. paintings by Matisse and the Fauvists. As mentioned earlier, he claims that his early experience with these paintings affected him in such a way that he never became an artist himself. He was, for instance, incapable of painting the above-mentioned picture by Derain which was a shock for him: "It was very strong, almost somewhat violent." Seeing Derain's and these other painters' works in Paris made such a strong impression on him that he decided not to paint for the simple reason that he could not. He could not see, he could not get it right, he attempted to, but could not avoid copying, he claims. If he was going to paint, he had to be able to paint something as good as The Two Barges. Since he could not make art that way, he became an art lover instead, he says. Through seeing these paintings, he understood the limits of his talents and that he would not be able to paint something as magnificent.

David understands and accepts his own melancholia better through seeing it depicted in some of Munch's paintings. As mentioned in the *intense personal interest* section he experiences that "one is not alone in one's depression. It [depression] is a common human experience," and "I have some symptoms, some characteristics, that also have a positive side, and it was something that was accentuated by this Munch exhibit." The pictures affect him emotionally and change his understanding of his own emotional life.

Retrospective interpretations of meanings of art.
The above characteristics are, or could be, present in the aesthetic experiences of all the participants. When it comes to the retrospective interpretation of the meaning of these experiences, what the different participants reveal are not part of a common experiences, since their claims are explicit statements and, as such, not present in all the accounts. Some of the most significant meanings of art which the participants disclosed in the retrospective interpretation are delineated in the following. It could be the case that, if asked, the rest of the participants would agree.

To all of the participants, however, art creates a special experiential sphere that expands and gives content to existence. More specifically, for Siv, seeing art "is just as if one has cold fingers and one gets inside and warms up in front of a fireplace." It carries a meaning that gives comfort in difficult times. Thomas visits the museum to "have an experience." To visit museums is a good experience and it may "increase [his] mood in either direction." He seeks out desirable experiences and tries to sense more and more what it is he likes, what he feels says something to him. He cannot say in particular what it is, but it is usually something which lifts his mood. He attempts not to think too much before seeing art, but "tries instead to notice what it says to him." The best kind of experience with art demands an atmosphere of a certain calmness that places the "everyday" in the background. It is an experience of something that cannot be experienced somewhere else. It is very contradictory to an ordinary way of living that is hectic and noisy, but for the moment one is given over to the situation without any other external demands, he says.

For Kristina, art "opens a picture or gives a different vision [of the world], a vision that is contrary to other information one receives." It gives her "a completely new way of seeing the world... one can follow it, one can easily recognize it, but one could not have made it oneself. It was a recognition of something which one did not really know existed... It sends something into our lives, or body, or such, where there is a connection. An unexpected one which...evokes a response down in me which makes me not just push it aside, because if it did not have that I would just say: 'well, what has this have to do with me?'" With art that reaches her she recognizes or accepts the worldview presented: "it is an accept, but isn't an accept... for instance that fascistic [in the Gormely exhibit], I do not care for it, I find it alarming in a way, so I do not know whether I accept it. But I recognize that it is there." On a more concrete level she feels she gets to understand other minds through experiencing art. For instance, in relation to the Gormley exhibit she claims that the art work is not necessarily just about war and torture, but can just as well refer to the mind. Not her own mind, but other minds, minds with schizophrenia, for instance – minds

that are more disturbed. Through the art work she feels she gets to somewhat understand what it is like to have a troubled mind. The art work reveals a state or way of mind that is not hers, but one into which she feels she gets a glimpse.

To Lise, art is a "special kind of free experience," because with art she does not experience order or instructions, just possibilities. Indirectly she says that from the pluralities of perspectives in art, you experience that things can be interpreted in many ways, "where it becomes more difficult to convince people of what is true and false." With art, one is "free to think."

Horizons of Expectations

Both the first aesthetic encounter and the retrospective interpretation of the encounter are colored by the horizons of expectations. Jauss claims that horizons of expectations are to be found in a "historical reading." What this means is that the reception and the expectations with regard to reception are delineated, beginning with the initiation of the work to the reception at contemporary times. The historical reading involves, for instance, an investigation into what essential words of the text mean now and what they have meant before. It comprises an overview over the text's historical reception. In this book, Jauss' historical investigation into horizons of expectations is adjusted to investigations into the participant's expectations toward their encounter with art. But as Paul de Man (1982, p. xi-xii) notes, "the historical consciousness of a given period can never exist as a set of openly stated propositions. It exists instead as a horizon of expectation." This part of the analysis therefore not only comprises the participants' explicit expectations, but also contains an interpretation of their underlying, pre-conscious expectations toward the aesthetic encounter. This is the reason why this act of aesthetic experience is not only named "expectations," but horizons of expectations.

Harmony between the work and the horizons of expectations is a necessary condition for the experience of a first aesthetic encounter.[3]
Investigations into the participant's horizon of expectations reveal that to experience a first aesthetic encounter is dependent on the work harmonizing with the viewer's expectations of normality. Although expecting newness from art, the newness needs to harmonize with the anticipated frames for newness. The abnormality of the work cannot be too great. When it is, the work of art is rejected. This aspect is most pronounced in Lise's story.

[3] Parts of this section have been published in my article, *Toward a Phenomenology of Art Appreciation (2008)*.

Lise deems her experience with the installation Meaning is What Hides the Instability of One's Position by Sander and Geyer to be unnecessary and annoying (see a detail of the installation on p. x). She rejects the work due to its abnormality in relation to her expectations for works of art. It is a rather large installation comprising a labyrinth with walls of changing images of an airport, including text related to themes that can arise when traveling. As soon as Lise enters into the art work she experiences relatively strong bodily reactions and her mood and emotions are significantly altered from being relatively calm and composed to experiencing strong frustration. She tries to read the text, but it moves too fast and she cannot read it. The work appears as something without meaning. Her heart starts to pound. She feels highly aware of her frustration and rapid heart rate, and wants to leave the work immediately. Her reaction is related to the text and not the images, she claims, as she hardly saw the images. She has not anticipated such a work, or her own reaction to it, and feels overwhelmed. She leaves the work of art as soon as she can, but for a few moments she is lost in the labyrinth. The frustration stays with her to the extent that she feels too affected to be interviewed and prefers to be interviewed about the experience the following day. When talking about the experience the following day she feels frustrated again. She attempts to make sense of her frustration and connects it to her perceiving the work as meaningless when wanting to understand its meaning. She repeats over and over again how not understanding it leads to a rejection of it. She accepts that it is art as it has been given a prominent place at the museum, but wants to understand what the work is about and why it is art. Talking about the installation two years later, she is still frustrated with it. She says, "I was extremely irritated about it [the installation], actually really angry... I can almost sense the irritation [now]."

Her initial encounter with the work of art is one of frustration. It is a strong emotion wherein the body is highly present, too (emotions include, but are not reducible to, the body [see Roald, 2007]). In the retrospective interpretation, she wants to understand both her frustration as well as the work of art. She underscores how understanding the works of art and perceiving some kind of meaning in them leads to an appreciation of them. When such understanding is not present, she rejects the work and wishes she did not have the experience. Her horizon of expectation is, as such, rather pronounced. She rejects the unexpected when she does not understand the meaning: "when I do not understand what it is about then it disturbs or annoys me... It is not a good experience." Rejection takes place when the unknown overwhelms her. Two years later she still does not know what the art work is about, and she gets irritated when thinking about it. If, however, she had anticipated such a work, she might have enjoyed it, especially if given an explanation. Her horizons of expectations change from not

having such an experience to obtaining an intellectual understanding of the work of art. The work does not have the possibility of a first aesthetic encounter for her, as the first aesthetic encounter is not an intellectual experience. Yet, if the appropriate context is given, if she knows that she is to experience something she thinks she is not going to understand, then she does not need to reject it, but can enjoy it. If she expects it, or feels a sense of choice or agency, then it does not overwhelm her: "It is the whole context, which you yourself have chosen to go in to have that experience." She tolerates ambiguity, but only when it is an ambiguity that does not challenge her fundamentally.

The horizons of expectation change when the experiential conditions change.
When the experiential circumstances for aesthetic experience change, the horizons of expectation change, and vice versa. For instance, to be interviewed about their experiences with art changes some of the participants' expectations toward their aesthetic encounters. Adam and Jenny's experience is an illustrative example. In general, the two of them expect more of a stimulation of the sensing by the more formal aesthetic elements in the works of art. When they visit museums and exhibits they characterize their response to each work with reference to a like/dislike polarity, and move rather rapidly from work to work. Adam says "we have always talked about the object, not [about] oneself. It has been: 'that work I really like, that work I don't like.' Then we move on." They both agree that they have found it too pretentious to stand in front of works of art and talk, and have therefore limited themselves from such experiences. Toward the end of the interview, Adam claims that, "we have understood something new about art." Now they feel they get more out of moving in relation to the work, trying to understand the artist's intentions, as well as trying to access their own responses to the works. Along that line, he says, "we have most likely gotten more out of the interview than you because we have been forced to talk about it… Now I will continue to investigate it [his experiences with art], what I feel when I see it, what it really is that I am thinking." When experiencing a different way of relating to art, they no longer anticipate just a like/dislike response to the work, but their horizon of expectation changes to one of personal engagement with the work of art.

Lise reflects on her experience of *Meaning is What Hides the Instability of One's Position* and similar ones, and it becomes clear to her how her rejections of art are dependent on her expectations as well as on the context in which she experiences it. It is analogous to her experience with "modern music." For instance, she generally does not like modern music, she says. When it is played on the radio at home she turns it off; it is just noise. But when she knows that she is going to hear it and has decided to go to a concert, then she might enjoy it. It

does not overwhelm her; if the music is presented when she expects and wants to hear it, she can appreciate the experience. Therefore, she claims, if she had understood what *Meaning is What Hides the Instability of One's Position* was about and had expected to experience something like it, she might in the end have like it. Such an experience happened once when she saw an exhibit of paintings by Francis Bacon. Seeing the Bacon pictures at first was irritating as she did not understand what they were about. Then she went on a tour where they were explained to her. Now, years later, she really appreciates his work.

When works of art do not harmonize with one's horizons of expectations, one's attitude to the work of art can be changed by receiving an explanation of the works' importance. This could potentially change one's horizons of expectation toward that kind of art in general, although it possibly would not lead to an aesthetic experience. Therese points out, "if one talked to those folks [the artists] and listened to what they wanted to do, then it could become interesting... but that would make it into an intellectual experience."

The horizons of expectations reveal the first aesthetic meeting as extending structures of subjectivity.
As the work of art becomes internal to subjectivity it also extends structures of subjectivity. Through aesthetic experiences the subject becomes more, or different, than it was. For instance, Nadja and Michael expect that through getting to know the art of a culture you also get to know the culture. Through art, they argue, you get to learn about the local culture in comparison to that with which you are already familiar with; Nadja and Michael feel it increases their understanding. Nadja also expects something out of the ordinary in her encounter with art; she anticipates "shock therapy... for one-dimensionality" which they experience as penetrating much of their lives. Nadja wants art to expand and stimulate her subjectivity.

Stefan claims that he is affected, struck or moved by art, because, to him, art "transcends." Derain's work accomplishes this by surprising him. Works by Købke also deeply fascinate Stefan. He cannot explain it, he states, yet it is as though Købke paints an idea, for example the idea of "the healing of the tree." To Stefan, Købke paints a different world which can very well appear overwhelming as it surpasses the painting and becomes a symbol. Stefan gets involved with what the painting symbolizes and claims that it wants to give him an idea which makes him intimately familiar with something (which thereby becomes a part of his subjectivity). Once he visited Arles and the saw the house van Gogh lived in. After being there he could better understand van Gogh's paintings: he had painted the hopelessness that is present there. It is a place where one becomes crazy and Stefan and his company had to escape. The sun is

so strong and it is windy all the time. Van Gogh paints the hopelessness and the dreariness Stefan is able to see. Said differently, Stefan contends that van Gogh paints something more: he paints a new way of seeing, he paints a mind. Købke also paints the mind; van Gogh paints a new world, a new way of seeing, an opening. Stefan expects this kind of experience from art – he expects art to transcend in this way, and through the transcendence he gets to understand other minds.

Therese expects "grand art" to move something. She expects that it can "move her," "play with her," and "confront her." To experience art is to remain open to the world: "art is a part of being confronted with something which is different from one's self and gives us a broader understanding of existence, of humanity," she claims. Therefore, "it [art] is not unimportant; it is not just for fun." It "opens one to other channels… from which one becomes more tolerant, understands more;" to experience art is to remain open to new experiences, to alterity and other worlds. It involves an openness to be changed by art and thereby to change one's subjectivity. To Therese, this is art's imperative.

Henrik expects from art that one is invited into the picture one way or another. This happens, for instance, with Per Kirkeby's paintings where the paintings depict something "completely fundamental or aboriginal…and he [Kirkeby] invites me into this rather extreme nature." When seeing his pictures one "develops like Kirkeby does…When he changes I change too." Thus, when Henrik views the pictures of Kirkeby he incorporates what he sees into his own subjectivity and alters according to the paintings.

Art as Intrapellation

Since art objects are unique, yet have similarities, only rather general postulations, as seen above, can be claimed for the wide-ranging phenomenon that is art. At the same time, art relates to its tradition, but is art by virtue of changing it. And it is exactly in change that aesthetic experiences stay the same: because the work of art offers something new, this experiential newness is an essential feature of art, and the experiential newness can be described through what I have termed an "*intra*pellation." The participants intrapellate and incorporate the work of art into their subjectivity, wherein the aesthetic experience becomes a background tone or color which, most of the time, decreases over time, but which, in some instances, can take over the foreground at essential moments. As such, the intrapellation is possible through the body-subject's conscious and preconscious horizons of expectations against the expected unexpected.

Before venturing into the concept "*intra*pellation," a short description of the counterpart to "intrapellation," namely the concept "*inter*prellation," will be pro-

vided. "Interpellation" is a Latin word which describes an action: "The action of interpellating or of interrupting by question or appeal" (Oxford English Dictionary, 1994). Historically, by the 1700s the term was no longer used in English, but was revived in French in the 19th century to denote a procedure by which someone in a legislative body interrupts regular proceedings in order for a representative to give an explanation (ibid.).

*Inter*pellation is first developed as a philosophical concept by Louis Althusser in his essay *Ideology and Ideological State Apparatuses* (1971). Writing from a Lacanian-inspired, neo-Marxist point of view, he introduces the concept in order to negate the conception of subjectivity as "false consciousness." He indirectly critiques the popular conception of the subject as "the disappearing moment" by developing a Marxist theory with a positively situated subject and consciousness. According to Althusser, there can be no consciousness but a positive (appearing) one, and consciousness cannot arise save in ideology. Along this line he writes that we all "live 'spontaneously' or 'naturally' in ideology in the sense... that 'man is an ideological animal in nature'" (Althusser 1971, p. 116). Ideology and subjectivity are all-embracing (save for science), and the former cannot exist without the latter, and vice versa. Interpellation is, in this regard, the process by which ideology creates subjectivity; it is the positioning of someone as a particular kind of subject, comprising both recognition and misrecognition. Althusser gives an example of interpellation: "we all have friends who, when they knock on our door and we ask, through the door, the question 'Who's there?, answer (since 'it's obvious') 'it's me'. And we recognize that it is 'him' or her'. We open the door, and 'it's true, it was really she who was there'" (ibid, p. 117).

Interpellation connotes a concrete act that someone does to somebody else. There cannot be ideology without concrete subjects "carrying" ideology, and Althusser emphasizes this very concrete relation between subject and object or, perhaps more appropriately, between subject and subject. Interpellation, then, should not be construed as a noun, but as a verb, such that someone interpels someone else, and it is when this second someone accepts the interpellation that she becomes interpelled. It is "ideological recognition," whereby ideology refers to any kind of cultural artifact or "practical ritual" that is not scientific.[4] In this system there is a degree of freedom, posits Althusser, since one can ignore the interpellation. Then one is a "bad subject," yet a subject nonetheless. The subject must exist as (an accumulation of) positive acts, and is compelled into action

[4] To Althusser, science exists only as "pure" and without subjectivity. The scientist might be scientific, but is also always ideological.

through the sheer fact of being born – it cannot exist only through "negative acts" or through negating interpellations.

Judith Butler, who was instrumental in popularizing the concept, stresses in her book, *Excitable Speech: Politics of the Performance* (1997), that the constitution of subjectivity also occurs in the rejection of an interpellation, since it is through a Hegelian dialectic (without synthesis) that the subject creates its position and comes into being. (When reading Althusser, there are some explanatory problems in the relation between ideology, subject, interpellation, and rejection of interpellation[5] which Butler expands upon in her dialectical constitution of subjectivity.)

So perhaps an interpellation can be negated, neglected, and ignored. Žižek (1999) argues in *The Ticklish Subject* that it is exactly in this act of acknowledging yet refusing an interpellation, in the act of resistance or struggle, that the subject comes into being; it is when the subject does not recognize itself in the interpellation that it comes into being; it is in this struggle with the gaze of the Other that the subject exists, attributing certain perspectives onto this gaze and engaging in battle with this projecting and projected gaze.

Keeping these various conceptualizations of interpellation in mind – what is *intra*pellation? Theoretically, "intrapellation" presupposes an internal psyche that is positively situated in a polar relation to the world. This assumption rests on the existence of a "minimal self-awareness" or a "stream of consciousness" (somewhat different experiential features, but this difference does not matter here). These structural features are not reducible to the external world, thus the subject cannot be a "disappearing moment" or only relationally constituted. They are universal, positively-set-forth features of subjectivity. In the meeting with a work of art, this positively-appearing subject[6] experiences the other (not the Other). It experiences something new which is simultaneously not so radically new that it is too different to be accepted. It experiences something which

[5] Because Althusser emphasizes the acceptance of the interprellation as the constitution of subjectivity, but at the same time the "bad subject," the subject that rejects the interpellation is also recognized as a subject.

[6] Experience varies in intensity and awareness, and, in this regard, it may be paradoxical to call the individual a "subject" in the meeting with art, as it might be one of those situations in which the individual is 1) the most free (as e.g. Schiller (1795) and Marcuse (1978) argued), or 2) closest to itself in the way that its whole autobiography might be in play. It might also be an act of heightened awareness to the extent that the whole individual is alert and concentrated with a greater degree of freedom, as it is only indirectly a subject-subject relation while directly a subject-object relation. "Hell is other people," said Sartre (*No Exit*, 1946), and it might be that in the meeting with art, one obtains the benefit of the presence of the other while avoiding the other's direct gaze.

harmonizes with previous experience, but also extends this experience toward its limits. This new experience does not directly challenge the subject, because it is not a battle, but the experience calls either gently, harmonically, loudly, or insistently to the subject to accept this experience as its own. There is no overwhelming resistance; it is either an active or passive acceptance of this new experience. By accepting this call, the subject acknowledges its present self and also the self into which it is moving. It extends the limits of its experience, thereby altering its own self-understanding ("understanding" in its broadest conception, as it is also emotional). Its self-awareness has expanded (directly or indirectly) by means of intrapellation: by being open to and accepting its own experience as real, the subject calls upon itself to change, to take its own experience seriously. It is a partially self-initiated plunge of self-understanding. Thus, when meeting the work of art, the subject projects a certain part of its experiential dimension onto the object. The work of art has the power not only to meet the projection, but also to enclose it and add to it to the extent that the primary projection becomes intertwined with some new content, thereby having the potential for expanding subjectivity by the creation of a new experiential presentation. The work of art contains new material which one can accept and by which one can understand one's self. Intrapellation is therefore a projection of feelings and imaginings onto the work of art (externalization) which the work of art somehow confirms and expands, and in meeting this expansion, one agrees and identifies with it (internalization). It is at once recognition and acceptance to the extent that it expands subjectivity such that it is no longer a projection, but an acceptance of the new experience. It is somewhat similar to the psychoanalytic concepts of introjection and projection, where the affective valence determines whether an object becomes introjected or projected. If it is "good," then the significant features of the object become part of the self via "introjection," and if it is "evil" it is placed in the external world via "projection" (Olsen and Køppe 1988). In regard to intrapellation, it is not mainly the affective valence that determines the kind of process in play, but, rather, whether the work of art makes sense – whether or not it gives meaning – not only for understanding, but for the whole affective body-subject in its world. The call to accept this new experience can also be rejected, however. The subject may be closed off in its world and does not, for various reasons, dare to enter new territory. In this sense, the intrapellation is rejected even before it has the possibility to take effect. Few works of art have the chance at a particular point in time to unite with a particular, developing subjectivity. But there are many subjects, many works of art, and many themes that are common to a larger number of people. It becomes evident, then, that the work of art should exist at the limits of experience through a constant process of renewal.

Based on the structures of subjectivity, the structures of aesthetic reception, and the empirical material, it appears that a particular intentionality constitutes (one type of) aesthetic experience. Paraphrasing Merleau-Ponty's writings, it is of a quiet, yet all-encompassing emotionality; one of openness, quiet contemplation, and (over)powering vitality. It appears as an experiential mode that has significance beyond the intellect, yet includes understanding, as broadly conceived. Experiences with art bring to light the various experiential modalities in all of their vivacity – their activities and their various combinations – (perception, thought, affectivity, language, sexuality) in a continuous exploration at their outermost limits. Also, in experiences with art, one's manner of being in the world, at that point in time, is projected onto the work of art, and the work of art can, under the right circumstances, meet and return the projection with an increase in content or a renewed power, whereby it functions as a work of art. At the same time, the fascination in the meeting with art lies in its "power of equivocation" and in the "process of escape." There is no one particular meaning, but many. Still, a particular function can be identified which lies in the interruptions, "breaks," or "intra-ruptions" of self-understanding; the art works by what is named an intrapellation.

Experiences with art are not autonomous, not of a particular presentation or constitution of mind, but of a particular biographical mind which is not only personal but social, and which links particular experiential modes to the work of art in question. It is a continuous constitution of the social and the individual in a dynamic, mutual, and polar relation, whereby the art work and the experience are given and created in a continuous and partly concealed process. Nevertheless, experiences with art are anticipated yet occur ambiguously, as the experience is, at times, an unexpected meeting with an unknown object. The experience is also dynamically sedimented in history and biography, and it is, therefore, an impossible undertaking to seek a full explanation for why a particular work matches a particular and continually evolving biography.

Based on these analyses, it appears likely that art works by expanding the experiential modes; that it illuminates new ways of experiencing. This working also comprises the interplay between the subject and the object that is not limited to any one feature in the experiencing subject. There is a harmonic recognition: an experience of harmony which is not necessarily of "the beautiful" or "the good," but can just as well reveal "the ugly." It is surprising, yet contains both recognition and acceptance simultaneously.

Aesthetic experience can be investigated, described, and interpreted as it occurs in time through not only the first aesthetic meeting, but also as it comes into view in the "sobriety in retrospection" and in the "horizons of expectations" as depicted in the interviews. Although the experience is one of personal history

and biography, general experiential structures beyond the particular subjectivity can be identified. Based on these structures a particular function of aesthetic experience appears: aesthetic experience has the potential to change the self-understanding through the act of externalization and internalization – through intrapellation.

5

Aesthetic Experience as a Challenge to Subjectivity and Aesthetic Theory

In the previous, empirical chapter, it was discovered that art works by means of intrapellation. This conclusion was proposed as a conclusion of general validity: if one has an aesthetic experience it is because one has had an experience of intrapellation. It was also realized that the act of intrapellation builds on several general characteristics and conditions of aesthetic experience. In this chapter, these findings will be discussed in relation to structures for subjectivity and traditional objects of aesthetics. The overarching theme is the validity of aesthetic experience as intrapellation – aesthetic experience qua experience – as a challenge to aesthetic theory. In this regard, validity is temporal, dynamic, open-ended, and without absolutes. It is neither fully transparent nor completely opaque, and emerges through the development of concepts and theories that are intersubjectively convincing. With validity, as Merleau-Ponty argues in regards to perception, perspectives blend and coincide. Validity is dependent on the strength of the relation of the findings to the theoretical and empirical.

The results of the empirical study showed that the first aesthetic encounter is one of intense personal interest, an interest which is characterized by affection. Although affect cannot be reduced to the body, the first aesthetic encounter is characterized body ambiguity and includes the body as an affective presentation. It contains subject-object ambiguity and, as such, time and space ambiguity. It is an open meeting with something new and unexpected, a meeting which resonates as compelling and convincing, yet is largely pre-reflective. Differently, the retrospective interpretation is one of reflection, but appropriates many of the same characteristics as the first aesthetic encounter. As such, it is characterized by open inquiry and by affection. The retrospective interpretations also reveal that the work of art becomes most reflectively meaningful in the more immediate time after experiencing it, and the work of art appears through intuitive reflection rather than formal reflection. The retrospective interpretation also reveals art as expanding self-understanding, and understanding the work of art is a dialectical process through which the work becomes internal to the subjectivity.

Beyond these characteristics, the retrospective interpretation shows that aesthetic experience does not have one particular meaning but many. It is in marked contrast to everyday experience, laden with radiant meaning or fraught with significance. Full of meaningful reassurance, it intensely and significantly reveals other minds and other world views, showing one's own world and one's own view as one among many. One's world is but one perspective, wherein truth has become complex. Easy answers are therefore no longer an option, possibly leading to "rebellious subjectivities," who do not accept simple solutions being handed to them. At the same time, the horizons of expectation reveal that a certain degree of harmony between the work and the expectations of the work is a necessary condition for the experience of a first aesthetic encounter. That a degree of harmony is necessary means that the work of art cannot be too radical in its newness, as it will be rejected as a possibility for an aesthetic encounter. Yet, the newness can be given a new framework for understanding in that the horizons of expectation change when the experiential conditions change. Finally, the horizons of expectations reveal the first aesthetic meeting as extending structures of subjectivity.

All these characteristics described above inform the conclusion that aesthetic experience functions by means of intrapellation. The claim based on the empirical chapter is this: if an aesthetic experience takes place, these characteristics are present (besides the one of the retrospective interpretation where aesthetic experience has many meanings). The characteristics cannot be detected in all the interviews, but they have the possibility of being present in all of them. There is nothing in the interviews which contradicts that they could be present. It appears, however, as though there are individual variations in respect to the intrapellation where different experiential dimensions take the foreground dependent on the individual and the work in question.

Nevertheless, these characteristics together do not give a complete account of aesthetic experience. The characteristics are necessary conditions, but they are not sufficient in the sense that they do not distinguish aesthetic experience from all other experiences; they are not exhaustive. For instance, why can an experience of another human with projection and introjection, as psychoanalysis proposes, not be an instance of intrapellation? What is the particular content of art that generate intrapellation? No accurate answer can be given based on the empirical material and the theoretical review, and this book is a part of the continuous delineation of aesthetic experiences in relation to the art phenomenon. Perhaps what distinguishes aesthetic experience from other experiences is the lack of a gaze that looks directly back. Art only represents, perhaps gratefully so, an indirect other, possibly leading to a different degree of freedom, which is nevertheless also present in the apparent lack of external demands and

in its distance from mundane, everyday life. Perhaps the intrapellation of art is conditioned by these features in conjecture with the sensuous materiality of art.

This conclusion that aesthetic experience works by intrapellation is based upon the empirical material and Merleau-Ponty's structures of subjectivity as developed in *Phenomenology of Perception* (1945a). This juxtaposition of the theoretical and the empirical raises the question of whether it is legitimate to use *intra-* as the prefix in *intra*pellation? After all, Merleau-Ponty claims that the self is "outside," that I am "identical with my presence in the world and to others," and "I am all that I see, I am an intersubjective field" (ibid., p. 525). He concludes, moreover, that, "nothing determines me from the outside, not because nothing acts upon me, but, on the contrary, because I am from the start outside myself and open to the world" (ibid., p. 530). These statements seem, at first, to suggest that the subject is determined by "outer" events, that there is no self with internal structures which affect how the subject acts in the world. Instead, the self is the coming together of certain forces at any given time.

These are not the only statements or arguments which support the assertion that for Merleau-Ponty there is not an inner self; other features of Merleau-Ponty's model of perception support the claim that there is no "inner." For instance, when he builds his theory of perception, Merleau-Ponty argues against representations. To him, there is no such thing as representations (which would structure the inner). From a mechanistic and scientific point of view, the "experience of the body degenerates into a 'representation' of the body; it was not a phenomenon but a fact of the psyche" (Merleau-Ponty 1945a, p. 108), he argues, and there is "no interposed context" (ibid., p. 157). In line with much of the phenomenological tradition, he finds "representations" a useless concept which ignores the immediate access of consciousness to the world.

Another reading of Merleau-Ponty shows that he contradicts himself. He has become too radical in his explicit rejections of representations; implicitly they are present in his theory. For instance, the citation where he says that subjectivity is "identical with my presence in the world" is not consistent with the rest of his writings, because there is also an internal which is not immediately transparent, in Merleau-Ponty's writings. The first person givenness of experience, i.e., that experience must be experienced by someone and that there normally is no doubt about the fact that it is I who experience, is a principle which suffuses his work. A view is always a view from somewhere; perception is always perception from a given perspective. A fundamental characteristic of subjectivity is its transcendence toward the world, and that fact is conditioned by there being someone who transcends. There is an absolute polarity of subjectivity which is in contrast to the world; it is the foundation for the transcendence, but, via the transcendence, is also the world. The self is both outer and inner, and the one is a condition for

the other; they are in a reciprocally dependent relation. The subject is inseparable from the world, but it also has an inner world that is formed through its action in the outer world that "sediments" in the inner (and is the condition for spontaneity). In keeping with this, Merleau-Ponty contends that there is "internal," "inner perception," (Merleau-Ponty 1945a, p. 442) as well as "external" perception, and he refers to "psychological structures" (ibid., p. 529). And as Merleau-Ponty reveals in the chapter, "Others and the Human World," the condition for intersubjectivity is that there is subjectivity, an absolutely given perspective. Subjectivity conditions and is conditioned by intersubjectivity. Intersubjectivity is developed as the subject acts in the world and discovers other perspectives which it can take up as its own, whereby the other perspectives become a part of the subjectivity.

This internal part of subjectivity is further structured by what Merleau-Ponty names "body-image"[1] (Merleau-Ponty 1945a, p. 113, 114, 163, see also Gallagher, 2005), which is an activation of representations disguised as "body-image." When Merleau-Ponty argues against representations it is against the traditional view of representations as inner mental tokens which mediate between the self and the world. "Body image" is (just) another term for a mental representation transferred from the ontology of a solipsistic cogito to that of a body-subject in the world. The traditional view of representations maintains that they are mental associations learned from experience. A representation of the body, for instance, would be a mental image of the various body parts positioned in relation to each other, learned from association derived from experience of an objective body. Instead, Merleau-Ponty argues that "body image" is an image based upon the totality of experiences of the body-subject's projects in the world. It is an immediate awareness of one's own body, other bodies, the cultural as well as the natural world, and not an intellectual synthesis. The body-image functions by means of the body-subject's history or biography. To be aware of having a history, however, is to have associations, or representations, broadly understood (for instance Husserl 1966a argues this). It is not necessarily explicit associations arrived at through an intellectual synthesis, but associations which are sedimented, lived, and implicit. Merleau-Ponty, therefore, camouflages representations within the concept of "body-image" as a feature that helps

[1] In the original French version of *Phenomenology of Perception* (1945b), Merleau-Ponty uses the word "schéma corporel" (pp. 128, 129), which is translated as body-image in the English version. It could just as well have been translated into body-schema. The translator possibly wanted to avoid translating "schéma corporel" into body-schema as it lies closer to the word "representation" via the use of "schema" and "schemata" in cognitive psychology.

structure inner subjectivity. Intrapellation is not, then, a concept developed against Merleau-Ponty's theory of perception, but is coherent with it.

After developing the concept of intrapellation on a phenomenological basis, support for the concept, or for the mode of functioning which the concept denotes, can be found in other fields of psychology and art theory. The more the concept can be mirrored in other traditions, the more likely it is that the concept mirrors something that is true, because, as Merleau-Ponty suggests: "we shall find this same structure of being underlying all relationships" (Merelau-Ponty 1945a, p. xxi). Its presence in other schools of though suggests that it represents an essence of truth beyond tradition. In this regard, support for intrapellation is found both in psychoanalysis as well as in art history.

From a psychoanalytic perspective, Anton Ehrenzweig (1993) describes the creative process on behalf of the artist akin to the reception process of intrapellation. Ehrenzweig argues that artistic creation[2] takes place through "projection, followed by the partly unconscious integration (unconscious scanning) which gives the work its independent life, and finally the partial re-introjection and feedback on a higher mental level" (ibid., p. 57).[3] Thus, he ascribes both projection and introjection as being essential features of artistic creation, similar to those which the concept of intrapellation denotes for art, albeit based on an unconscious. Ehrenzweig gives several examples which resemble intrapellation. For instance, in relation to music the novice listener focuses on the principal melody as the object of the music and is not able to hear other aspects. With training, however, Ehrenzweig proposes that the listener can hear both the main melody and the totality of sound: as the novice progresses, other features of the music can take precedence and the listener can now flexibly move between different aspects of a piece; between "total listening" and listening to the main melody, for instance. In such development, Ehrenzweig proposes, the listener has moved beyond the common gestalt principle of "focused perception" (ibid., p. 27), i.e., of hearing simple forms. As a trained listener, the focused perception is dispersed and the listener hears wider aspects of the music, such as how the main melody interacts with a counter melody or a secondary theme to create a synthesis. This process resembles intrapellation in the way that the subject projects its own form of hearing onto the music, but then the music contains even more, which listeners gradually understand and incorporate into their own subjectivity as a new way of perception.

[2] Ehrenzweig does not say much about the reception process.
[3] Unconscious scanning, Ehrenzweig proposes, is perception that is undifferentiated and total.

But there is a particular, phenomenological aspect of Ehrenzweig's theory which appears to go against the characteristics given for aesthetic experience: that artistic creation is anxiety-producing. In the stories of reception told by the participants of this study, the aspect of harmony was much more present than that of anxiety. The opposition between the theories is only superficial, however, because the presence of harmony does not mean that there is no room for anxiety. There were anxiety-producing interactions with art in the empirical material. Differences in degrees of newness (as well as in content) have different existential importance. Newness exists on a continuum where radical newness can, most likely, be overwhelming and cause, or nearly cause, rejection of the work of art. At the other end of the spectrum, however, the newness harmonizes with previous experience, yet brings some new aspect in, leading to the view that the work is in complete accordance with what it should be, which, nevertheless, was not already known.

Ehrenzweig refers to the art historian Ernest Gombrich who presents a process similar to that of intrapellation in both his famous works, *The Story of Art* (1950) and *Art and Illusion* (1959). Gombrich argues that art has history because it works through representations, and significant changes in representations lead to new styles: a culture creates horizons of expectations which form relations to works of art. These expectations are the base on which the work can be experienced as meaningful and, when there are new representations in art, "shock" and "adjustment" follows (1959, p. 47). Incorporating the new representations into one's subjectivity could be a part of the act of intrapellation. An example could be the transition away from the Renaissance. In the Renaissance, the general purpose of art was to portray natural beauty. At the dawn of the French Revolution, a new style of reflection, or self-consciousness, was on the rise in the visual arts, too. Gombrich (1950) gives the example of the painting, *Charles I demanding the surrender of the five impeached members of the House of Commons* (1641), by John Singleton Copley (p. 482), who shifted from portraying beauty to representing historical events. Copley felt much freer in terms of the subject matter and was no longer confined to the beautiful. The work portrays representatives of the people rebelling against unjust authority. Those who saw the picture likely experienced quite a shock, due to its unusual subject matter. Yet it likely resonated with the overall mood at the time, and its content perhaps gradually took form in their subjectivities, too. Not that there hadn't been rebellious subjectivities before, but it was the first time in the Renaissance where these sentiments could reverberate in a picture, which may have led to an aesthetic experience of intrapellation.

Gombrich gives other examples in *Art and Illusion* (1959), for instance of the painter John Constable, working in the 1800s, who discovered and experimented

Aesthetic Experience as a Challenge 143

with "the shift of scale" (ibid., p. 327), or changes in the use of lighter colors. Such an event brought about a new, lighter way of experiencing nature and this effect was named as "Constable's snow" by his generation (ibid., p. 327). The work, therefore, followed an aim of art, which is to teach one to see "the visible world afresh" (ibid., p. 324). Thus, Gombrich shows how the artist is guided by contemporary rules and schemata, experimenting with their limits, possibly arriving at different schemata (which give rise to new canons). When the representations reveal something new and convincing, the given culture incorporates the schemata into their mode of visual thinking. This leads to a large scale, collective intrapellation, which reflects the changes in style, confirming that art has a history.

Aesthetic Experience and Structures of Subjectivity

Some comments were made above about intrapellation in relation to similar conceptualizations in other fields of inquiry. Now the topic shifts toward the relation between aesthetic experience as intrapellation and the structures of subjectivity, as discussed in Chapter Two. Do the ways in which these structures are present in aesthetic experience confirm or correct for the previous theoretical conceptualization of subjectivity?

With regard to the pre-reflective aspects of aesthetic experience, their significance is lost to that which cannot be said. The significance is not lost to the one who experiences it, but to the one who sets out to convey it in words. Aesthetic experience contains more than its linguistic translation, making comparisons between variations in pre-reflection difficult to verbalize. Nevertheless, there are some points of divergence as well as convergence in regard to pre-reflection in the empirical material and the theory presented in Chapter Two.

In relation to aesthetic experience and pre-reflection, the self comes into expression (among other things) as intensely present in the object. Does this aspect of aesthetic experience mean that the experience is immediate and direct, without representations? If aesthetic experience is one of the most intense experiences to be had, then Husserl's dictum that those experiences with the highest degree of presence are without representations needs clarification. Presence without representation is not a main characteristic of aesthetic experience because aesthetic experience, based on the empirical material, clearly links to personal history and is therefore comprised of memory and representations. Representations are at least a part of the precondition for the selection of the work of art as relevant and present in the interpretation of the first aesthetic encounter. Yet it is possible that prior to and after the

representations, the work overwhelms and presents (not represents) something. There is room for a moment without representation. This means that Husserl's postulation is not sufficiently nuanced, but also that Merleau-Ponty could possibly be correct in his proposition of direct contact; that there is a "field of primordial presence" (Merleau-Ponty 1945a, p. 106), wherein the "object speaks directly to all the senses" (ibid., p. 264). This potential for a moment without representation in aesthetic experience holds open the possibility for a pre-personal encounter, which allows for Merleau-Ponty's argument that "every perception takes place in an atmosphere of generality and is presented to us anonymously," (ibid., p. 250) and that there is "a primordial silence" (ibid., p. 214) which underlies and penetrates all experience. The pre-reflective characteristics of aesthetic experience are intensely personal (through the representations), but can potentially have pre-personal characteristics, too. It could be the case, however, at the level of pre-personal experience, that perception is so basic that art does not exist. Perhaps art is of higher complexity so that at the pre-personal level the work does not exist as art, but as colors and shapes without unity, without work characteristics.

As concerns aesthetic experience as pre-reflective experience and presence experience, the fact that art is, in principle, both of the natural and cultural world confounds the application of Gumbrecht's (2004) presence experience (experience of materiality) on aesthetic experience. The presence experience of art cannot mainly be of materiality as art is of both material and culture, but transcends its materiality in order to be art (as described on p. 38). Therefore, when aesthetic experience is a presence experience[4] and art is per definition more than its materiality, then Gumbrecht's presence experience describes only one of the fundamental aspects of aesthetic experience. In converse to Gumbrecht's presence experience, aesthetic experience is both cultural and structural, yet the possibility cannot be denied (based on the given theoretical and empirical material) that in the act of the expansions of the projection there are moments which are acultural and astructural. The possibility that aesthetic experience has moments which are acultural and astructural is perhaps a part of why the experience is commonly described as "ineffable" or "indescribable." But such a description is largely incomplete as the aesthetic experience for the most part attains its significance when the work achieves cultural and personal relevance and importance (as Gumbrecht persuasively observes).

Other aspects of pre-reflection in aesthetic experience are its elements of time and space. Intentionality, time, and space consciousness take place in the object and oscillate between the subject and object, where they are ambiguous and flow

[4] This appears in the subject-object ambiguity of aesthetic experience.

in and from the relation between the subject and object. And Jauss' model allows for such ambiguity. The linear, measurable time of Jauss' model, where time necessarily flows from the first aesthetic encounter to the retrospective interpretation of it, is close to experienced or subjective time, as the first aesthetic meeting is obviously also the experiential precondition for the reflection upon it.

In regard to sensing, the results from the empirical material concur with Merleau-Ponty's claim that sensing is behavior, in the way that behavior is a part of the sensing and informs it. The participants take up the experiential body-positions of the work of art or of the exhibit, affecting or filtering the subsequent focus or process of sensing. That objects demand attitudes, or bodily positioning, does not mean that we all react to the same objects the same way or that culture does not have a say in our reactions, as evident from the empirical material with the individuals' specific relations to the work of art. This is in line with Merleau-Ponty's thinking in that he stresses such personal relations to objects, as he argues that "I find that in the sensible a certain rhythm of existence is put forward – abduction or adduction – and that, following this hint, and stealing into the form of existence which is thus suggested to me, I am brought into relation with an external being, whether it be in order to open myself to it, or to shut myself off from it...the sentient subject...enters into a sympathetic relation with them [external beings], makes them his own and finds in them his momentary law" (p. 248). In other words, an object implies ways of engaging with it which can take different forms dependent upon the individual in question and becomes a part of that individual's sense history (which forms later ways of sensing). The empirical material supports Merleau-Ponty's claim that sensing is shaped by an individual's history of sensing, where the object or fields of perception are formed both by one's history of perceiving and by the objects themselves which demand a particular, unavoidable way of perception.

Aesthetic Experience, Affection, and Emotion
Hegel explains a process of desire which has similarities to that of intrapellation. He describes sensing as a process of "mere apprehending" of the object, followed by internalization and externalization of it. Turning that process on its head, intrapellation begins with a projection (which could be said to be an externalization). There is no "mere apprehending" of the art work as the art work is perceived through the projection. Then the introjection (or internalization) takes place, where the projection has been met with an increase and invigoration in content, which becomes a part of the subjectivity. Intrapellation is close to Hegel's description of the process of sensing, but in reverse.

Similar to Hegel's conception of sensing, aesthetic experience is of desire, affection, and emotion. Distinguishing between affect and emotion, aesthetic experience, on a general level, comprises a degree of affection toward the work of art. Affection in aesthetic experience is in keeping with Merleau-Ponty's argument of affection as a part of perception. Aesthetic experience can also contain more distinct emotions, however, which take place on a much more specific level, depending on the specific subjectivity and the specific work of art in question as well as their affective and emotional horizons. In this sense, intrapellation can be said to contain both affect and emotion, as the initial projection contains affect, but when the affect is met with new content it has a potential to be turned into an emotion (which is more distinct) which becomes a part of the introjection in the body-subject. (The projection could possibly also work the other way and comprise a more distinct emotion which becomes diffused into affect throughout the intrapellation). An important point here, especially when stressing the body-subject is that emotions are not reducible to physiological reactions of the body (as argued in Roald 2007). Emotions of the body-subject are still defined through their felt, experiential aspects (as Merleau-Ponty also points out), and not by their physiological correlates.

In aesthetic experience emotions are always "true" and not "false" or "misrepresented," as Merleau-Ponty proposes emotions can be (see Chapter Two). The subject feels what it feels in front of the work of art, and as Merleau-Ponty also says, when felt, an emotion is always true. They are, as such, neither false nor misrepresented, but emotions and affects can have varying degrees of reality for the subject and can be accepted as more or less relevant. That being said, there could be cases of misrepresentations, but then the experience is not aesthetic. Irrelevant emotions can be projected onto the work, whereby there would be a mismatch between the content of the work and the emotions felt. Ehrenzweig (1993) worries about this feature: the subjects' potential to "project their private daydreams" or "any meaning" (p. 97) onto the work of art, thereby not engaging with the art as art. When such events take place, however, it is not an aesthetic experience that occurs, because for an aesthetic experience to take place, the projection needs to be met in the work of art, whereby the introjection becomes one that contains invigorated and new content. Then the work is met as a work of art. Only in the case of not encountering the work of art but only ones daydreams does it make sense to talk about "misrepresented" or "inauthentic" emotions (although it probably makes more sense to talk about irrelevant emotions). In aesthetic experience, however, there is room for different degrees and kinds of emotionality, although intensely present affect is one of the characteristics of aesthetic experience.

Continuing with the emotions, Merleau-Ponty also claims that emotions are arbitrarily constituted. In aesthetic experience, the only arbitrary aspect of emotions lies in the possible accidental meeting between a specific subjectivity and a specific work of art. When a work of art works on a specific subjectivity, how the emotions are constituted or introjected is not at all accidental but fully dependent on the work of art and the particular subjectivity.

Merleau-Ponty also argues that emotions sustain a situation. That feature is particularly present in intrapellation: affect (and possibly emotion) is a part of the projection, but an emotion can be developed when the projection is met with new content. This affective content, as a part of the introjection, help sustain the situation – the first aesthetic encounter – and the transformation into the retrospective interpretation of the significance of this first aesthetic encounter. In the aesthetic experience, then, emotions and affects are continuously constituted in the dialectical process between the subject and the work of art. They are not internalized then externalized, but vice versa: they are projected and introjected. Affects, emotions, and feelings are created in the dialectical process of the body-subject in action in the world.

Aesthetic Experience, Reason, Reflection, and Self-understanding
Aesthetic experience is not only of the affects and emotions, or indistinguishably intertwined with them, but pronounced in the retrospective interpretation of the first aesthetic encounter. A truth of art is available to reflection, but it is not in the formal reflection upon the work's characteristics where the work attains its significance, but in the informal reflection. If our contemporary time is mainly a *reflexionskultur*, aesthetic experience could be, as Hegel suggests, a remedy to alienating, formal reflection. However, since subjectivity is constituted intersubjectively, the artist's sensuous truth is not only subjective, as Hegel claims, but intersubjectively available. With Merleau-Ponty's model of subjectivity, the significance of art is not lost to subjective self-expression, and the intense, affective presence of the work of art in aesthetic experience could be a counterbalance to the otherwise destabilizing reflection. Aesthetic experience carries a certainty or conviction about the work of art whereby aesthetic experience negates doubt; it reassures the self beyond reflection. This experiential certainty is beyond the cogito, yet it is to the cogito that the explicit significance of the aesthetic experience is revealed.

Therefore, with Merleau-Ponty's use of the terms "reason," "reflection," and "self-understanding," there is an unnecessary shift in the meaning of the terms. For instance, when Merleau-Ponty says that thought is "pure feeling of the self" (p. 470), and thought must be said to be synonymous with reflection, its meaning overlaps with feeling to such an extent that it becomes meaningless. Although he

points out that it is the body-subject which is the condition for reflection, experientially the phenomena of reflection and emotion should be distinguished, although there is no cognition without emotion and vice versa. The limits of reflection with regard to aesthetic experience also delimit the explicit significance of art, just as affect, emotion, and pre-reflection hide its implicit significance.

In the meeting with art, self-understanding is always expanded implicitly, and the same can take place explicitly, too. In converse to Merleau-Ponty's theory of the body-subject, where the cogito is held to be a gift, yet largely ignored as important in meaning creation, explicit self-understanding (of the cogito) cannot be ignored as unimportant, as explicit understanding is based on the implicit understanding (as Merleau-Ponty shows), and, most likely, explicit self-understanding in aesthetic experience is the process coming full circle.

In relation to Merleau-Ponty's concept of hyper-reflection, it is not clear that it exists in relation to art. Hyper-reflection is described by Merleau-Ponty as the pre-reflective reflection that investigates the gap between reflection and pre-reflection. If such a concept has aspects of reality, it is not revealed as a significant characteristic in the meeting with art.

Aesthetic Experience and Aesthetic Theory

If the arguments for the nature of these structures of subjectivity and for the conclusion of aesthetic experience as intrapellation carry a conviction, they also pose a challenge to aesthetic theory. The following section takes up this challenge and compares aesthetic experience as intrapellation with the aesthetic theory reviewed in Chapter Two, beginning with the formal inauguration of aesthetics as a theoretical discipline.

With Baumgarten, the object of aesthetics is to scientifically investigate the formal rules of beauty. Aesthetics is presented as a rational inquiry which links the arts to the affects at the same time as it subsumes the perception of art under the cognitive faculty. Aesthetic experience as intrapellation shares some similar features to Baumgarten's early aesthetics. Both models conceive art as linked to affects. At the same time, aesthetic experience as intrapellation uses a more psychologically nuanced model than Baumgarten's, and supports, as well as challenges, his psychological assumptions. As argued elsewhere (Roald 2007), there is a point in distinguishing thought from the cognitive process of perception. In this way, the foundation of intrapellation is similar to Baumgarten's model in that the first aesthetic encounter is not of thought, but of perception that is also cognition. In line with Baumgarten, cognition is not pure cognition of the art, but cognition that is linked to affect. Baumgarten also argues

that aesthetics is perfect presentation, and the same must be said to be the case when aesthetic experience as intrapellation takes place. The work of art is the perfect presentation for a specific subjectivity, or specific subjectivities. Contrary to Baumgaten, however, there is no need to subsume aesthetic experience under cognition, as it is just as much of affection. Perception is both cognitive and affective; the dominance of one over the other is not warranted. There is no reason to characterize the experience as dominated by cognition because affection sustains the aesthetic situation. The affects reveal the truth claim of the situation for the subject.

In contrast to the view of the Pythagoreans, with the conception of aesthetic experience as intrapellation it is not an objective cosmic order which should be harmoniously represented in art, but subjective truths. These subjective truths are intersubjectively available and harmonize with the horizon of experience in particular subjectivities. In this sense, representations in art are not false, as Plato proposes, although they could represent illusions. In addition, Plato can be faulted for connecting art with hedonism. Emotions and affects in aesthetic experience are neither part of a subject that self-indulges (at that moment) nor are they alienated from reason; instead it is an experience which strengthens subjectivity in informal reflection. At the same time, in line with Plato, aesthetic experience is a continuous desire via the "educative Eros of the transient senseworld," and emotions such as pleasure and gratefulness follow the first aesthetic encounter. It does not necessarily involve a purification of the emotions, though.

In opposition to Kant's philosophically detached mode of investigation, aesthetic experience has been delineated via the empirical, intertwined with theory. Through this process, the a posteriori results of intense interest are at odds with Kant's a priori disinterest. Even though aesthetic experience is a pleasurable experience where no concerns but those of the work of art are present, it nevertheless comprises specific concerns which match specific concerns of a subjectivity. Although Kant's concept of disinterest does not involve there being no interest at all, the interest in aesthetic experience as intrapellation is definitively personal interest beyond a pleasurable response. The experience is of desire. So, distinct in kind from Kant's proposition of aesthetic experience as free, aesthetic experience contains an increase in the degree of freedom – it is not colored by daily concerns. The freedom is also possibly present in the lack of the direct gaze of the other. At the same time, the object appears as a unit, as convincing and coherent, assimilating the process of coherency in the subject as it assesses the work as "convincing." The subject is convinced in its appreciation.

As pertains to Hegel's questioning: art is a relief from reality, but not as a "luxury;" it expands subjectivity and alters self-understanding. Aesthetic experience offers sensuous meaning (apparently also conceptual meaning in concept art), yet it is a meaning that is not universal, but subjective and general. Feelings are no longer "just" subjective, nor in opposition to thought. There are also similarities between Hegel's ideas of art and intrapellation. For instance, since art is diffuse in the era of Symbolic form, it does not offer the ultimate mode of experience, and the subject does not therefore have the potential to intrapellate through art. As Hegel proposes, the subject is not changed by art in this period. However, in the classical era art offers potential for intrapellation as it represents the culture's sensuous truths where the subject can understand itself, including its emotions, as well as others through art. To Hegel, when art works on the emotions it is because they are objectified. The emotions become externalized, whereby their power is reduced. In intrapellation, the opposite takes place: when it is of the emotions, the emotions become internalized (and their power can increase or decrease); they become the subject's own – integrated and understood.

If one agrees with the conception of aesthetic experience as intrapellation, then the status of aesthetics is no longer ambiguous (an ambiguity which Bowie points out for aesthetics in modernity). On the one hand, since the subject is "condemned to meaning" (Merleau-Ponty 1945a, p. xxii) and the psyche is the producer of meaning, then projections, and aesthetic projections, cannot be but meaningful. Art represents artistic, not artificial, meaning. On the other hand, aesthetic experience can represent an experience that has a greater degree of freedom than "everyday" experience. The ambiguity of art as meaningless or as ultimate freedom in modernity is resolved in favor of art containing meaningful projection – the subject arrives at a continuation or development of itself.

Husserl relies on Kant's conception in his treatment of the aesthetic: to perceive something aesthetically is to perceive without interest or concern. Therefore, the object appears more clearly, Husserl claims. In intrapellation the opposite takes place: the object is perceived with personal interest, and this is a reason why the object appears as relevant, clear, and understandable. Husserl also contends that the pure aesthetic perception of a work of art involves suspension of the natural attitude. This claim can be seen as similar to what takes place in aesthetic experience because of the close connection between subject and object. The work is not necessarily seen as an independent object, but closely linked to the subjectivity perceiving it. Aesthetic experience does not, however, need to involve questioning of the object's metaphysical status.

Continuing a phenomenological tradition, intrapellation is an experience of dynamic, lived, and subjective truth, largely in the pre-reflective mode.

Aesthetic Experience as a Challenge 151

Heidegger and Merleau-Ponty would agree with this; pre-reflective aspects of experience are understood in aesthetic experience. The truth is disclosed for a subjectivity that has positively defining characteristics that can lead to changes in self-understanding. Adjusting Sartre's conception of the creation of literature to the reception process, aesthetic experience does cultivate and portray subjectivity. In aesthetic experience, aspects of subjectivity are extended. Also concurring with Sartre, through aesthetic experience, the art object is esteemed and the subject feels secure and calm in its harmonic experience with the object. And finally in comparison with Seel's levels of appearing, aesthetic experience as intrapellation is similar to artistic appearing in that it is a sensuous presentation that involves understanding (but also affect which he ignores in artistic appearing), but dissimilar in that it does not demand art-historical knowledge.

In regard to psychological aesthetics, aesthetic experience as intrapellation is at odds with experimental approaches to art. While art is worthy of scientific treatment (as Hegel rhetorically questions), scientific psychology in the form of quantification reduces the art object so that the topic of inquiry no longer is art, but the conjecture of form and color, etc. It annihilates or ignores the object it seeks to understand. At the same time, psychology, through its continuing "humanistic" and qualitative analyses, has the potential to investigate the art object, the experiential subject, and the relation between the two. Such an endeavor assumes that there is something that is "art," but even if it turns out that "art" is too broad a category, continued investigation can nevertheless gradually delineate what kind of responses different "art"objects elicit. As such, it becomes nonsensical to compare aesthetic experience as intrapellation to experimental approaches as they investigate different objects.

Beyond Classification Language

The claim and argument throughout this book has been that aesthetic experience can be described beyond the characteristic of being "ineffable," beyond the use of classification language. But what is entailed in describing aesthetic experience beyond classification language?

For Favrholdt (2003, p. 29), the premise for the indescribability of aesthetic experience is that the quality of experience in *general* cannot be described. It cannot be described in principle, he argues; it can only be classified, and classification does not entail description. Favrholdt's claim is, as such, more radical than the assertion that aesthetic experience cannot be described *completely*. Rather, it cannot be described *at all*. Favrholdt contends that this is because sensing is private and not identical for individuals. He uses the famous

inverted color scenario as an example where it is impossible to know whether we all see the same kind of red color. It could be that we have all learned to name the color "red," but that our experience of it is nevertheless different. This difference is impossible to detect. Favrholdt likewise asserts, in regards to aesthetic experience, that we can agree upon several characteristics of it in the same way as we can agree upon characteristics of an orange, yet certain aspects of the experience of the orange cannot be shared. What can be shared is that which can be named through (one example being: "have you seen the red hat she is wearing?"), but not in experience language ("yes, it has a pretty nuance") (ibid., p. 31). In other words, "primary" qualities of aesthetic experience can be named, that is, those qualities closest to the physical, such as weight and height, but not "secondary" characteristics like color and taste (ibid., p. 32). Only that which is the closest to the physical can be described, and not the remainder of experience which occurs from a first person perspective.

From a phenomenological perspective, such claims are invalid. Aesthetic experience is not completely and infallibly subjective. Instead of accepting the physical as the only realm of valid description, the ontology of phenomenology demonstrates the subjective as the beginning point for description. Phenomenology explains that the subjective is the precondition for saying anything at all and shows that experiential structures are not completely individual (Favrholdt agrees to some extent with this as he accepts psychic principles). When taking Merleau-Ponty's insights seriously, Favrholdt's view on language can be classified into an empiricist position where speech is a mechanical, inhibited, third-person process, which ignores the spontaneity and creativity in language beyond the perfunctory world of classification. By inquiring into concrete experiences, through the use of phenomenological psychology, aesthetic experience is shown to comprise a rhythm, an understanding, a description that lies beyond classification as "red," or "warm," or "pretty." If the propositions, or results of this investigation, are simply words of classification language, they nevertheless obtain a greater meaning beyond classification within the context of a sentence and a paragraph. As Merleau-Ponty shows, words reveal a meaning beyond their concrete definition; they reveal a mode of being in the world. They take part in the phenomenal field where they derive their significance from our actions and experiences. The results of this study are perhaps a form of classification, but also a form of description, interpretation, and explanation. This does not mean, however, that there is no more left to say, but, contrary to Favrholdt's conception, that to describe does not rely on complete linguistic clarity.

One reason why Favrholdt states that nothing more can be said about aesthetic experience is because he is first and foremost a philosopher, dealing in

abstract thought and not in the concrete and psychological. Perhaps due to a rejection of the subjective he will not take seriously actual and tangible experiences with art. Or, it could be that he has taken the claims or stipulations for science too seriously and thereby rejects the case study carrying a potential for generalization. Martyn Hammersley (1990) poses the dilemma of qualitative methods this way: "on the one hand social phenomena cannot be understood without taking account of subjective as well as objective factors; yet, at present, we have no way of capturing subjective factors that meets the requirements of science" (p. 4). Instead of arguing against impositions of such requirements for science, perhaps Favrholdt opts to accept its claims of objectivity, with the consequence that the subjective should be ignored. What is ignored in such an argument is the fact that phenomenology has served as a convincing corrective to such claims through its eradication of the radically subjective.

Returning to Seel's position, he is somewhat correct when he argues that aesthetic experience lacks the possibility of "epistemic fixation." The experience cannot be described or defined once and for all, and what can be known about it cannot be fully determined, especially because of its significant pre-reflective aspects. As with all other phenomena, what we can know about aesthetic experience is limited by the "incapacities of language," and the hermeneutically described limits of knowledge. Some aspects of aesthetic experience are ineffable and "empirically unknowable," and will continue to be so. Other aspects of aesthetic experience are empirically knowable, but have not yet been investigated. At the same time, since aesthetic experience intensely discloses pre-reflective meaning, such meaning becomes more discernible precisely in aesthetic experience. Thus, aesthetics is a field of inquiry which allows us to synthesize and cross the boundaries of what can be scientifically stated about experience. Based on these premises, the next part of this book – the conclusion – will provide a synthesis of aesthetic experience and the subject of aesthetics.

Conclusion

The Subject of Aesthetics

"To undertake an inquiry into aesthetic experience may appear ambitious," began the French phenomenologist Mikel Dufrenne his book, *The Phenomenology of Aesthetic Experience,* from 1953. Now, more than fifty years later, this statement certainly appears no less true. Aesthetic objects have continued to differentiate since one of the characteristics of the arts is their constant renewal; art comprises both its historical objects as well as its new ones. By virtue of the partial dialectical constitution between subject and object, or between object and experience, it could be the case that aesthetic experience, too, has increased in differentiation. Though the aesthetic is not only art, the topic for this book has been the aesthetic as limited to art, and, accordingly, experiences that are experiences of art. This limitation did not make this inquiry any less ambitious, but to inquire into aesthetic experience is what this book set out to do. In it, general aspects of aesthetic experience were explored through an investigation of the way in which experiences with art occur, in other words, investigating the experiencing subject. Without resorting to naïve empiricism, it took as its primary object actual and concrete experience, and not merely logically or primarily theoretically delineated, derived, and abstracted experience.

As seen earlier, the nature, including the limits, of experience is a main topic within phenomenology and this book has found its theoretical foundation within phenomenological psychology and phenomenological philosophy. Thus, the nature of experience has been framed here within both the factual, local, and specific as well as within the theoretically supported models of consciousness and universals of experience. In these so-called "postmodern times," where the subject has been seen as dispersed, constructed, and deconstructed into language structures and power games, among other, with a rejection of metaphysics and a solid place of origin, this project has had the positive task of describing primary and fundamental experiential and psychic structures, both as they appear in principle and as they reveal themselves empirically. In converse to Merleau-Ponty, the task has not been to elucidate the ontological and synthesizing functions in experience, but to illuminate the very relation(s) between various experiential modes of experience and art. The book began therefore with a theoretical inquiry into the relevant history of aesthetics. What had been the

historical and phenomenological objects of aesthetics? What had been seen as the tasks of aesthetics? Through this exposition of aesthetics, the explicit and implicit theoretical structures of subjectivity in aesthetic experience appeared. These were the starting points for the second chapter: the conceptual clarification of the relevant structures of subjectivity.

Experience and experiential modes of consciousness were central concepts in this book, and their structures have continuously been discussed within the phenomenological traditions. Subsequently, this book drew heavily on egological theories of phenomenology. For (at least early) Husserl, experience begins and ends with the transcendental ego. It is a subject, or an ego, which is identical to its own consciousness – an absolute self-identity – an ego which in his later writings becomes ambiguously, yet apparently constitutively, dependent upon a "lebenswelt." For Merleau-Ponty, however, the external and internal worlds are polar opposites, already and always given, but continually and reciprocally developed, with the body as a material, yet dynamic, frame of transcendent experiential features (body and flesh) that unifies the Cartesian dichotomy of body and soul in experience. Drawing mainly on Merleau-Ponty's work, *Phenomenology of Perception*, the chapter on subjectivity nevertheless began with Husserl's inauguration of phenomenology and the problem of direct access to phenomena versus that of interpretation. It is an important problem for the understanding of aesthetic experience, for how does the art object appear? Thus, a model of the mind in relation to art was displayed. It entailed a description and discussion of essential aspects of subjectivity which are particularly active in relation to art. It includes aspects of pre-reflection: of sensing, intentionality, representations, time, and space, as well as no less important aspects of affects and reflection. These are features of subjectivity and aesthetic experience which are present in the history of aesthetics and present in empirically knowable meetings with art.

Experiences with art are primarily seen as any kind of experience with that which is commonly viewed as art, but only with art that has an impact. Thus, those experiences which leave us cold are viewed as a "no go"; experiences in which Art is not met as Art. It appears rather different what works for whom, and this project has thereby taken its point of origin in subjective experiences of different works of art. If modernity is demarcated by Kant's Copernican revolution, then this project may be characterized as one having its metaphysical framework placed within "modernity" or perhaps "late modernity" in the sense that its ontological platform is the individual's subjective experience and that it is consciousness (here the subjective experience) which limits what we can have knowledge about. As Husserl later claimed, it is irrelevant what is out there as we can only have knowledge of objects as they appear to consciousness. The

Husserlian point is to figure out what and how phenomena appear for consciousness as we then will also come to know consciousness, too, as consciousness *is* this intentional act: "consciousness is always consciousness of something." Merleau-Ponty later shows that subjectivity is intersubjectively constituted, and that subjectivity, as such, is not a radicalized or lonely subjectivity, but one that also includes the Other, whereby self-knowledge is never finite, but always containing elements of strangeness. As Merleau-Ponty himself claims, "Probably the chief gain from phenomenology is to have united extreme subjectivism and extreme objectivism" (p. xxii), an understanding he develops throughout *Phenomenology of Perception*. This aesthetic project contained what has been viewed as subjectivism of the realm of aesthetic experience which historically has been regarded as an unscientific, unfeasible project as it may appear to only contain isolated or ideographic accounts. The phenomenologists, in particular Merleau-Ponty, have shown, however, how subjectivity is never completely so, and as Gadamer has contended, the particular is always an instant of the universal. This book, then, contains an objectification of subjective aesthetic experiences, but it is with a foundation in the subjective which lacks the historical philosophical horror of such a project (claimed by e.g. Jauss 1982).

Art and Experience
Not only has subjectivity been described at different levels of experiences with art but also as it develops in time. Subjectivity in aesthetic experience has been based upon Jauss' model for the reception of literature which comprises:

1. a first aesthetic perceptual reading
2. a retrospective interpretive reading
3. a historical reading, which begins with the reconstruction of the horizon of expectations

These different "steps" were described as they occurred in the interviews, with detailed descriptions of how they occur in (descriptions of) the actual act of experiencing and in the retrospective reflection, both including "horizons of expectations."

With the empirical investigation, several characteristics of aesthetic experience were demarcated. One of the features that stand out the most is that aesthetic experience is not disinterested but of intense interest – against the Kantian *a priori* aesthetic legacy stands the empirical and personal of intense interest and affection. This is not, however, a return to a Romantic conception of the arts. Reason and understanding are not ignored as general features of aesthetic experience, and the role of reflection is a part of this book' duality. The

objective is to reflect over aesthetic experience at the same time as it is unavoidable to embrace the possibilities which lie beyond reflection.

Based on the expositions of this book – through the investigation into experiences with art – the object of the experience is also more closely comprehended in this reciprocal relation, and the phenomenon of art can be progressively delimited.

- Works of art work differently on different people according to their personal biography, including their habitual manner of experiencing, the level of consciousness which dominates their experiential manner, their experiential attitude (e.g., degree of openness/ closedness). To stress the importance of personal biography does not mean that the personal is primary and the social secondary, or to deflate the influence of culture, as the personal is seen as a dimension deeply entrenched in the social.

- Although a work of art works differently for different people or not at all for others, for something to be regarded as art it needs to work for someone. The larger the group of "someones," the more people the work of art works on, the more likely it is that the work is revealing experiences which characterize common experiences, portraying the zeitgeist or parts of it, reaching an issue, or dilemma, that is characteristic of the experience for a certain group of people. Through such a conceptualization the work of art cannot be seen as a timeless presence which rises above history, as it does not contain the "totality of tension"; Classicism is not the final art form (as, for instance, Hegel proposes).

- When a work of art works, it does so in particular ways. It is limited by the modes in which it can be experienced; it works within given experiential parameters. Based on this proposition it may appear as if art is met in an ever-present, always identical, experiential structure. As Merleau-Ponty might have said, such a statement is based on a universalized notion of experience, for only then can the meeting with art be identified as one stable act. In this project, however, the subject of aesthetics has been seen as a hermeneutically situated psyche that is limited by the modes of experience which is characteristic for its particular historical space-time, limited by modes of experience which are, at least

partially, historically changeable, yet most likely comprising certain structures of a more permanent character (e.g., that we are given a body, have a minimal form of self-awareness, yet, as Hegel claims, reflexivity may appear in various historical disguises).

- Therefore, there is no apparent reason why art, in principle, should be delimited to work on any one particular way of experiencing (form) or to any one particular experiential theme (content); no one experiential model is necessarily the dominant one. All psychological features may be in play as art may bring to bear on all aspects of the subject. Thus, affectivity, emotionality, various modes of sensing and so on can all be modes of experiences in which the art works, although it is only in theory that one can fully separate these different functions from each other.

- At the same time, art works by expanding the experiential modes; it shows ways of experiencing which are new. When the work of art works it is not on the cognitive faculties of the imagination and the understanding in a state of distanced, free, and harmonic play, as Kant proposes. The working exists rather in the relatively harmonious interplay between the subject and the object which is not limited to any one or two features in the experiencing subject. This means that the work of art harmonizes with certain aspects of the subject. There is a harmonic recognition; an experience of harmony which is not necessarily of "the beautiful" or "the good," but can just as well reveal "the ugly." This recognition, which can also be emotional, is of a previous or potential experience or phenomenon. It is a recognition of something that has been latent in the sense that when it is revealed, it is obvious that it must be in exactly this way. Aesthetic experience can, therefore, be characterized as comprising what Buytendjik has called the "phenomenological sigh" or, to paraphrase Gadamer, as the "process" in which things are named what they are – "so it is, it must be so." It contains both recognition and acceptance at once. The work of art resonates with and calls to previous or potential experience.

- The resonance, therefore, comprises both a recognition and an acceptance, but it is unexpected and surprising. In this sense it is an experience of alterity which cannot, in principle, be radical or of the fundamentally different Other. At the same time, it is an experience of presence. It contains the hermeneutic movements of alterity and closeness, not as movements between two parts, but as both phenomena at the same time. It is an experience of alterity with a particularly present intensity. This movement can work on different experiential dimensions. For a work of art to work, then, it has to contain the possibility of experiential transcendence. It contains an experiential rupture, an *intra*ruption, or *intra*lude; a transgression of common experiential modes, leading to "breaks" in self-understanding. These breaks can be of various kinds – of sense experience, of the more explicit understanding as well as of the more implicit affections. What unites these experiences is their significance as "breaks," and particular as "breaks" which move the self and the understanding of the self (reflectively or pre-reflectively) in the intrapellation.

Overall, the power of art lies in its ability to reveal hidden or pre-conscious possibilities for experience, which exist neither purely within the realm of the "intellectual" nor the "emotional," but exactly in the possibility of surpassing simplified and stultified modes of experience. Although experience is a main topic for much of philosophy, the philosophical aesthetics works with a frozen and abstracted subject. As shown, psychology can paint a picture that, in principle, is neither photographic nor complete, yet has the possibility for continually showing us the role(s) and importance of the arts in our lives, and in more ways than one, facilitating the continuous and never-ending process of self-understanding.

This book confirms aesthetic experience as displaying meaning beyond concepts and propositions, with intense meaning in pre-reflection and in informal reflection. Thus, aesthetic experience can be the beginning point for investigations into the boundaries of experience, both for philosophy and psychology. Psychology can investigate actual, lived meaning in a contemporary framework for subjectivity while philosophy, via its continuous questioning, can reveal the limits of such frameworks.

When art, as one of its characteristics, reveals something new, and this new aspect works on experience via the intrapellation, then the implicit object of art is actually the subject – the subject understood as human experience. The subject (as in object) of aesthetics is the subject. When the object of aesthetics is the

subject, and psychology is the field which can investigate subjectivity in the "live," concrete and empirical realm, then aesthetics is profoundly psychological. The future of aesthetics lies in the psychological enfranchisement of art.

Bibliography

Adorno, Theodor W. 1997. *Aesthetic Theory*. London: The Athlone Press.
Allesch, C.G. (2006). *Einführung in die psychologische Ästhetik*. Wien, Austria: WUV verlag.
Althusser, Louis P. 1971. *Lenin and Philosophy and Other Essays*. New York: Monthly Review Press.
Aristotle. 330BC/1986. *De Anima (On the Soul)*. London: Penguin Books.
Arnheim, Rudolf. 1954/1974. *Art and Visual Perception*. Berkeley: University of California Press.
—— 1969/2004. *Visual thinking*. Berkeley: University of California Press.
Aschenbrenner, Karl and William B. Holter, 1954. 'Introduction' In Alexander Baumgarten, *Reflections on Poetry*. Berkeley and Los Angeles: University of California Press, pp. 1-34.
Baumgarten, Alexander G. 1735/1954. *Reflections on Poetry*. Berkeley and Los Angeles: University of California Press.
Beiser, Frederick C. 2005. *Hegel*. New York and London: Routledge.
Benson, C. (1993). *The absorbed self: Pragmatism, psychology and aesthetic experience*. New Jersey, NJ: Prentice-Hall
—— 2001. *The cultural psychology of self. Place, morality and art in human worlds*. London, England and New York, NY: Routledge.
—— 2013a. Acts not tracts! Why a psychology of art and identity must be neuro-cultural. In Tone Roald and Johannes Lang (Eds.), *Art and identity. Essays on the aesthetic creation of mind*. Amsterdam, the Netherlands and New York, NY: Rodopi, pp. 39-65.
—— 2013b. New kinds of subjective uncertainty? Technologies of art, 'self ' and confusions of memory in the twenty-first century. In R. W. Tafarodi (ed.), *Subjectivity in the twenty-first century: Psychological, social and political perspectives*. Cambridge, MA: Cambridge University Press, pp. 140-166.
Bowie, Andrew. 2003. *Aesthetics and Subjectivity. From Kant to Nietzsche*. Manchester and New York: Manchester University Press.
Butler, Judith. 1997. *Excitable Speech: A Politics of the Performance*. New York and London: Routledge.
Chatterjee, Anjan. 2010. Neuroaesthetics: A Coming of Age Story. *Journal of Cognitive Neuroscience* 23(1): 53-62.
Collin, Finn and Køppe, Simo (eds). 2003. *Humanistisk videnskabsteori*. Copenhagen: DR Multimedie.

Crabtree, Benjamin F. and William L. Miller, 1999. 'Using Codes and Code Manuals: a Template Organizing Style of Interpretation' in Crabtree, Benjamin F. and William L. Miller (eds), *Doing Qualitative Research*. Newbury Park, California: Sage: 163-178.

Cupchik, G. C. 2002. The evolution of psychical distance as an aesthetic concept. *Culture & Psychology*, 8(2), 155-187.

—— 2013. 'I am, therefore I think, act, and express both in life and in art.' In Tone Roald and Johannes Lang (Eds.), *Art and identity: Essays on the aesthetic creation of mind*. Amsterdam, the Netherlands and New York, NY: Rodopi, pp. 67-92.

—— (in press). *The aesthetics of emotion: Up the down staircase of the mind-body*. Cambridge, England: Cambridge University Press.

Danto, Arthur C. 1986/2005. *The Philosophical Disenfranchisement of Art*. New York: Columbia University Press.

Darwin, Charles. 1872/1998. *The Expression of the Emotions in Man and Animals*. London: Harper Collins publishers.

de Man, Paul. 1982. 'Introduction' in Jauss, Hans R (1982): vii-xxv.

Descartes, René. 1651/2008. *Meditations on First Philosophy*. Oxford: Oxford University Press.

Dewey, John. 1934/2005. *Art as Experience*. New York: Penguin Group.

Drees, Hajo. 2001. *Rainer Maria Rilke. Autobiography, Fiction, and Therapy*. Berlin, New York: Peter Lang Publishing.

Dufrenne, Mikel. 1953/1973. *The Phenomenology of Aesthetic Experience*. Evanston: Northwestern University Press.

Ehrenzweig, Anton. 1993. *The Hidden Order of Art. A Study in the Psychology of Artistic Imagination.* London: Weidenfeld.

Favrholdt, David. 2003. *Æstetik og filosofi. Seks essays.* Copenhagen: Høst og Søn.

Faye, Jan. 2000. *Athenes kammer. En filosofisk indføring i videnskabernes enhed.* Copenhagen: Høst & Søn.

Fechner, Gustav T. 1876/1898. *Vorschule der Aesthetik*. Leipzig: Breitkopf & Hartel.

Freud, Sigmund. 1910/1975. *Leonardo da Vinci and a Memory of his Childhood* (Standard Edition 11). London: Hogarth Press: 209-236.

—— 1914/1953. *The Moses of Michelangelo*. (Standard Edition 13). London: Hogarth Press: 209-236.

Funch, Bjarne S. 1986. 'Det æstetiske' in Moustgaard Ib, K. and Petersen Arne F. (eds) *Udviklingslinjer i Dansk Psykologi fra Alfred Lehmann til i dag*. Copenhagen: Gyldendal

—— 1997. *The Psychology of Art Appreciation*. Copenhagen: Museum Tusculanum Press.

—— 2003. 'Den fænomenologiske metode i museologisk forskning' in *Nordisk Museologi* 1: 13-38

—— 2013a. 'The beauty of life in art'. In Hösle Vittorio (ed.) In *The many faces of beauty*. Notre Dame: University of Notre Dame Press, pp: 210-239.

—— 2013b. 'Art and personal integrity'. In Tone Roald and Johannes Lang (eds.) *Art and Identity: Essays on the Aesthetic Creation of Mind*. Amsterdam/New York: Rodopi, pp. 167-197.

Gadamer, Hans G. 1960/1989. *Truth and Method.* New York: The Continuum Publishing Company.
—— 2001. *Gadamer in conversation.* New Haven and London: Yale University Press.
Gallagher, Shaun. 2005. *How the body shapes the mind.* Oxford, England: Oxford University Press.
Gammelgaard, Judy. 2013a. Like a Pebble in Your Shoe: A Psychoanalytical Reading of Lars von Trier's Breaking the Waves and Anti-Christ. *International Journal of Psychoanalysis,* 94(6): 1215-1230.
—— 2013b. Reading Proust: The little shock effects of art. In Tone Roald and Johannes Lang (eds.) *Art and Identity: Essays on the Aesthetic Creation of Mind.* Amsterdam/New York: Rodopi, pp. 113-131.
Giddens, Anthony. 1991. *Modernity and Self-Identity. Self and Society in the late Modern Age.* Cambridge: Polity Press.
Giorgi, Amadeo. 1975. 'An Application of Phenomenological Method in Psychology' in Giorgi, Amadeo et al. (eds), *Duquesne Studies in Phenomenological Psychology, II.* Pittsburgh: Duquesne University: 82-103.
Gombrich, Ernst H. 1950/2003. *The Story of Art.* London, New York: Phaidon Press Limited.
—— 1959/2002. Art and Illusion. A Study in the Psychology of Pictorial Representation. London, New York: Phaidon Press Limited.
Gumbrecht, Hans U. 2004. *The Production of Presence. What Meaning Cannot Convey.* Stanford: Stanford University Press.
—— 2012. *Atmosphere, Mood, Stimmung: On a Hidden Potential in Literature.* Stanford: Stanford University Press.
—— 2013. Steady admiration in an expanding present: on our new relationship to classics. In T. Roald and J. Lang (eds.). *Aesthetic Creations of Mind. Philosophical and Psychological Essays.* Amsterdam, New York: Rodopi.
Habermas, Jürgen. 1968/1972. *Knowledge and Human Interests.* Boston: Beacon Press.
Hammersley, Martyn. 1990. *The dilemma of qualitative method: Herbert Blumer and the Chicago tradition.* London: Routledge.
Hegel, Georg W. F. 1807/1977. *Phenomenology of Spirit.* Oxford, New York: Oxford University Press.
—— 1886/2004. *Introductory Lectures on Aesthetics.* London: Penguine Classics.
Heidegger, Martin. 1926/1962. *Being and Time.* Oxford: Blackwell Publishing.
—— 1935/1977. 'The Origin of the Work of Art' in Krell (ed.) *Martin Heidegger Basic Writings.* New York: HarperCollins Publishers: 139-212.
Helles, Rasmus and Køppe, Simo. 2003. 'Kvalitative metoder' in Collin, Finn and Køppe, Simo (eds.) *Humanistisk videnskabsteori.* DR Multimedie: 278-302.
Henry, Michel. 1985/1993. *The Genealogy of Psychoanalysis.* Palo Alto, CA: Stanford University Press.
Husserl, Edmund. 1900/2001. *Logical Investigations. Volume 2.* London and New York: Routledge.
—— 1913/1982. *Ideas Pertaining to a Pure Phenomenology and to a Phenomenological Philosophy.* First book. Dordrecht, Norwell: Kluwer Academic Publishers.

—— 1927/1971. Phenomenology. Edmund Husserl's Article for the Encyclopaedia Britannica. *Journal of the British Society for Phenomenology*. 2: 77-90

—— 1937/1970. *The Crisis of European Sciences and Transcendental Phenomenology*. Evanston: Northwestern University Press.

—— 1966a/1991. *On the Phenomenology of the Consciousness of Internal Time*. Dordrecht: Kluwer Academic Publishers.

—— 1966b/2005. *Phantasy, Image Consciousness, and Memory*. Dordrecht: Springer.

James, William. 1884. 'What is an emotion?' in *Mind* 9 (34): 188-205.

—— 1890/2007. *Principles of Psychology. Vol. 1*. New York: Cosimo Classics.

Jauss, Hans R. 1982. *Toward an Aesthetic of Reception*. Minneapolis: University of Minnesota Press.

Johnson, Mark. 2007. *The Meaning of the Body. Aesthetics of Human Understanding*. Chicago and London: University of Chicago Press.

—— 2013. Identity, Bodily Meaning, and Art. In Tone Roald and Johannes Lang (eds.) *Art and Identity: Essays on the Aesthetic Creation of Mind*. Amsterdam/New York: Rodopi, pp. 15-38.

Jørgensen, Dorthe. 2003. *Skønhedens metamorfose: de æstetiske idéers historie*. Copenhagen: Gyldendal.

—— 2006. *Skønhed – en engel gik forbi*. Aarhus Universitetsforlag.

Kant, Immanuel. 1781/2007. *Critique of Pure Reason*. London: Penguin Books.

—— 1790/1951. *Critique of Judgement*. London: Collier Macmillan Publishers.

—— 1791/1983. *What Real Progress has Metaphysics made in Germany since the time of Leibniz and Wolff*. New York: Abaris Books.

Kennedy, Mary M. 1979. 'Generalizing from Single Case Studies' in *Evaluation Quarterly* 3(4): 661-178.

King, Nigel. 1998. Template Analysis. In Symon, Gillian and Cassell, Catherine (eds.) *Qualitative Methods and Analysis in Organizational Research*. London: Sage: 118-134.

Koffka, Kurt. 1940. 'Problems in the Psychology of Art' in Bernheimer, Richard, Carpenter, Richard, Koffka, Kurt and Nahm, Milton (eds.) *Art: A Bryn Mawr Symposium*. Bryn Mawr, PA: Bryn Mawr College: 179-273.

Krstič, K. 1964. '*Marko Marulič – The Author of the Term "Psychology"*'. On line at: www.psychclassics.yorku.ca/Krstic/marulic (consulted 25.07.2014).

Kvale, Steinar. 1996. *InterViews: An Introduction to Qualitative Research Interviewing*. Thousand Oaks, CA: Sage Publications.

Køppe, Simo. 2000. 'Psychosomatics and the Pineal Gland' in Andersen, Peter B., Emmeche, Claus, Finnemann, Niels O. and Christiansen, Peder V. (eds.) *Downward Causation. Mind, Bodies and Matter*. Aarhus: Aarhus University Press: 81-98.

—— 2004. *Neurosens opståen og udvikling i 1800-tallet*. Copenhagen: Frydenlund.

—— 2008. 'The Emergence of the Psyche' in *Nordic Psychology* 60(2): 141-158.

Langdridge, Darren. 2007. *Phenomenological Psychology. Theory, Research and Method*. New Jersey: Pearson Prentice Hall.

Leary, David E. 1992. 'William James and the Art of Human Understanding' in *American Psychologist*. 47 (2): 152-160.

Leder, Helmut et al. 2004. 'A Model of Aesthetic Appreciation and Aesthetic Judgment' in *British Journal of Psychology* 95: 489-508.
Leder, Helmut, Gerger, Gernot, Dressler, Stefan G., & Schabmann, Alfred. (2012). How art is appreciated. *Psychology of Aesthetics, Creativity, and the Arts* 6: 2-10.
Lehmann, Alfred. 1884. *Farvernes elementære Æstetik: en objektiv psykologisk Undersøgelse*. Klein.
Machotka, P. 1979. *The nude. Perception and personality*. New York, NY: Irvington.
—— 2003. *Painting and our inner world: The psychology of image making*. New York, NY: Kluwer Academic Publishers.
—— 2012. Understanding aesthetic and creative processes: The complementarity of idiographic and nomothetic data. *Psychology of Aesthetics, Creativity and the Arts,* 6 (1), 43-56.
Marcuse, Herbert. 1978. *The Aesthetic Dimension. Toward a Critique of Marxist Aesthetics*. Boston: Beacon Press
Merleau-Ponty, Maurice. 1942/1963. *The Structure of Behavior*. Pittsburg: Duquesne University Press.
—— 1945a/1962. *Phenomenology of Perception*. London: Routledge & Keagan Paul.
—— 1945b/2008. *Phénoménologie de la perception*. Paris: Gallimard.
—— 1961/1993. 'Eye and Mind' in Johnson, Galen A. and Smith, Michael B. (eds) *The Merleau-Ponty aesthetics reader*. Evanston: Northwestern University Press: 121-149.
—— 1964/1968. *The Visible and the Invisible*. Evanston: Northwestern University Press.
Olsen, Ole A. and Køppe, Simo. 1988. *Freud's Psychoanalysis*. New York and London: New York University Press.
Oxford English Dictionary. 1994. Oxford: Oxford University Press.
Ramachandran, Vilayanur S. and William Hirstein 1999. 'The Science of Art. A Neurological Theory of Aesthetic Experience' in *Journal of Consciousness Studies.* 6: 15-51.
Ricoeur, Paul. 1970. *Freud and Philosophy. An Essay on Interpretation*. New Haven and London: Yale University Press.
Rilke, Rainer M. 1908. *Der neuen Gedichte anderer Teil*. Leipzig: Im Insel-Verlag.
—— 1997. *New Poems*. Manchester: Carcanet.
Roald, Tone. 2007. *Cognition in Emotion: an Investigation through the Appreciation of Art*. Amsterdam, New York: Rodopi.
—— 2008. 'Toward a Phenomenology of Art Appreciation' in *Journal of Phenomenological Psychology* 39(2): 189-212.
Roald, Tone and Køppe, Simo. (2008). 'Generalisering i kvalitative metoder' in *Psyke og Logos,* 29: 86-99.
—— (2015) 'Sense and Subjectivity. Hidden Potentials in Psychological Aesthetics' in *Journal of Theoretical and Philosophical Psychology*. 35- 1: 20-34.
Sartre, Jean-Paul. 1943/1984. *Being and Nothingness. A Phenomenological Essay on Ontology*. New York: Washington Square Press.
—— 1946/1955. *No Exit and Three Other Plays*. London: Vintage Books.
—— 1972/1998. *Hva er litteratur?* Oslo: Pax Forlag A/S.

Schiller, Friedrich. 1795/2004. *On the Aesthetic Education of Man.* New York: Dover Publications.
Seel, Martin. 2000/2005. *Aesthetics of Appearing.* Stanford: Stanford University Press.
Shusterman, Richard. 2000. *Pragmatist Aesthetics.* Boulder, New York: Rowman & Littlefield
—— 2005. The Silent, Limping Body of Philosophy. In the Carman, Taylor and Hansen, Mark B. N. (eds) *Cambridge Companion to Merleau-Ponty.* Cambridge: Cambridge University Press: 151-180.
Spradley, James P. 1979. *The Ethnographic Interview.* Chicago, London: Holt, Rinehart and Winston, Inc.
Verstegen, Ian. 2005. *Arnheim, Gestalt and Art: A Psychological Theory.* Springer.
—— 2014. *Cognitive Iconology. How and When Psychology Explains Images.* Amsterdam, New York: Rodopi.
Vygotsky, Lev S. 1971. *The Psychology of Art.* Cambridge, MA: The M.I.T. Press.
Wertz, Frederick J. 1983. 'From Everyday to Psychological Description: Analyzing the Moments of Qualitative Data Analysis' in *Journal of Phenomenological Psychology* 14: 197-241.
Zahavi, Dan. 2001a. *Husserls fænomenologi.* Copenhagen: Gyldendal.
—— 2001b. 'Beyond Empathy. Phenomenological approaches to Intersubjectivity' in *Journal of Consciousness Studies* 8 (5-7): 515-167.
—— 2002. 'Edmund Husserl – fænomenologi og kunst' in Brøgger, Stig og Pedersen Otto J. (eds) *Kunst og filosofi I det 20. Århundrede.* Copenhagen: Det Kongelige Danske Kunstakademi: 9-27.
—— 2004. 'Husserl's Noema and the Internalism-Externalism Debate' in *Inquiry,* 47(1): 42-66.
Zeki, Semir (1999). Art and the Brain. *Journal of Consciousness Studies* 6: 76-96.
Žižek, Slavoj. 1999/2008. *The Ticklish Subject.* London: Verso.

Index

Adorno, Theodor W., 32
aesthetic experience, 11, 17, 18, 19, 20, 21, 22, 23, 24, 25, 32, 33, 39, 40, 41, 45, 46, 52, 55, 70, 77, 83, 97, 99, 101, 105, 107, 115, 118, 127, 129, 130, 131, 135, 136, 137, 138, 139, 142, 143, 144, 146, 147, 148, 149, 150, 151, 152, 153, 155, 156, 157, 160
aesthetics, 11, 12, 18, 20, 21, 22, 23, 25, 27, 28, 29, 30, 31, 32, 34, 35, 36, 37, 38, 39, 40, 41, 43, 44, 46, 47, 48, 50, 52, 53, 54, 55, 56, 100, 137, 148, 150, 151, 153, 155, 156, 158, 160
affection, 45, 59, 72, 79, 102, 105, 115, 120, 137, 146, 149, 157
affects, 17, 30, 34, 51, 54, 72, 73, 74, 96, 102, 109, 146, 147, 148, 149, 156
alienation, 11, 34, 35, 77
Allesch, C.G., 50
alterity, 53, 69, 73, 76, 91, 116, 117, 118, 131, 159
Althusser, Louis P., 84, 132, 133
ambiguity, 53, 64, 69, 74, 79, 90, 107, 109, 111, 115, 129, 137, 144, 145, 150
appearance, 19, 20, 38, 39, 46, 48, 59, 60, 61, 62, 80, 87, 95, 100
Aristotle, 28, 29, 31
Arnheim, Rudolf, 51, 55
art, 7, 12, 18, 19, 20, 22, 24, 25, 27, 29, 30, 31, 32, 33, 34, 35, 36, 37, 38, 39, 40, 41, 42, 43, 44, 45, 46, 47, 48, 49, 50, 51, 52, 53, 54, 55, 56, 59, 72, 77, 81, 83, 84, 96, 100, 101, 102, 105, 106, 108, 109, 111, 113, 115, 116, 117, 118, 119, 120, 122, 123, 124, 125, 126, 127, 128, 129, 130, 131, 133, 135, 137, 138, 141, 142, 143, 144, 145, 146, 147, 148, 149, 150, 151, 153, 155, 156, 157, 158, 159, 160
Aschenbrenner, Karl, 28
attention, 23, 37, 39, 42, 45, 46, 48, 49, 69, 72, 85
auto-affection, 73, 81

Bacon, Francis, 123, 130
Balzac, Honoré de, 42
Baudelaire, Charles, 100
Baumgarten, Alexander G., 27, 28, 29, 30, 31, 38, 54, 55, 77, 148
Beauty, 23, 30, 32, 37, 49
Beiser, Frederick C., 38, 77
Benson, Ciarán, 52
body, 24, 43, 45, 62, 64, 65, 66, 67, 68, 69, 70, 71, 72, 74, 75, 76, 77, 78, 79, 80, 81, 89, 90, 91, 95, 105, 107, 108, 111, 113, 115, 120, 126, 128, 131, 132, 134, 137, 139, 140, 145, 146, 147, 148, 156, 159
body-image, 140
body-subject, 24, 43, 45, 62, 64, 67, 72, 76, 77, 79, 80, 81, 90, 91, 131, 134, 140, 146, 147, 148
Boesen, Trine, 109, 110
Bowie, Andrew, 23, 32, 37, 150
Brandes, Peter, 109, 124
Butler, Judith, 133

catharsis, 31, 37, 51
Cezanne, Paul, 42
Chatterjee, Anjan, 51
classification language, 19, 20, 25, 99, 151, 152
cogito, 45, 64, 67, 78, 79, 80, 81, 140, 147, 148
cognition, 28, 102, 148
cognitive faculties, 32, 77, 159
cognitive faculty, 28, 29, 148
Collin, Finn, 92, 93
color, 47, 66, 67, 73, 107, 113, 121, 124, 131, 151, 152
consciousness, 12, 20, 23, 32, 34, 36, 38, 44, 48, 55, 56, 59, 60, 61, 62, 64, 65, 66, 69, 71, 74, 79, 81, 86, 87, 89, 107, 127, 132, 133, 139, 144, 155, 156, 158
Constable, John, 142, 143
Copley, John Singleton, 142
Cupchik, G. C., 52
Cupchik, Gerald, 52

Danto, Arthur C., 19, 20
Darwin, Charles, 72
Dasein, 41, 63
de Man, Paul, 127
Derain, André, 106, 116, 121, 125, 130
Descartes, René, 28, 78, 79, 80, 81
description, 11, 19, 22, 23, 24, 45, 48, 61, 62, 63, 64, 69, 71, 74, 75, 76, 81, 84, 85, 86, 87, 88, 89, 90, 91, 92, 94, 96, 97, 105, 113, 131, 144, 145, 151, 152, 156
descriptive phenomenology, 59, 89
desire, 12, 17, 43, 55, 72, 73, 75, 76, 77, 105, 116, 145, 146, 149
Dewey, John, 27, 47
discourse, 11, 43, 80
disinterested contemplation, 32
Drees, Hajo, 17
dualism, 69, 70
Dufrenne, Mikel, 155

Ehrenzweig, Anton, 141, 142, 146
eidetic variation, 94
eidos, 89, 94
emotions, 30, 36, 37, 47, 48, 49, 52, 55, 56, 59, 72, 73, 74, 75, 76, 78, 120, 128, 146, 147, 149, 150
empathy, 91
empiricism, 18, 21, 54, 57, 64, 155
Enlightenment, 28, 78
epistemology, 23, 32
Esbjerg Museum of Art, 25
existential phenomenological approach, the, 52
explanation, 21, 24, 25, 48, 55, 70, 73, 88, 90, 97, 128, 130, 132, 135, 152
externalization, 34, 35, 37, 38, 72, 134, 136, 145

Favrholdt, David, 18, 151, 152, 153
Faye, Jan, 92
Fechner, Gustav T., 47, 53
feelings, 33, 34, 36, 40, 41, 55, 56, 59, 72, 73, 74, 75, 78, 96, 115, 117, 120, 124, 134, 147
first-person perspective, 83, 84, 85, 90
freedom, 11, 32, 34, 37, 44, 49, 50, 76, 132, 133, 138, 149, 150
Freud, Sigmund, 38, 51, 79, 90
Funch, Bjarne, 7, 47, 50, 52, 87

Gadamer, Hans G., 9, 18, 21, 27, 90, 92, 93, 157, 159
Gallagher, Shaun, 140
Gammelgaard, Judy, 51
generalization, 24, 93, 153
German-Idealism, 33
Gestalt principle, 141
Gestalt psychology, 52
gestalt tradition, the, 51
Geyer, Andrea, 113, 114, 128
Giddens, Anthony, 78, 80
Giorgi, Amadeo, 86, 87
Gombrich, Ernst H., 142, 143

Gormley, Anthony, 109, 111, 119, 120, 122, 126
Gumbrecht, Hans U., 63, 144

Habermas, Jürgen, 85, 92
habit, 64, 71
Hammersley, Martyn, 153
Hansen, Sven Wiig, 120, 124
hearing, 67, 141
Hegel, Georg W.F., 19, 33, 34, 35, 36, 37, 38, 42, 53, 54, 55, 56, 72, 76, 77, 79, 145, 146, 147, 150, 151, 158, 159
Heidegger, Martin, 23, 33, 41, 42, 54, 56, 63, 90, 93, 151
Helles, Rasmus, 84, 92, 93
Henry, Michel, 72, 73
hermeneutics, 91, 99
Hirstein, William, 51
Holter, William B., 28
horizons of expectation, 129, 130, 138
Husserl, Edmund, 20, 21, 24, 38, 39, 40, 41, 48, 53, 54, 60, 61, 62, 65, 79, 80, 86, 88, 89, 90, 94, 107, 140, 143, 144, 150, 156

imagination, 32, 44, 49, 87, 159
imaginative variation, 94, 95
intellectualism, 57, 64
intentional arc, 64
intentionality, 61, 62, 64, 66, 69, 71, 73, 87, 88, 89, 108, 135, 156
interiority, 73
interpretation, 10, 11, 12, 19, 45, 48, 59, 60, 61, 62, 63, 64, 69, 71, 72, 75, 84, 86, 88, 90, 91, 100, 101, 102, 118, 120, 121, 124, 126, 127, 128, 137, 138, 143, 145, 147, 152, 156
intrapellation, 11, 12, 25, 131, 133, 135, 136, 137, 138, 139, 141, 142, 143, 145, 146, 147, 148, 149, 150, 151, 160

introjection, 25, 134, 138, 141, 145, 146, 147
introspection, 101
Iser, Wolfgang, 9, 10

James, William, 47, 53, 72, 79, 84
Jauss, Hans R., 9, 10, 11, 20, 25, 97, 99, 100, 101, 102, 118, 119, 127, 145, 157
Johnson, Mark, 27, 46, 69, 70
Jørgensen, Dorthe, 19, 23, 31, 32
Jørn, Asger, 111
Judgement, 32

Kant, Immanuel, 28, 31, 32, 33, 37, 38, 54, 55, 77, 78, 79, 80, 100, 149, 150, 156, 159
Kennedy, Mary M., 92
King, Nigel, 91
Kirkeby, Per, 117, 131
Klee, Paul, 116
Købke, 115, 130
Koffka, Kurt, 51
Køppe, Simo, 7, 52, 54, 66, 70, 83, 84, 92, 93, 96, 134
Krstič, K., 29
Kvale, Steinar, 84, 85, 86, 87, 96

Langdridge, Darren, 86, 91
language, 18, 21, 24, 41, 46, 55, 59, 64, 70, 81, 90, 93, 118, 135, 152, 153, 155
Leary, David E., 47
Leder, Helmut, 51
Lehmann, Alfred, 47
lifeworld, 23, 48, 53, 88, 94

Machotka, Pavel, 52
Marcuse, Herbert, 48, 49, 50, 133
Marx, Karl, 90
Marxism, 49
materiality, 39, 46, 48, 59, 62, 63, 70, 71, 93, 139, 144
Matisse, Henri, 106, 116, 122, 125

meaning condensation, 85, 86, 91, 97
meaning-making, 27, 69
melancholy, 105
Merleau-Ponty, Maurice, 20, 22, 23, 24, 25, 40, 41, 42, 43, 46, 48, 53, 54, 57, 59, 60, 62, 63, 64, 65, 66, 67, 68, 69, 70, 71, 72, 73, 74, 75, 76, 77, 78, 79, 80, 81, 84, 85, 90, 91, 93, 95, 99, 101, 107, 111, 124, 135, 137, 139, 140, 141, 144, 145, 146, 147, 148, 150, 151, 152, 155, 156, 157, 158
metaphors, 47
mimesis, 31, 33, 37
mind, 21, 28, 31, 32, 33, 34, 35, 36, 40, 46, 47, 48, 56, 60, 66, 67, 69, 70, 72, 78, 81, 116, 119, 126, 131, 133, 135, 156
Modigliani. Amedeo, 106, 113, 116
Monet, Claude, 122
mood, 31, 40, 105, 126, 128, 142
Munch, Edvard, 105, 115, 125

natural attitude, 40, 60, 62, 150
nature, 18, 23, 31, 32, 34, 37, 38, 39, 40, 46, 50, 56, 64, 65, 67, 68, 70, 75, 78, 80, 84, 96, 99, 100, 107, 109, 123, 124, 131, 132, 143, 148, 155
neuroaesthetics, 51, 84
Nietzsche, Friedrich, 90
noema, 86
noesis, 86

Olsen, Ole, 134

painting, 43, 47, 101, 106, 111, 116, 121, 125, 130, 142
Pedersen, Carl Henning, 120
perception, 9, 28, 29, 30, 32, 41, 42, 45, 47, 48, 51, 52, 53, 54, 56, 61, 62, 63, 64, 65, 66, 67, 68, 69, 72, 73, 78, 79, 89, 101, 102, 118, 135, 137, 139, 141, 144, 145, 146, 148, 150
perceptual field, 65, 67
phenomenological psychology, 21, 24, 52, 84, 85, 86, 87, 88, 90, 91, 94, 152, 155
philosophy, 9, 18, 19, 20, 21, 23, 27, 28, 29, 30, 31, 32, 33, 34, 36, 37, 38, 41, 43, 46, 53, 54, 56, 77, 81, 88, 89, 91, 160
Picasso, Pablo, 19, 124
picture, 37, 39, 53, 62, 70, 101, 105, 106, 107, 108, 109, 111, 115, 116, 117, 120, 122, 124, 125, 126, 131, 142, 160
Plato, 30, 31, 149
pleasure, 30, 31, 39, 40, 41, 44, 50, 51, 56, 67, 71, 73, 102, 120, 149
pleasure principle, 50
pre-predicative understanding, 86
pre-reflection, 43, 59, 61, 62, 70, 71, 72, 143, 144, 148, 156, 160
presence, 20, 21, 39, 46, 61, 62, 63, 64, 71, 72, 75, 85, 87, 100, 109, 113, 133, 139, 141, 142, 143, 144, 147, 158, 160
presentation, 10, 23, 35, 36, 37, 38, 41, 45, 61, 74, 89, 111, 120, 134, 135, 137, 149, 151
projection, 12, 25, 64, 77, 134, 135, 138, 141, 144, 145, 146, 147, 150
Proust, Marcel, 42
psyche, 21, 23, 24, 29, 31, 48, 52, 54, 64, 65, 70, 133, 139, 150, 158
psychoanalysis, 51, 138, 141
psychologism, 20, 40, 48
psychology, 18, 19, 20, 21, 23, 24, 25, 28, 29, 30, 31, 38, 40, 42, 46, 47, 48, 50, 52, 53, 54, 56, 75, 88, 89, 99, 100, 140, 141, 151, 160
psycho-physical tradition, 47, 50, 52
Pythagoreans, 30, 31, 149

Index

Ramachandran, Vilayanur S., 51
rationalism, 102
rationality, 24, 29, 30, 36, 37, 77, 79
reality principle, 50
reason, 18, 21, 24, 25, 27, 28, 30, 33, 34, 35, 36, 38, 39, 42, 43, 49, 54, 63, 65, 69, 72, 77, 79, 80, 81, 83, 100, 106, 123, 125, 127, 147, 149, 150, 152, 159
reflection, 23, 34, 35, 36, 42, 43, 46, 56, 59, 60, 61, 62, 64, 65, 67, 69, 70, 71, 77, 78, 79, 80, 81, 87, 94, 101, 119, 121, 122, 123, 137, 142, 143, 145, 147, 148, 149, 156, 157, 160
Rembrandt, 117
representation, 33, 36, 61, 62, 64, 66, 69, 70, 71, 73, 139, 140, 143
repression, 50
rhythm, 68, 109, 111, 118, 123, 145, 152
Ricoeur, Paul, 62, 90, 91
Rilke, Rainer M., 15, 16, 17, 18
Roald, Tone, 9, 11, 12, 22, 42, 43, 50, 54, 77, 96, 128, 146, 148
Rodin, August, 17
Roepstorff, Kirstine, 112

Sander, Katya, 113, 114, 128
Scheler, 79
Schelling, Friedrich, 32, 33
Schiller, Friedrich, 133
sedimentation, 64, 68, 71
seeing, 12, 17, 47, 107, 113, 117, 119, 120, 123, 124, 125, 126, 131
Seel, Martin, 18, 20, 27, 44, 45, 56, 100, 151, 153
self, 32, 34, 37, 56, 67, 73, 75, 76, 78, 81, 124, 131, 134, 139, 140, 143, 147, 160
self-consciousness, 19, 32, 78, 81, 142
self-expression, 77, 147
selfhood, 73, 87

Self-identity, 78
self-understanding, 19, 38, 41, 77, 79, 81, 124, 134, 135, 136, 137, 147, 148, 150, 151, 160
sensate cognition, 28, 29
sensate discourse, 28, 29
sensation, 62, 65, 66, 67, 68, 107, 111
sense experience, 28, 40, 47, 78, 160
sense impression, 28, 61, 66
sensing, 28, 29, 33, 34, 41, 43, 45, 53, 55, 61, 62, 64, 66, 68, 71, 72, 76, 87, 90, 102, 129, 145, 146, 151, 156, 159
sensuous expression, 28
sexuality, 53, 64, 72, 73, 135
shame, 73, 76
Shusterman, Richard, 30, 69
Sisley, Alfred, 122
space, 64, 71, 88, 95, 107, 109, 115, 124, 137, 144, 156, 158
spatiality, 72, 73
spontaneity, 64, 71, 140, 152
Spradley, James P., 84
Stendhal, 49
Stevns, Niels Larsen, 107, 108
suspicion, 91

tacit understanding, 80
taste, 32, 152
template analysis, 91, 97
The cognitive tradition, 51
The National Art Museum, 25
thought, 20, 27, 28, 33, 34, 36, 42, 46, 47, 52, 77, 80, 81, 87, 119, 122, 123, 135, 147, 148, 150, 153
time, 9, 10, 11, 17, 23, 28, 30, 32, 35, 36, 39, 41, 43, 45, 48, 49, 56, 60, 62, 63, 64, 65, 66, 68, 70, 71, 72, 73, 77, 87, 88, 89, 95, 96, 100, 102, 106, 107, 109, 113, 115, 116, 117, 118, 119, 120, 121, 122, 124, 125, 131, 133, 134, 135, 137, 138, 139, 142, 144,

147, 148, 149, 151, 153, 156, 157, 158, 159, 160
transcendence, 62, 116, 131, 139, 160
transcendental ego, 24, 60, 74, 79, 156
transcendental I, 78
transcendental phenomenology, 89
truth, 18, 19, 28, 29, 33, 34, 36, 38, 41, 42, 46, 48, 53, 54, 62, 77, 78, 80, 81, 84, 92, 138, 141, 147, 149, 150

understanding, 18, 19, 20, 22, 23, 24, 27, 31, 32, 34, 37, 39, 43, 45, 46, 51, 53, 59, 77, 80, 81, 82, 91, 94, 96, 102, 117, 118, 123, 125, 128, 130, 131, 135, 138, 152, 156, 157, 159

Valery, Paul, 42
validity, 54, 92, 93, 137
van Gogh, Vincent, 116, 117, 121, 130, 131
Verstegen, Ian, 51
Viola, Bill, 113
Vygotsky, Lev S., 48

Wertz, Frederick, 94, 95, 97

Zahavi, Dan, 21, 22, 38, 39, 40, 41, 48, 60, 61, 76, 80, 89, 95, 107
Zeki, Semir, 51
Žižek, Slavoj, 133